The Informed Eye

ALSO BY BRUCE COLE

Titian and Venetian Painting, 1450–1590
Piero della Francesca: Tradition and Innovation in Renaissance Art
Italian Art, 1250–1550
The Renaissance Artist at Work
Sienese Painting from Its Origins to the Fifteenth Century
Sienese Painting in the Age of the Renaissance
Masaccio and the Art of Early Renaissance Florence
Giotto and Florentine Painting, 1280–1375
Agnolo Gaddi
Art of the Western World (co-author)
Giotto: The Scrovegni Chapel, Padua
Studies in the History of Italian Art, 1250–1550

The
Informed
E Y E

*Understanding
Masterpieces of Western Art*

Bruce Cole

Ivan R. Dee

CHICAGO

THE INFORMED EYE. Copyright © 1999 by Bruce Cole. All rights reserved,
including the right to reproduce this book or portions thereof in any form. For
information, address: Ivan R. Dee, Publisher, 1332 North Halsted Street, Chicago
60622. Manufactured in the United States of America and printed on acid-free paper.

Illustration credits and permissions will be found on page 229.

Library of Congress Cataloging-in-Publication Data:
Cole, Bruce, 1938–
 The informed eye : understanding masterpieces of western art / Bruce Cole.
 p. cm.
 Includes bibliographical references and index.
 ISBN 1-56663-255-2 (cloth : alk. paper)
 ISBN 1-56663-278-1 (pbk. : alk. paper)
 1. Art appreciation. I. Title.
 N7477 .C645 1999
 701'.1–dc21 99-39154

For
Carol, Julia, Mort, and Peter

Acknowledgments

Lynne Munson has been a source of encouragement and good advice for this book and other projects—I am in her debt. The scholar/editor Jody Shiffman once again whipped an unruly manuscript into shape with skill and tact. Ivan R. Dee and Sheri Shaneyfelt also made a number of useful suggestions which improved the text. My family, Doreen, Stephanie, Ryan, and Br an, a new son-in-law, have furnished various forms of aid and comfort

B. C.

August 1999

Contents

List of Illustrations

The Informed Eye

Introduction

This book is written for those who wish to understand the fundamentals of Western art. In the following pages I aim to introduce the reader to the properties, concepts, and meanings of Western art through a series of concise, specific explorations (one might call them case studies) of a single work of art or a group of related works. These paintings, sculptures, and buildings—from widely varying cultures and times— are all major representatives of the scope and diversity of Western culture.

Each of the case studies explores some of the major conceptual issues involved in the understanding of all art. These include, among others, the relation of form and function; the nexus between medium (the artist's mode of expression) and design; the meaning of style; and the role of symbol and icon in art. The role of the artist, the function of the art objects, their relation to their particular social matrix, and their patrons will, among other subjects, also be investigated. Because no work of art is produced in a stylistic or intellectual vacuum, some knowledge of its position in the history of art is necessary. This context will be furnished by discussing the works chronologically.

Because this book is an introduction to the concepts and major issues of art and not an encyclopedic history of art, I have made no attempt at comprehensive coverage or equal representation from all periods. Rather, I have chosen the works discussed here because they particularly illustrate the points I wish to make and because they are all objects of the highest formal and interpretive order; all are masterpieces. I must also confess that many of them are old friends whom I have long loved and admired.

Whenever possible I have avoided or deemphasized the standard

art historical categorization—Antique, Baroque, International Style, and so forth. Such artificial labels pigeonhole works of art and often mask their unique individual characters. For the type of coverage that includes classification by style or time category, the reader may eventually wish to turn to any of the survey textbooks on the history of art.

Throughout this book I have tried to avoid, whenever possible, art historical jargon, obtuse theory, and fashionable interpretation. I want to explain these works as plainly and directly as I can for those just starting to look at and think about art.

This book is written at a time when the history of art is becoming less and less concerned with the work of art and its physical and stylistic properties. Today many, but not all, art historians approach art not directly but theoretically. They are interested in methods and ideologies borrowed from other disciplines—literature, psychiatry, economics—which they use to describe how art is merely illustrative of social, gender, or class conditions. Attention is now focused more on the society from which the art arises than on the artist or on the individual work of art as an independent, complete entity with a unique form and meaning. Central questions of quality, the relation between art and artists, and artistic process are often ignored altogether. The very notion of masterpieces with universal meaning is strongly questioned or completely denied.

I happen to believe that this approach is mistaken and of only transitory interest. Great art, while always linked closely to the society that produced it, transcends the narrow societal boundaries from which it springs. As long as it exists, such art embodies universal, transcendent meanings which can illuminate, instruct, and ennoble. The informed contemplation of a single work of art can be life enhancing, a source of lasting joy, comfort, and spiritual invigoration. Art can teach us many things about ourselves and the world around us. My efforts will be well rewarded if, after finishing this book, the reader agrees.

Those who wish to explore further either the individual objects or the more general questions that surround them will find bibliographical references in the Suggestions for Further Reading.

1. The Ruler as God

*The Triad of Mycerinus** *

When asked where art is found, most people would say in museums; and, indeed, in the late twentieth century the word *art* is synonymous with the paintings and sculptures housed in those institutions. Much of today's art is made specifically for museums, where it is displayed alongside works from the past. In museums, art, both old and new, is viewed with hushed reverence. The museum has become the twentieth-century cathedral: in it art is admired, one might even say worshiped, for its formal, emotional, and philosophical elements and for its ability to enlighten, to provoke introspection, and to give both visual and cerebral pleasure.

This is, however, a very modern and unique concept of art, a concept that would not have been understood by the past. Until the nineteenth century, art in most epochs and places served a function: it performed time-honored and specific tasks. The functions fulfilled by works of art were numerous. Often they were an integral part of religious ceremonies; they were employed by rulers for purposes of propaganda; and they were used to inculcate moral and civic values, to name just three of the many roles art has played in society. In other words, art was used, it was not something simply destined for a museum. In fact, the museum meant for the general public is itself a rela-

* Although not Western in origin, this work is included here because the culture of ancient Egypt has influenced Western civilization in many ways. Societies as diverse as ancient Greece, the Italian Renaissance, and nineteenth-century France have been inspired by Egyptian painting, sculpture, and architecture.

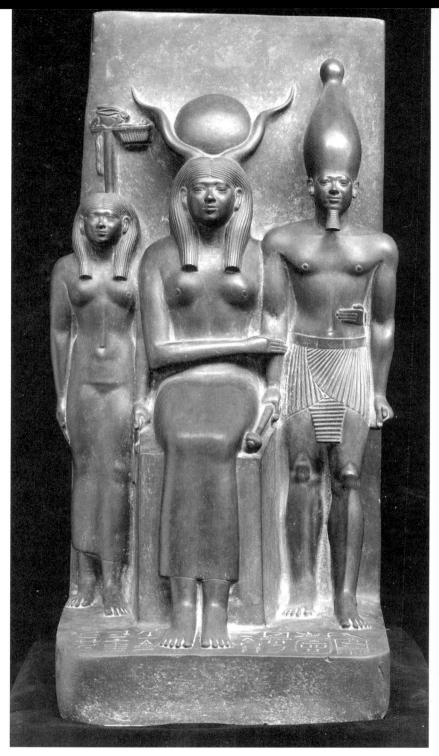

[1] *Triad of Mycerinus*, c. 2500 B.C., Museum of Fine Arts, Boston

tively new institution which can trace its roots only to the nineteenth century.

A discussion of the function of art might profitably begin with ancient Egypt where, for nearly two thousand years, artists made numerous objects of highly specific function and use. Many of these works were destined for tombs and their attendant temples, where they played an integral, indispensable role in a major Egyptian system of belief and rituals centering on death and the afterlife. The sculptural group known as the *Triad of Mycerinus* is one such work [fig. 1].

The three figures represented are, from left to right, the Hare Nome, personification of a province in Upper Egypt; the seated goddess Hathor wearing her traditional horned headdress; and King Mycerinus (who died around 2500 B.C.). The king wears a kilt, a symbol of his kingship, and his name is carved on his belt. Made of dark greywacke (a slatelike stone) which was originally painted, the overall form of the *Triad* retains much of the shape of the block from which it was carved: in the vertical and horizontal slabs of stone behind and below the figures, the form of the block remains visible. The figures themselves are not (as may seem at first glance) freestanding but are everywhere attached to the slabs, and to each other, in a dense, compact mass. The overall visual impression of the *Triad* is one of weighty stability and monumentality. In fact, so seemingly monumental is the *Triad* that it comes as a surprise, for those who know it only through photographs, to learn that it is not over life-size but just about three feet high.

Much of the blocklike quality of the *Triad* derives from the concepts and methods employed by Egyptian sculptors who were organized in workshops under the direction of a master — this was the normal working arrangement for artists in most epochs until the nineteenth century. Before beginning the carving, the sculptor would draw a squared grid on each face of the stone block. Next, outline drawings, which were used to regulate scale and proportion, were drawn over the grid on each face. On the front of the block was designed the frontal view of the figures; on the sides, each of the side views was drawn; and on the top, the top view was sketched. After all these outlines were drawn, the sculptors would attack the block with tools which, in the

period of the *Triad*, were made of either hard stone or copper. With chisels made of copper, the stone would gradually be cut away from all sides to reveal the figures. It would then be polished with rubbing stones and an abrasive substance, often sand [fig. 2]. What ensued, as we see in the *Triad*, was a blocklike sculpture with figures conceptualized and carved with separate, distinct views.

In the *Triad*, as in all their art, the ancient Egyptians were concerned not with the fleeting, temporal images registered by the eye but with the underlying eternal nature of things. Thus their paintings and relief sculptures often depict the human torso and legs in profile, the shoulders in a frontal view, and the head in profile with a frontal eye. For the Egyptians, this combination of views represented the real essence of men and women: an eternal truth, not a transitory moment of vision.

The figures of the *Triad*, consequently, are not intended to be realistic; instead their bodies and faces are composed of a series of highly stylized forms, almost pictographic in nature. One need only look at the facial features, the musculature, the stiff, braided wigs, the rigid fingers, or the sharp pleats of the king's kilt to see the extent of this stylization. Similar to the pictographic hieroglyphs of Egyptian writing, these forms convey not the particular topography and individuality of the face and body but a transcendent reality: the nature of goddesses and kings. In their carefully shaped and calculated relations, these

[2] **Egyptian sculptors at work on various statues. Drawing after a painting in the tomb of Rekhmire, c. 1475 B.C.**

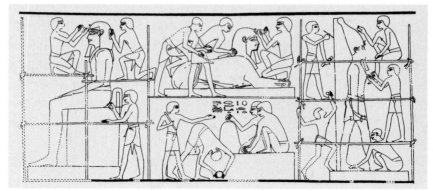

[3] *Triad of Mycerinus* (detail)

forms endow the three figures with an inescapable sense of grandeur, majesty, and permanence.

Yet within the rigid framework of this system of representation there exists a considerable sensuality of form and carving. The hard stone has been shaped into a series of smooth, polished, undulating forms which invite the viewer's exploring touch. Even in the schematized forms of the bodies there is a strong sensuosity, especially in the firm pectoral muscles of the king and in the swelling breasts of the goddess and the Hare Nome, which are revealed by their skin-tight gowns [fig. 3].

The *Triad* seems to have been one of eight similar sculptures placed in portico chapels in a temple near the immense pyramid tomb of King Mycerinus [fig. 4]. Little is known about this king, though he is mentioned by the early Greek historian Herodotus, who claimed to have traveled to Egypt in the fifth century B.C., some two thousand years after Mycerinus died Herodotus praises the king who, he says (probably mistakenly), opened the temples to the public. And he writes, "Of all their kings, too, he judged lawsuits most justly, and, in

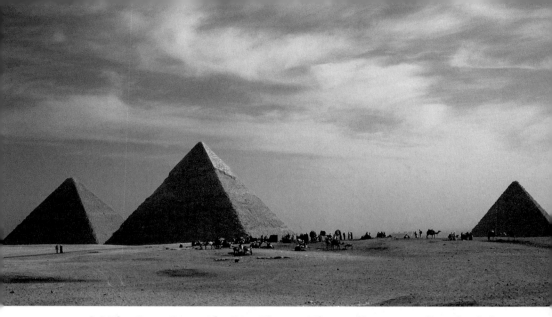

[4] The Great Pyramids, Giza Plateau. The smallest pyramid was built for Mycerinus, c. 2470 B.C.

respect to this, he is praised by the Egyptians above all that were kings among them." Unfortunately, according to Herodotus, Mycerinus was told by an oracle that he had only six years to live. When he heard this, the king kept lights burning day and night and indulged in ceaseless drinking, devoting himself to the pursuit of pleasure. Herodotus says he did all this "because he wished to prove the god a liar, that he might have twelve years instead of six, since nights became days."

While Herodotus's story is probably more fable than fact, the *Triad* is closely tied to the death of Mycerinus. Its specific function in the temple near the king's tomb is not precisely known, though the statue was certainly part of the elaborate, private rites that revolved around the dead king. Probably the priests of the temple laid offerings of food before the statue to feed Mycerinus in his afterlife. The dead king's spirit inhabited the statue and could accept these offerings and even become animate during certain ceremonies. For the contemporary Egyptian, the statue was an awe-inspiring, living, divine presence filled with potency and surrounded by magic.

Magic and supernatural awe play little role in the art of the second half of the twentieth century. Today art is admired and appreciated, not feared or worshiped; it contains none of the animism which dwells in

the *Triad of Mycerinus*. It is neither magical nor filled with divinity, nor is it part of a cosmic scheme of being; its effects are usually cerebral rather than visceral.

Contemporary attitudes toward art are, however, in the vast history of humankind, of a very recent vintage; for much of the history of civilization they would have seemed strange indeed. In many societies throughout the world, magic has been, and still is, a dominant part of art. Starting in the West with the first known art of the prehistoric period, painting and sculpture have been used primarily in magical rituals to aid the hunter, to strengthen the warrior, and to increase fertility. The use of the word *art* in the generic sense — something that represents a group of objects valued in twentieth-century terms — is really not applicable to the past. In the West, for example, the supernatural power of the image remained strong until the eighteenth century, and in parts of today's world, images remain fearsome objects imbued with divinity and power.

In its time the *Triad of Mycerinus* was not admired for its beautiful form or as an expression of its artist's psyche. Rather it was revered, by those select few who were allowed access to it, as an object filled with potent magic surrounded by ritual. Its form perfectly expresses this function. Around 1910 the *Triad* was excavated from its temple and placed in a museum, where it is now viewed historically and archaeologically as an object from a distant and dead epoch. The many visitors who stand before it today marvel at its age and are enchanted by the beauty of its forms and the skill of its carving. Yet the *Triad*, like many other objects never intended to be displayed in museums, is neither inert nor neutral. By knowing something of the beliefs that surrounded it and by understanding the functions it once fulfilled, it is still possible for one to imagine, however dimly, its original power and majesty and to see it as something much greater than a mere "work of art."

2. Form and Function

The Euphronios Crater

Occasionally an object of simple function made of humble material becomes a superior work of art. Such is the case with some ancient Greek vases. These were used for a wide variety of household, commercial, and religious functions. Over many centuries the shapes of these vessels were perfected by skilled and sophisticated potters to serve particular functions. They produced not only shapes of maximum utility but objects of considerable beauty. When these were embellished by equally skilled painters (who were sometimes potters as well), the result was a marriage of form and function seldom matched in the history of art.

Such unity occurs on a masterpiece of Greek vase painting dating from around 525 B.C. [fig. 5]. This is a crater, a vessel used for mixing wine and water—the Greeks seem never to have drunk their wine neat. Its shape is highly functional: the large mouth would not only facilitate mixing but would also allow the wine to aerate quickly. The body of the vase tapers to a circular base whose size and shape seem perfectly fitted to the swelling volume of the vessel. The crater could be carried by the two handles whose curving forms direct the eye upward from the base to the vase's mouth. The size of the vase suggests that it was used for feasts; it must have been a prized possession reserved for special occasions. This hypothesis is confirmed by the fact that the crater was discovered in a tomb where it had been buried along with the owner's other prized objects. Although found in Italy, the vase was made in Athens by the potter Euxitheos and the painter Euphronios, whose

names are written on the vessel. How the crater found its way to Italy remains a mystery.

On one side of the vase Euphronios, whose name also appears on other extant vases, has illustrated the death of the Lycian hero Sarpedon, a son of the god Zeus [fig. 6]. This story is taken from Homer's *Iliad*, probably written in the eighth century B.C. This epic poem, along with the *Odyssey*, also by Homer, is one of the earliest and greatest works of Western literature. Centering on the heroes, gods, and battles of the Trojan War, although written some four hundred years after the events, the *Iliad* is a profoundly moving story of battle, heroism, death, fate, and tragedy, all unfolding under the often merciless eyes of the

[5] *Euphronios Crater*, c. 525 B.C., The Metropolitan Museum of Art, New York

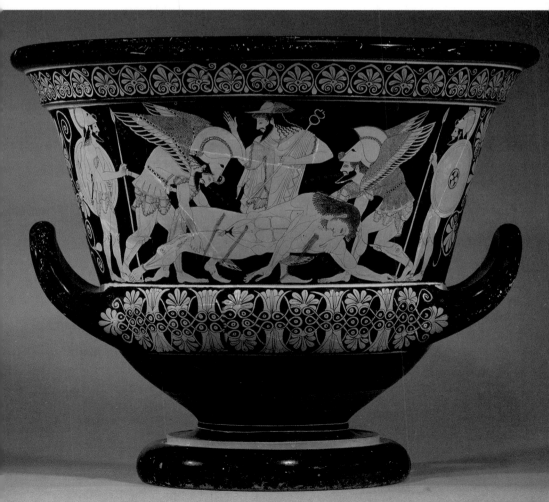

gods. It is this sense of Homeric tragedy that so pervades Euphronios's painting.

Sarpedon, Homer recounts, was killed in furious combat by a spear and "fell as an oak tree falls or a poplar, or a tall pine."

Zeus, watching the ensuing struggle over the body, sent Apollo, another of his sons, to spirit Sarpedon away from the battlefield:

> Apollo lifted godlike Sarpedon away from the weapons' range, and carried him far away and washed him in the running stream of a river and anointed him with ambrosia, and dressed him in immortal clothing, and he gave him into the hands of the swift messengers, Sleep and Death, twin brothers, to carry him with them, and they quickly set him down in the rich land of broad Lycia.

Euphronios has depicted Sleep and Death about to carry the body away, but he does not follow the *Iliad* exactly: instead of Apollo he represents Hermes, the messenger and guide of the gods. Why the painter made this change is a mystery, but often artists of originality make substantial modifications to texts or stories to suit their own needs.

Like the vase itself, the painting is made of unpretentious material used with brilliant simplicity. In this technique, called red-figure, the vase is first made by the potter and then turned over to the painter, who with black paint outlines the floral decoration and figures on the red ceramic ground. Next, the entire area outside the figures and decoration is painted solid black, and the pot is fired in a kiln. After firing, the contrast between the shiny, deep black areas and the matte orange-red of the unpainted areas (achieved often by the addition of red ocher to the clay) is aesthetically pleasing. The red-figure technique is just the opposite of the earlier black-figure technique, in which the figures are in black paint against the background of the unpainted red ceramic of the vase itself.

Vase painting is a graphic medium in which success depends on the artist's skillful manipulation of silhouette and line, and on the harmony between the vessel's shape and its decoration. This process was well understood by Euphronios, who bracketed the scene of Sarpedon's death with the two standing warriors. Their bodies and spears both frame the composition and echo the sloping sides of the vase; like

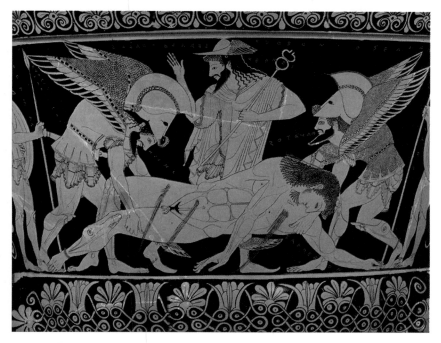

[6] *Euphronios Crater* (detail)

the spectator, these men are witnesses to the drama. The edges of the decorative floral bands are emphasized by the patterns of feet and heads. In fact, the entire figurative part of the painting can be read as a beautiful, nearly flat pattern which lies on the surface of the vase, emphasizing its shape, solidity, and mass. Euphronios and other skillful Greek vase painters realized the necessity of a delicate balance between painted shapes and the overall form of the vase: all decoration had to underscore and complement the vessel's shape, not fight against it.

The figures arranged around the fallen hero are harmoniously balanced in the center of the composition. The bent, winged figures of Sleep and Death, almost mirror images of each other, are linked by the giant, broken body of Sarpedon sprawled at their feet. Exactly between the personifications stands Hermes, whose form marks the center of the composition. Although carefully composed, the figures are neither static nor rigidly symmetrical. The straining personification of Sleep and Death, the gesturing Hermes, and the huge, limp figure of Sarpedon

are carefully interwoven into a rhythm of horizontals, diagonals, and curves which move across the surface of the scene. This slow, deliberate, dirgelike rhythmic interplay is a perfect visual metaphor for the sorrow surrounding the hero's death and for the momentous mythical events occurring around his body. The lines that create all the forms are marvels of subtle skill and surpassing grace. Line is an important component of many works of art from ancient Greece to the present, but seldom has it been executed with such fluency and elegance. Thin, thick, curving, or zigzagging line moves effortlessly across the surface, forming and defining the tragic event with breathtaking economy. The faces are given expression and decided, forceful character by only a few lines; the tension, weight, and carriage of the bodies are realized with only the marks essential for the task. Line schematizes, but at the same time it endows all the figures, even the dead Sarpedon, with a majesty and power flawlessly expressive of the epic nature of the *Iliad*. Refined, dignified, and ineffably moving, the painting expresses universal human feelings of suffering, death, and loss.

Although Greek vase painters and potters (Euphronios was just one of a number of talented masters who worked over several centuries) lived at the dawn of European art, they produced paintings and vases of remarkable refinement made with naturally occurring, common materials. Their deft and knowing manipulation of shape, line, and color made memorable, living images which often seem incapable of further perfection and profundity. Their work is proof that less is often more.

3. The Birth of Western Art

Three Greek Statues

One of the characteristics that so distinguishes Western art from the art of most other cultures is its ability to evolve, to metamorphose itself radically, in both form and content. The history of Western art is the history of unceasing change: one interpretation or style succeeding another, and often, as in the twentieth century, in rapid succession.

To see how the Western tradition differs from that of other cultures, one can, for example, compare it with the art of ancient Egypt, whose long and distinguished history extending over several millennia represents one of the most sustained traditions in the entire history of art. In an art with such an enormous history there was, naturally, change and development, but it was of a limited nature, slow and incremental—not the sort of radical change that is one of the hallmarks of Western art from its very beginning in Greece. The Egyptian *Triad of Mycerinus* [fig. 1], for example, is carved in a formal language which, with minor variations, remained unchanged for almost the entire history of Egyptian art.

This was natural because Egyptian art was centered on the portrayal of eternal verities and divine beings not subject to the vagaries, imperfections, and mutabilities of ordinary human life. The rigid hierarchical system of Egyptian society discouraged change and experimentation in art as it did in thought and life generally.

When the earliest manifestations of Greek sculpture appear around 600 B.C., the influence of Egyptian art is already apparent. The Greeks were engaged in trade with the Egyptians, and by at least the seventh century some of them had settled in Egypt as traders and mer-

chants. It is not therefore surprising that they would have turned to Egyptian art with its powerfully conceived and modeled sculpture when they began to develop their own art.

Among the earliest Greek statues is a group of nearly life-sized nude males called *kouroi*. The depiction of the nude, which so fascinated early Greek sculptors, would become one of the major preoccupations of Western art. These *kouroi* statues were placed over graves, not as effigies of the deceased but as memorials to them. They were probably meant to represent the human attendants of Greek gods rather than the gods themselves.

Even a cursory glance at one of these statues, a *kouros* from around 600 B.C. in the Metropolitan Museum of Art in New York, reveals a number of striking similarities to Egyptian figural sculpture [fig. 7]. The tense carriage of the body, the arms held rigidly to the sides with hands clenched as though gripping something, the schematization of the hair, the pose with one leg advanced, and the inscrutable fac-

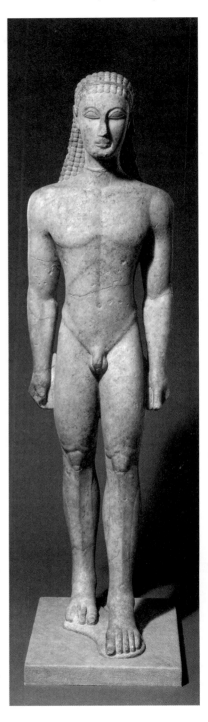

[7] *Kouros* figure, 600 B.C., **The Metropolitan Museum of Art, New York**

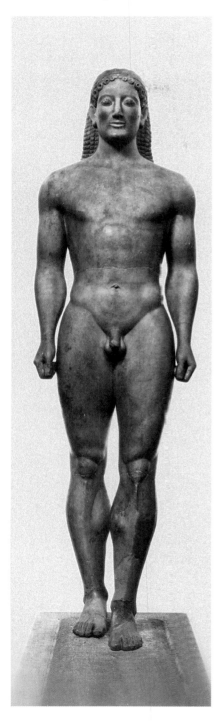

ial expression all depend on Egyptian prototypes similar to the *Triad of Mycerinus* [fig. 1].

There are, however, a number of notable differences. Even though the *kouroi*, like their Egyptian forerunners, reflect the shape of the marble block from which they are carved, their backs are no longer attached to the block—they are perfectly freestanding and fully carved on the front, sides, and back. They are also now completely nude, but, more important, they express a sense of vibrancy, human life, and latent energy which is new in the history of art.

This was only the beginning, for within just decades the *kouroi* rapidly displayed an ever-increasing naturalism. This progress is readily apparent in a *kouros* in Athens [fig. 8] carved around 525 B.C., some seventy-five years after the statue in New York discussed above. A comparison between the two demonstrates that the Athens statue, while still created within the rigid conventional framework of the New York *kouros*, reveals a fuller under-

[8] *Kouros*, c. 525 B.C., **National Archaeological Museum, Athens**

standing and more skillful carv-
ing of the human body. Its artist
is more sophisticated. He has
abandoned much of the schema-
tization of the earlier examples
for a body conceived in a subtler,
more organic fashion. The vari-
ous parts of the nude are organi-
cally unified. The transitions
between the chest, stomach, and
hips are smoother and much
more realistic. The left hip of the
Athens figure is slightly higher
than the right hip, implying a
sense of movement lacking in
the more static New York *kouros.*
By its larger and fuller volumet-
ric forms and nuanced carving,
the Athens figure is both fleshier
and more monumental than its
predecessor. It has a remarkable
living presence and new poten-
tial for action in sculpture. The
quite remarkable power of this
kouros is, however, matched by
some of the contemporary works
of the great Greek vase painters
such as Euphronios, whose
crater [fig. 5] in the Metropoli-
tan Museum of Art was painted
with similar vigor and economy.

The development of realism
continued apace in ancient

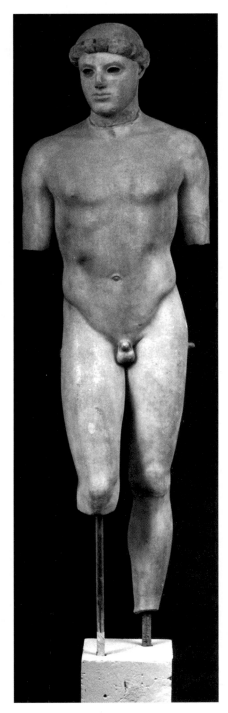

[9] *Kritios Boy,* c. 480 B.C.,
Acropolis Museum, Athens

Greece. Around 480 B.C., some fifty years after the completion of the Athens statue, it resulted in one of the most celebrated sculptures of antiquity, the so-called *Kritios Boy* [fig. 9]. Found in fragmentary form near the Parthenon, the great Athenian temple of the mid-fifth century, and now in the Acropolis Museum, this *kouros* substantially advances the conquest of naturalism begun nearly a century before. The unknown artist of the *Kritios Boy* has radically modified the *kouros* type by rejecting, once and for all, the rigid and static body that had so characterized the work of even his most advanced forerunners.

The *Kritios Boy*, though he now has lost his arms and part of his legs, seems to be a fully organic figure caught in a moment of slow forward movement. His left leg fully sustains his weight while his right leg, gently bent at the knee, advances. That the body is shifting on its axis is clear from the raised hip, the unevenness of the buttocks, the slight diagonal of the shoulders, and the turn of the head. Slightly arched, the entire body conveys a sense of muscle, bones, and flesh, all functioning together as a complete organism. There is a delicate sense of equipoise which foreshadows the great achievements of Western sculpture from the *Augustus of Prima Porta* [fig. 10] to David Smith's *Cubi XVII* [fig. 128].

The head of the *Kritios Boy* is much more realistic than that of its predecessor. Like the body to which it belongs, it strikes a marvelous balance between the real and the ideal, between accurate description and the idealism that so characterizes Greek sculpture around the middle of the fifth century B.C.

Exactly why the Greeks made such remarkable strides in the depiction and understanding of the human body can never be ascertained with certainty—such major creative developments in the history of art usually do not lend themselves to precise analysis. Yet there seems to be little doubt that these developments were heavily influenced by the culture of the Greek city-states, Athens foremost among them. It was in Greece that the foundations of a human-centered philosophy, science, history, literature, drama, and the social organization we now call democracy developed. The names of the great Greeks, the founders of Western civilization, are many: the statesman Pericles, the historian Herodotus, the physician Hippocrates, and the philosophers Socrates,

Plato, and Aristotle all contributed to a civilization which, for the first time, valued individuals and sought to assert their place in the cosmos. Unlike the rigid, hierarchical Babylonians, the Hittites, or the Egyptians, the Greeks began to explore not only the exterior world which surrounded them but also themselves as physical, moral, and philosophical beings. It is just this sort of exploration that so characterizes the development of ancient Greek sculpture.

4. Art in the Service of Power

The Augustus of Prima Porta

Art has many roles. On the Greek vase, art creates a powerful tale of gods and men; in Greek sculpture it establishes ideal beings. Art is also used to form new mythologies which establish, amplify, or perpetuate power—this is not surprising because art is often commissioned by those powerful and wealthy enough to pay for it. Such is the case with the impressive marble statue (over six feet tall) of the Roman emperor Augustus, known as the *Augustus of Prima Porta* [fig. 10]. Excavated in the nineteenth century in the villa of Augustus's wife Livia at the site of Prima Porta near Rome, it is almost certainly a marble copy of a lost bronze original which once adorned a public place in the city of Rome. Sadly, as is often the case in early art, the name of the artist who carved the *Augustus of Prima Porta* is unknown.

A pivotal figure in the long, often stormy history of Rome, Gaius Julius Caesar Octavianus, later called Augustus, was the great-nephew and adopted son of Julius Caesar. After a series of military victories, culminating in the defeat of Mark Antony and Cleopatra in 31 B.C., he became the most powerful figure in Rome. Although Octavian, as he was then known, was called only First Citizen, he was in fact an emperor who, in all but name, deftly ruled over much of the known world (it was during his reign that Christ was born). In recognition of Octavian's descent from Julius Caesar and of his de facto power, the Senate conferred upon him the title "Augustus" as a sign of his illustrious character. As he gradually consolidated and expanded his rule, the Golden Age of the Roman Empire began, a period of peace that was to last for more than two centuries. He also embellished the city of

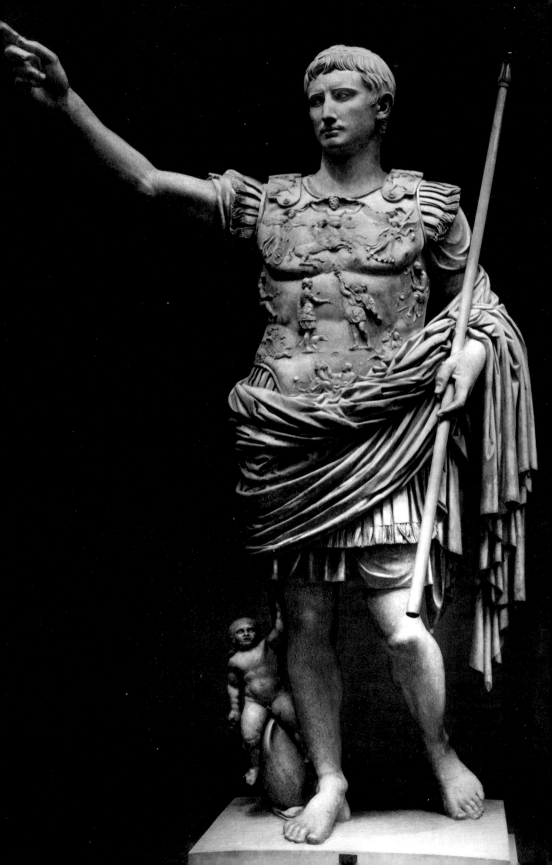

Rome through the construction of many new civic and religious build-
ings—the latter often connected with the imperial cult, a system of
beliefs by which the person of Augustus was associated with important
deities. So remarkable was this building program (which included
Augustus's own tomb, one of the largest in the ancient world) that he
could boast, "I found Rome built of bricks; I leave her clothed in mar-
ble." Augustus and his advisers consistently used art to enhance the
image of the ruler and to convey a sense of his power and divinity to a
large public audience throughout the empire.

This is the purpose underlining the imagery of the *Augustus of
Prima Porta*, whose meaning is comprehended through the interweav-
ing of form and symbol. The body of the emperor is given life and bal-
ance by the torsion and movement created by the advancing motion of
the legs. The left leg, raised on the toes, evokes action; the right leg
bears the body's weight. This torsion was first introduced into sculp-
ture, as we have seen, in ancient Greece. One arm is held close to the
body, the other extended almost fully into space. This massing of the
marble elements of the figure imparts an energy, order, and equipoise
directly reflecting the equilibrium and authority of Augustus himself.

The image of the emperor is, of course, idealized. The youthful,
handsome, serene face with its regular features and carefully arranged
hair had little to do with the actual appearance of Augustus, who was
approximately fifty years old when the statue was carved around 20 B.C.
[fig. 11]. Although the Roman historian Suetonius claims that Augus-
tus was handsome and graceful even in old age, he also writes that "his
teeth were small, few, and decayed; his hair, yellowish and rather curly;
his eyebrows met above the nose, he had ears of moderate size, a nose
projecting a little at the top, and then bending slightly inward." Sueto-
nius also describes the emperor's body as marred by blemishes and dry
patches that suggest ringworm. But it was not the sculptor's task to
depict the emperor accurately; rather, he was to present the onlooker
with a carefully conceived, idealized image of the ruler.

The formal idealization of the statue is derived from the bronze

[10] *Augustus of Prima Porta*, c. 20 B.C., **Vatican Museums, Vatican City**

Spear Carrier by Polyclitus, a Greek sculptor of the fifth century B.C. [fig. 12]. In the age of Augustus, a period when Greek culture was held in the highest esteem, this statue, known only from copies of the lost original, was considered the perfect embodiment of order, beauty, and majesty. Thus by appropriating its formal elements and style, the unknown sculptor of the *Augustus of Prima Porta* was able to transfer these associations to the image of the emperor. Such borrowing of style for ideological purposes occurs throughout much of the history of art.

This idealization of form is reinforced by symbols. Next to the emperor's right leg is a cupid astride a dolphin; both are references to Venus, who was the mother of Aeneas, a mythical ancestor of Augustus's family and one of the principal founders of Rome. The emperor's divinity is also demonstrated by his bare feet: only mortals needed boots.

It is, however, on the cuirass (the one represented was probably

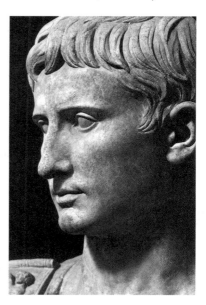

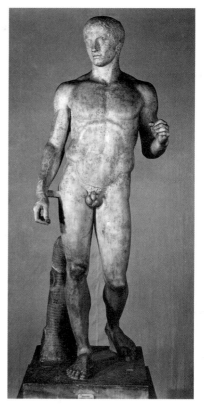

[11] *Augustus of Prima Porta* (detail)

[12] Polyclitus, *Spear Carrier*,
c. 450–440 B.C.,
Museo Archeologico, Naples

bronze and for ceremonial use only) that symbols cluster in greatest profusion [fig. 13]. The linchpin of this symbolism is at the center, where a Parthian king offers a battle standard surmounted by a Roman eagle to a figure who is either a Roman soldier or a personification of Mars Ultor, the Vengeful Mars. The interchange depicted here took place after the victory of the Roman legions over the Parthians in 20 B.C. This triumph was exceptionally important, not only because it avenged the earlier ignominious loss of the Roman standards and eagles to the Parthians in 53 B.C., but also because it initiated the long Golden Age of Rome. It also served symbolically to elevate the position of Augustus to the role of victor and infallible ruler. The extended right hand of Augustus may once have held out the recaptured standards as further display of his prowess.

The Roman victory is placed in a broader context on the rest of the cuirass. Flanking the restitution of the standards are two mourning women, personifications of the lands and peoples under Roman domination. Below the restitution is Mother Earth with her symbolic cornucopia. She is flanked by Apollo and Diana, two gods closely associated with the sun god Sol, and Luna, the goddess of the moon. Both Sol in his chariot and Luna carrying a torch appear above the return of the standards. Caelus, the uppermost figure, holds open the canopy of heaven. These personifications, which are typical of Roman

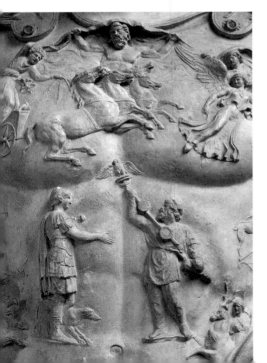

[13] *Augustus of Prima Porta* (detail)

[14] *Gemma Augustea*, c. 10 B.C., Kunsthistorisches Museum, Vienna

allegorical thought, enfold the victory in an elevating, cosmic scheme of deified earth and heaven. The triumph is made holy and eternal, characteristics also shared by the emperor, whose body is protected and adorned by the cuirass.

Similar calculated manipulations of form and symbol appear in much art made during the reigns of Augustus and many of the emperors who succeeded him. Some works, such as the *Gemma Augustea* (a sardonyx cameo carved, probably by a Greek artist, about 10 B.C.), are less subtle than the *Augustus of Prima Porta* in their use of imagery to enhance the power of the emperor [fig. 14]. The cameo, although small in scale (7-1/2 x 9 inches), is monumental in expression. Its luminous white figures (made of the upper of the cameo's two layers of stone) are disposed in two registers against the black of the lower layer; each register contains numerous figures realized in the same idealizing style found on the statue of Augustus.

The upper register is the physical and symbolic hub of the cameo. Here is the enthroned, idealized figure of Augustus in the guise of Jupiter, the absolute ruler of the gods. Sitting with Augustus, and staring at him, is the personification of Rome, while behind him are personifications of Italy, the oceans, and the earth who crowns Jupiter-Augustus. The emperor looks toward the left half of the register, where his chosen successor Tiberius descends from a chariot driven by Victory. In the lower register, the power of Augustus and of Roman arms are graphically demonstrated as soldiers capture barbarians and erect trophies as a sign of victory. The action in the earthly lower register is made possible by the emperor above, whose semi-divine status is manifested by both his perfect form and by the cluster of symbolic associations that surround and elucidate it.

The *Augustus of Prima Porta* and the *Gemma Augustea* demonstrate how the forms and symbols of art may be used for supra-artistic purposes. These representations are major works of art, but at the same time they are highly sophisticated transmitters of imperial mythology and propaganda. As one can see from these works, as well as from many other paintings, sculptures, and buildings throughout history, superior art and indoctrination are far from incompatible.

5. A Home for the Gods

The Pantheon

Architecture always has a function. While differing fundamentally from one another in size, material, shape, and design, all buildings, regardless of the period in which they were constructed, have a task to perform. The designs of any good architect must always spring from this purpose and revolve around it. This relationship must be conveyed by the basic properties of architecture, which include mass, space, surface, and decoration. It cannot rely on words and images to convey its meaning as do other art forms, such as literature and painting. Great architects make their structures express their function perfectly.

One of the most masterful expressions of function through architectural form is the Pantheon, a Roman temple dedicated, as its name implies, to all the gods. This building has remained a source of continual admiration and inspiration—it is one of the world's most imitated buildings—from the ancient world to today [fig. 15]. Its date can be fixed to around 125 A.D. by the brick used for its construction. Roman brickmakers stamped their bricks with information such as the names of then-reigning officials, which can be dated with considerable accuracy.

The architect of the building is unknown, but its patron was certainly the emperor Hadrian (76–138 A.D.). Hadrian's building replaced an earlier Pantheon which had been built by Agrippa, a favorite of Augustus. Modesty is not a characteristic usually associated with a Roman emperor (or with most statesmen, for that matter), but Hadrian was quite unassuming about his architectural patronage, for he replicated the inscription from Agrippa's original building on the new,

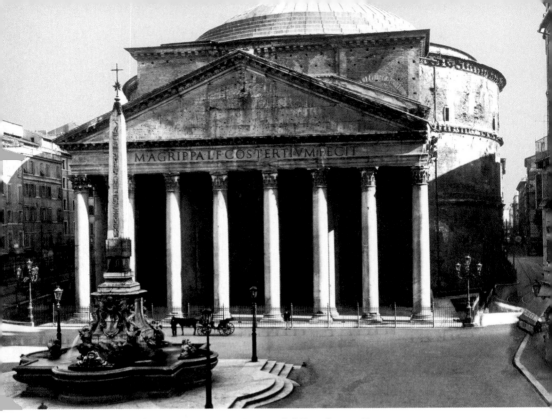

[15] Pantheon, c. 125 A.D., Piazza del Pantheon, Rome

much grander Pantheon: MARCUS AGRIPPA, SON OF LUCIUS, CONSUL THREE TIMES, BUILT THIS.

Set in a bustling Roman piazza, the Pantheon is still an overwhelming sight, but like many historical buildings its surroundings have changed, drastically altering the architect's intentions. Originally the Pantheon was fronted by a paved forecourt enclosed by two covered, parallel colonnades (perhaps four hundred feet long) closed off from the street by a wall running between these parallel colonnades [fig. 16]. This closed forecourt blocked a direct view of the building from the street. One had to enter the forecourt through a small gate in the short end opposite the Pantheon before the full size of the building burst forth upon the onlooker. It also seems that the parallel colonnades, which began at either end of the Pantheon's porch, would have masked a view of the great drum looming behind it; consequently, only after one entered the building would its true shape and size have

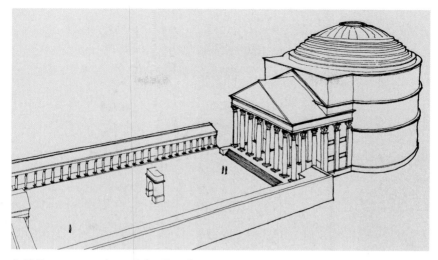

[16] **Reconstruction of the Pantheon**

been suddenly and dramatically apparent. Today there is no trace of the enframing and shielding forecourt; the Pantheon stands entirely alone, now deprived of this crucial architectural element.

Moreover the building was once approached by a flight of steps leading up to the series of columns forming its porchlike entranceway. These are no longer visible because over the centuries here, as elsewhere in Rome, accumulated debris has raised the street level considerably. Originally the building rose well above the street, but today it is level with it, as though its great weight has pushed it far into the earth.

The Pantheon is comprised of three elements: a porch supported by a forest of huge columns which carry a pediment and roof; a massive block of masonry set behind and above the porch; and a huge drum from which rises the most famous part of the building, a vast (134 feet in diameter) coffered dome opened to the sky at its center by a circular opening called an oculus [fig. 17]. The building, made of brick and poured concrete, is a marvel of planning. The design and construction of the huge concrete dome and its brick and concrete drum with the eighteen-foot-thick walls supporting its enormous weight demonstrate the Roman genius for engineering on an expansive scale. Such construction demanded not only master carpenters (the dome

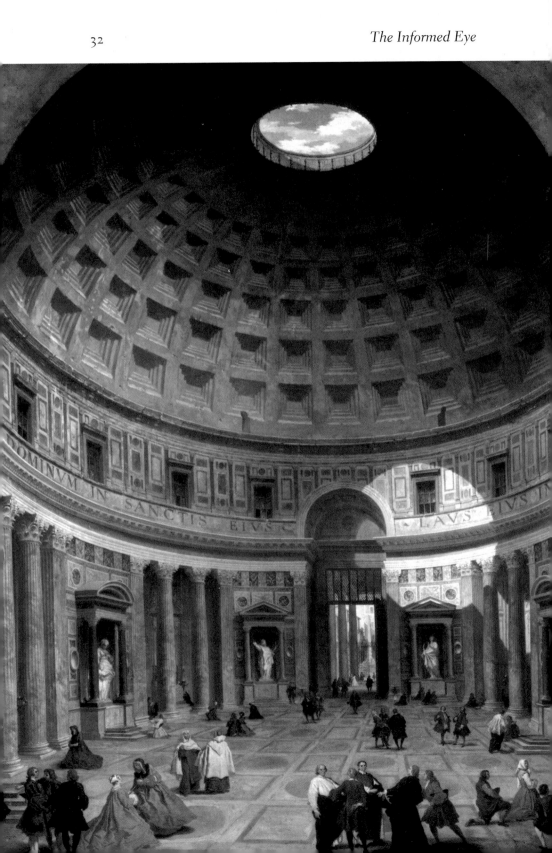

was poured into a hemispherical wooden mold supported by scaffold-ing), masons, and bricklayers but also a genius for the orderly organi-zation of thought, labor, and process that characterizes much of Roman society. The envelopment and definition of vast space by con-crete, also found in civic and secular buildings, is one of the principal characteristics of Roman architecture.

After traversing the dark, wide porch with its giant columns, and then passing through the original bronze doors into the domed interi-or, it is not, however, about engineering or architecture that one thinks, for the immensity of the seemingly unsupported domed space seems so harmoniously perfect as to be not of this world. Decorated by coffers once painted blue, which order and enliven its broad surface, the huge dome made of tons of concrete seems to hover weightlessly above the interior glowing with the colored marbles set into the walls and floor. Drum and dome are illuminated through the oculus by an ever-moving shaft of streaming daylight which circles the interior as the earth turns.

The dazzling architecture of the Pantheon is directly related to its function and is therefore very different from most other temples of the Roman world. The latter derive from the Greeks who, like the Romans, worshiped not inside but outside their sacred buildings. Consequently Roman stone temples, built using the post and lintel system (in which vertical columns supported horizontal beams), consisted of a small central block (called a *cella*) surrounded by columns and porches, a tightly massed group set in and surrounded by open space. These tem-ples, as the Roman example at Nîmes in southern France clearly demonstrates, were rather compact, closed entities with minimal inte-rior space [fig. 18]. Internal space was unnecessary because religious ceremonies were performed at an outdoor altar placed in front of the temple. From this altar the worshipers could glimpse a cult statue through the open doors of the small *cella* block set within enframing columns. This type of temple, which includes among its numbers some of the most renowned examples of Western architecture, includ-

[17] Giovanni Paolo Panini, *Interior of the Pantheon*, Rome, c. 1734, National Gallery of Art, Washington D.C.

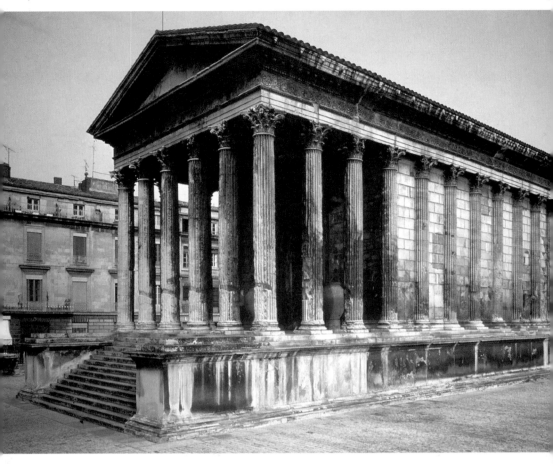

[18] **Maison Carrée, c. 15 A.D., Nîmes**

ing the Parthenon in Athens, was, like the Greek vase [fig. 5], a perfect
symbiosis of form and function, a highly evolved entity which was not
only perfectly workable but beautiful in shape.

The shape of the Pantheon is also beautiful but entirely different
from these earlier types. There is some concession to tradition in the
post and lintel porch which retained the steps, columns, and pediment
of the older temple type, but the interior space is dramatically innova-
tive. Unlike the small *cella*, it is enormous in size, domed, not sup-
ported by columns, and made of poured concrete rather than post and
lintel stone construction. But there is an even greater dissimilarity: the

basic concept of the older temple type has been turned inside out. Instead of a rather solid, compact building surrounded by space, the Pantheon consists of masonry and concrete membranes enclosing a seemingly limitless volume of space. Unlike the earlier temples' space, this is not that of the natural world: it is space created, defined, and made mystical by architecture. Moreover, because the space is enclosed, it can be fully experienced only by entering through the doors and standing in its midst.

The Pantheon's space is perfectly expressive of the function of the temple as the shrine of all the gods. Its rotundity does not draw the eye to one particular area but keeps it moving around and up the drum (in which statues of the major gods would have been placed) to the dome. Here, unlike the earlier temples, there was not just one cult image to worship but many, for the Pantheon was designed as a shrine to "all the gods." That this immense, domed interior space was meant to represent the home of the gods cannot be doubted. As early as the first years of the third century, the Roman consul Dio Cassius said that its vaulted roof resembled the heavens. This in fact is the feeling that has so impressed and often overwhelmed visitors through the centuries. Michelangelo called it "angelic and not human in design," and the poet Shelley wrote: "It is as if it were the visible image of the universe: in the perfection of its proportions, as when you regard the unmeasured dome of Heaven, the idea of magnitude is swallowed up and lost." These feelings arise from its architect's genius and his skillful and knowing manipulation of brick, concrete, and space, all in the service of the Pantheon's ultimate function as a sacred space inhabited by the gods.

6. The Reuse of Symbols

The Sarcophagus of Junius Bassus

On the 25th of August, 359 A.D., Junius Bassus died. He was the prefect of Rome, the highest official of the city, and also the head of the Roman Senate. He was forty-two years and two months old at the time of his death and had just recently been baptized. These bare facts are inscribed on his sarcophagus (the large, oblong carved marble box that housed his corporeal remains) originally set in the crypt of the Basilica of Saint Peter in Rome [fig. 19]. The church was the site of the tomb

[19] **Sarcophagus of Junius Bassus, c. 360 A.D., Saint Peter's, Vatican City**

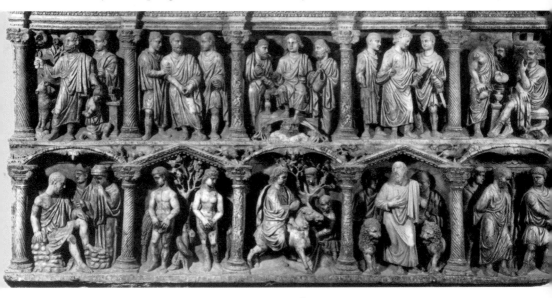

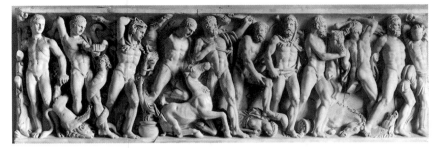

[20] **Labors of Hercules Sarcophagus, c. 200 A.D., Palazzo Ducale, Mantua**

of Saint Peter, the first pope and patron saint of the basilica. To Christians, Saint Peter's was Rome's most sacred place.

Obviously Junius Bassus was an important and respected figure in mid-fourth-century Rome. To his contemporaries, his last-minute baptism would not have been particularly surprising. Often Roman men of the world who wished to make their way outside the strictures of the Christian faith delayed their sacramental entry into the church until there was no longer any possibility of sin. That this was an accepted practice condoned by the church is demonstrated by the location of the sarcophagus of Junius Bassus within Saint Peter's.

The size of the sarcophagus of Junius Bassus and the rich, complex figurative and architectural decoration of its front and sides clearly place it among the most elaborate and costly sarcophagi of its period. These objects were made by specialized workshops which often produced them in assembly-line fashion, with various artists working on specific parts. Sometimes they were made without commission to await a buyer whose carved portrait would be added after purchase. But this does not seem to be the case with the sarcophagus of Junius Bassus. The high quality of the carving and the complex iconography (the meaning of its images) are of considerable intricacy. These unusual characteristics make the sarcophagus one of the major sculptural works of the middle of the fourth century, a period during which the production of large-figure sculpture, like the *Augustus of Prima Porta* [fig. 10], so characteristic of earlier epochs of Rome, declined dramatically.

This decline is partly attributable to the rise of Christianity

(declared an officially tolerated religion by Emperor Constantine in
313), a sect unwilling to sanction the displays of beautiful, ideal human
form, such as the *Augustus of Prima Porta*, that had been so much a
part of pagan culture. The figures on the sarcophagus of Junius Bassus
are less idealized, less comely in form than earlier examples of Roman
or Greek sculpture [fig. 12]. They are more squat, less correctly pro-
portioned, and less carefully interrelated. The front of the sarcophagus
is divided by columns into ten compartments, each occupied by figures
who seem uncomfortably jammed together in an indeterminate space.
Some scholars see a qualitative decline in the Junius Bassus sarcopha-
gus, as well as in other sculpture of the mid-fourth century A.D. in
Rome. And, in fact, when compared to earlier carving, such as a sar-
cophagus from around 200 A.D. for example [fig. 20], the sculptor of the
Junius Bassus sarcophagus seems remarkably uninterested in smooth-
ly articulating his figures or in accurately fixing their positions in space.

But does the Junius Bassus sarcophagus really represent a qualita-
tive decline, or is the style of its carving a direct response to a new set
of Christian values and beliefs which were directed toward the after-
life? One of the reasons Christianity thrived in the Roman world was
that in the midst of the disintegrating society of the empire, it promised
rebirth and salvation and, at the end of life, heaven for the virtuous
believer. This is what Junius Bassus was seeking. It was not something
he could find in the pagan cults, where the concept of an afterlife was
often ambiguous and relatively unimportant. The Christian of the
fourth century looked fervently beyond his or her imperfect material
world toward the salvation promised by faith. This emphasis on other-
worldly things, and the association of beautiful figure sculpture with
paganism, were probably responsible for a decided change in the way
the figure was carved. This change was reflected in the sarcophagus of
Junius Bassus, whose sculptor may have purposely distorted anatomy
and space in order to escape the glorification and idealization of the
human body so common in earlier pagan art.

The meaning of the Junius Bassus sarcophagus, like the style of its
figures, is a direct response to its Christian content. Stories from the
Old and New Testaments occupy the niches on the front of the sar-
cophagus. Portrayed on the upper level are, from left to right, the Sac-

rifice of Isaac; Peter's Capture; Christ Enthroned; Christ's Arrest; and
the Judgment of Pilate. The stories on the lower level are, again from
left to right, Job's Distress; Adam and Eve; Christ's Triumphal Entry
into Jerusalem; Daniel in the Lion's Den; and Paul's Arrest. The
choice of these stories was not accidental; they were very carefully
selected to convey certain fundamental Christian messages about life,
death, and salvation.

Salvation and redemption are necessary because of the original sin
of Adam and Eve. These figures are seen covering themselves in newly
acquired shame standing before the tree which bore the forbidden fruit
[fig. 21]. The early Christians believed that the ordeals of Job and
Daniel and their eventual triumph through faith and divine interven-
tion were Old Testament precursors of the Passion of Christ. Likewise
they saw the willingness of Abraham to sacrifice his son Isaac as fore-
shadowing God's sacrifice of his son Christ. Other trials of faith, this
time Christian, were endured by Paul and Peter, whose arrests are also
depicted on the sarcophagus. These saints were martyred for their
belief in Christ, whose own story occupies four of the ten scenes on the
front of the sarcophagus

Two of these scenes, Christ's Arrest and the Judgment of Pilate,
occupy the two compartments at the right on the upper level. Christ's
Triumphal Entry into Jerusalem and Christ Enthroned are set, respec-
tively, one above the other in the center of the sarcophagus. Flanked
by the other scenes, which frame them both in space and in meaning,
these are clearly the most important stories on the front of the sar-
cophagus. They depict Christ's triumphs both on earth and in heaven:

[21], [22] **Sarcophagus of Junius Bassus (details)**

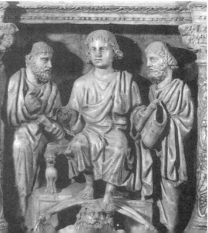

his entry into Jerusalem just before his crucifixion (the event is not depicted here because it was still associated with capital punishment), and his enthronement in heaven.

Both of these scenes retain strong references to the pagan past from which Christianity, and Junius Bassus, were still emerging. The Triumphal Entry of Christ would have been compared to the *adventus*, the triumphal procession of an emperor into a city. The scene of Christ Enthroned, here surrounded by Saints Peter and Paul, distinctly recalls similar images depicting enthroned secular rulers; in fact, the young, toga-clad Christ, perhaps the most idealized figure on the sarcophagus, resembles a Roman emperor [fig. 22]. Below the feet of Christ is Caelus, the same personification of the cosmos seen on the cuirass of the *Augustus of Prima Porta* [fig. 13]. The appearance of this personification upon the sarcophagus, as in the earlier statue, demonstrates the divinity of the Christ-emperor and his domain over heaven and earth.

Such connections with the pagan past are not surprising. Christianity, like any new religion, did not emerge complete with a new set of stories and symbols. Instead it often skillfully reutilized existing pagan images, such as a triumphal entry or the enthronement of an emperor. These images, charged with their own ancient, powerful, and often sacred meanings, could then be employed to enhance a new Christian context.

The scenes of Christ's Triumphal Entry and Christ Enthroned are directly related to the death of the newly baptized Junius Bassus. Like Christ and those other personages depicted on his sarcophagus, Junius himself would be reborn and saved, and would eventually find his place in heaven through his baptism and through Christ's sacrifice. And his Christian Roman contemporaries would themselves have found comfort in the complex network of messages of hope and salvation carved into this sarcophagus.

7. Icons of Power

The San Vitale Mosaics

The visitor to the northeastern Italian town of Ravenna marvels at the number of well-preserved, remarkably decorated buildings which survive from the fifth and sixth centuries A.D. These structures and the culture from which they arose occupy a unique place in the history of European art and thought.

In 191 Ravenna became a Roman town. Its important port of Portus Classis was used by Augustus as the headquarters for the Roman Adriatic fleet. (Today the sea has abandoned the city, moving some eight miles to the east.) But Ravenna was not important until the fifth century when, during the turmoil that engulfed the disintegrating Roman Empire, the emperor Honorius and his court fled to the safety of this small town. By this twist of fate, Ravenna became the capital of

[23] *The Battle of Issus*, c. 100 A.D., Museo Archeologico, Naples

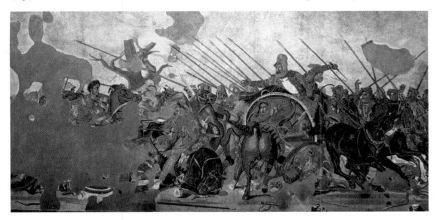

41

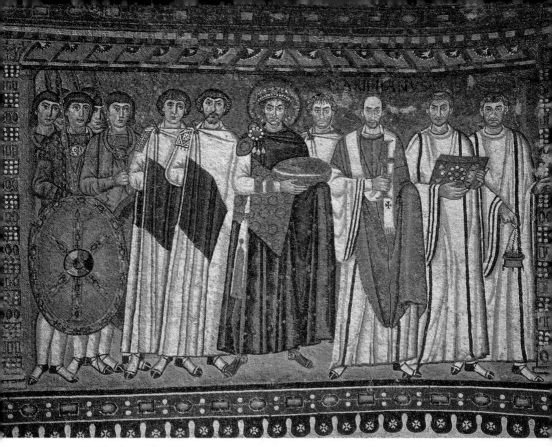

[24] *The Emperor Justinian and His Court*, c. 540, San Vitale, Ravenna

all that remained of what had once been the vast Western Empire of Rome (the empire had been split into western and eastern divisions by Constantine in the fourth century A.D.). In 476 the Western Roman Empire ceased to exist as Italy fell under a succession of barbarian kings who ruled from Ravenna. The city was retaken in 540 by Belisarius, the general of Justinian I, the Eastern Roman Emperor who ruled from the capital at Constantinople (present-day Istanbul).

Ravenna was no ordinary small coastal town but rather a major center of political and intellectual activity. The several churches, tombs, and other structures erected during the tumultuous history of the city are of a particular importance and magnificence befitting their significant patronage. Perhaps the most fascinating of these is the Church of San Vitale, built during the reign of Justinian. Begun

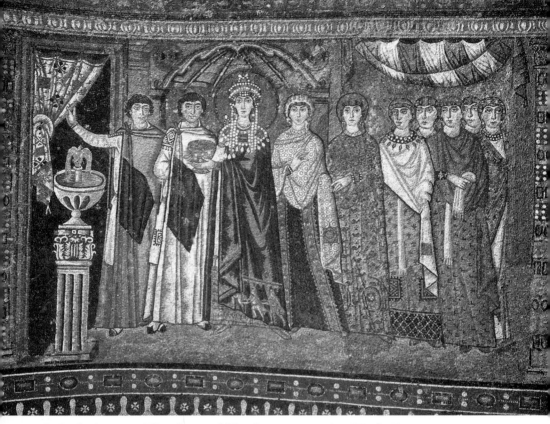

[25] *The Empress Theodora and Her Court*, c. 540, San Vitale, Ravenna

around 526 and consecrated in 548, the church retains much of its original sixth-century decoration. San Vitale's ensemble of richly variegated marble columns, marble revetment, and patterned marble pavement creates a particularly splendid color and opulence. But its greatest brilliance derives from its many resplendent mosaics.

Mosaic, a venerable art already known to the ancient Mesopotamians, was often employed by the Greeks and Romans. The medium of mosaic consists of embedding tesserae into a mastic, usually of plaster, mortar, or concrete, to form a design. These tesserae were usually made from a wide range of materials including pebbles, cut stones, tile, or glass. In San Vitale, glass tesserae were made by breaking or cutting sheets of opaque colored glass into small cubes. These cubes were then set into the mastic in the pattern and shapes previously designed by the

artist, either on paper or on the actual wall itself. When the tesserae were laid in the mastic, they were often placed at a slight angle to the wall and to each other so that their fractured edges protruded to reflect light. To further avoid a monotonous flatness, the tesserae were laid at various depths so that light falling over the uneven glassy surface was absorbed or reflected in a myriad of ways, imparting a glimmer and life otherwise unobtainable.

The San Vitale mosaics are heir to a long tradition of mosaic-making in the ancient world. In Rome and its territories, mosaic was used as decoration for walls and floors. Often the tesserae were arranged in pleasing abstract patterns of form and color, much like a rug or wallpaper, but with the advantage of greater sturdiness and ease of cleaning. Frequently vaults and floors were covered not with pattern but with illusionistic mosaic pictures much like murals. One of the finest of these is the *Battle of Issus* mosaic of around 100 B.C., unearthed in a house in Pompeii [fig. 23]. This vast and tumultuous composition (some fifteen feet across) depicts a battle between Alexander the Great and the Persians and may itself be modeled after a famous Greek example, thus furnishing some idea of what large-scale Greek painting originally looked like. In the *Battle of Issus,* mosaic is used to create a highly lifelike scene of action. Although there is no background—the representation of deep space would have been unnerving on a floor decoration—the struggling men and animals are very volumetric and realistically depicted. Their forms are modeled with the subtle gradations of light and dark made possible by the use of tiny tesserae.

In almost every way the mosaics in San Vitale are very different from the *Battle of Issus.* Their style demonstrates clearly, as did the sarcophagus of Junius Bassus [fig. 19], the development of a new, much less realistic art, emerging out of, but radically departing from, the old Roman world. This is seen clearly in the mosaics on the walls of the chancel of San Vitale, the church's most sacred area and the location of the main altar. The mosaic on the chancel's left wall, as one faces the altar, represents the emperor Justinian, the bishop Maximian

[26] *The Empress Theodora and Her Court* (detail)

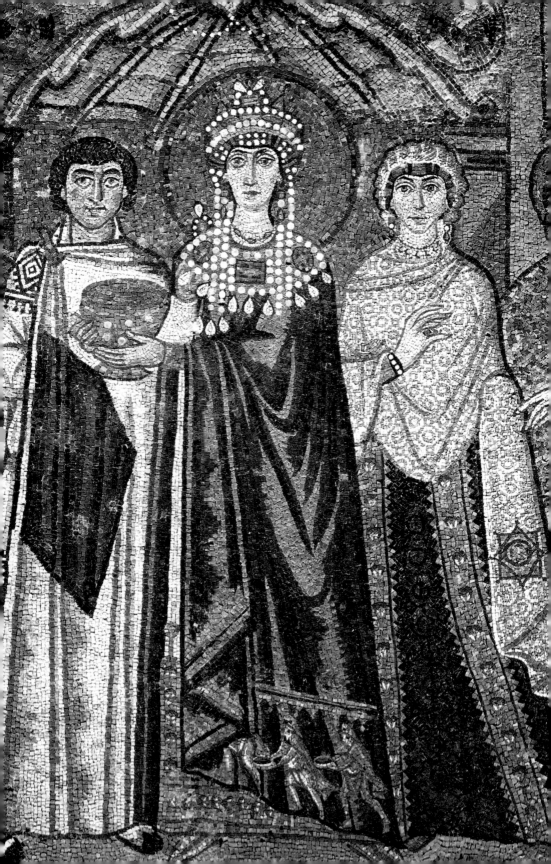

(appointed to the See of Ravenna in 546), and other members of the imperial court, including soldiers and high officials who, like the emperor, wear the imperial purple on their robes [fig. 24]. The opposite mosaic on the chancel's right wall depicts the empress Theodora with her ladies in waiting and other dignitaries [fig. 25].

Both of these mosaics are composed of tesserae much larger than those of the *Battle of Issus*. This is because the artist of the San Vitale mosaics was not interested in the nuanced depiction of light and the subtlety of modeling afforded by the smaller tesserae. Instead he selected larger, often irregularly cut tesserae to make more schematic, bolder, and perhaps coarser faces and bodies. He was interested fundamentally in creating an image not of the transitory effects of the real world but of another deeper, unworldly reality. For example, Justinian and his retinue are not set in any specific space. Because there is no indication of ground, the figures all appear to float or hover, rather than to stand. In the Theodora mosaic there is some indication of architecture in the niche behind the empress and the two figures flanking her, but the bodies still seem to levitate. In both mosaics the heads and feet are depicted on the same level, and the figures all seem rigid, their faces and large staring eyes betraying no emotion. In every figure, face, robe, and object there is an abundance of color and pattern. The tesserae, even in quite small areas, vary in color. There is an overall deployment of pattern on the robes, especially in the Theodora mosaic, which imparts a flat tapestrylike effect—as though there were no bodies beneath the robes [fig. 26]. The forms are further flattened by the large, shimmering expanse of golden tesserae behind the heads and shoulders.

How different are these depictions of the emperor and empress from the much more comely, realistic *Augustus of Prima Porta* [fig. 10]! Obviously this unknown artist and his patrons were not interested in an image of a transitory, corporeal world. Instead they wanted to depict both the mysterious presence and the divinity of the haloed emperor and empress, as though they were actually in the chancel of San Vitale. As an heir of the pagan Roman emperors, Justinian was considered divine. The presence of his floating, disembodied image near the altar of San Vitale would have seemed both fitting and believable to con-

temporary worshipers. Both Justinian and Theodora are participating in the offertory ritual of the Mass: he offers a paten, the vessel that holds the Eucharistic wafers, while she holds a bowl for the Eucharistic wine. But the images of the royal couple would not have been viewed simply as pictures; rather they were icons, the magical embodiments of the actual presence of the persons they depicted. As such, they would have helped to establish the imperial authority in Ravenna, the distant outpost of the Eastern Empire.

The duality of the divine and imperial nature of Justinian and Theodora are brilliantly illustrated in the imperial groups made by the thousands of glittering colored and gold tesserae glowing softly in the chancel of San Vitale. The shimmering, continuously shifting reflection of light from the multicolored tesserae imparts a mysterious inner life to these majestic and divine beings. These images could have been painted or carved, but neither of these mediums would have produced the perfect symmetry of ethereal form and supernatural content that make the San Vitale mosaics such remarkable masterpieces.

8. Inventing Western Drama

Giotto: The Lamentation

The names of most artists working before the fourteenth century are lost. There were, of course, artists of renown long before these times, but their fame was exceptional. Occasionally their names are associated with, or signed on, particular objects, such as the *Euphronios Crater* [fig. 5], but little or nothing is known about them as men; even the most basic facts of their lives are lost.

Giotto's *Lamentation over Christ*, painted around 1310 in the Scrovegni Chapel in Padua is, however, the work of a famous artist, one of the earliest to rise out of the anonymity that so obscured earlier painters, sculptors, and architects [fig. 27]. From Giotto's *Lamentation* onward, the names and accomplishments of many artists were to become a prominent part of Western culture. It is not surprising that this recognition should first occur in the Italian Renaissance, a period so passionately interested in the life and deeds of the individual.

Official documents, contemporary commentators, and even the poet Dante furnish records of the life, and beyond that of the celebrity, of Giotto the man (circa 1267–1337); all testify to his importance as one of the first famous artists in the history of European art. From these sources one learns that he was born around 1267, that he was sent to Florence as a youth to be apprenticed to a painter (probably the respected Florentine Cimabue), and that he soon surpassed his master. Within two decades Giotto had emerged as one of the leading artists of his time. So renowned was he that around 1305 he received one of the most important commissions of the fourteenth century, the decoration of the Scrovegni Chapel.

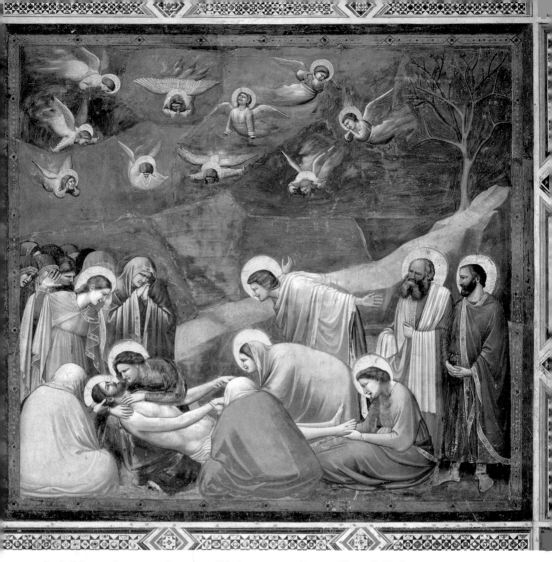

[27] Giotto, *Lamentation over Christ*, c. 1310, Arena Chapel, Padua

This small structure in the northern Italian town of Padua was the chapel of the palace (now destroyed) of the Scrovegni, one of the leading families in the city. The head of the family, Enrico Scrovegni, called Giotto to Padua from Florence, where he had a flourishing career, and commissioned him to decorate the structure completely with a series of frescoes depicting the life of Christ and his ancestors. Giotto knew that these paintings, which were to cover the entire wall surface, had to accomplish two things: they were to decorate the whole

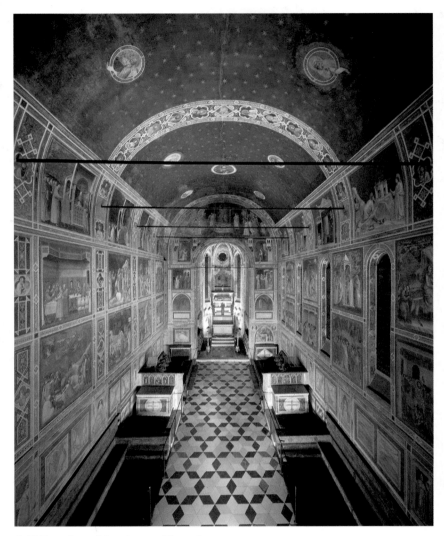

[28] Interior of the Arena Chapel

of the inside of the chapel with fields of color and shape; and they were to tell the holy stories in a series of pictures arranged in horizontal bands around the walls [fig. 28].

Giotto was to paint in fresco. This is an ancient, extremely durable medium in which pigment is applied to wet plaster which, as it dries, binds the color to it. Because the best results could be achieved only

during a short phase of the drying process, fresco painting was a race against time and, more particularly, against the rapidly drying plaster. Consequently its use fostered compositions designed with detail kept to an essential minimum. Images would be rapidly painted with large brushes. The process of fresco painting demonstrates how medium and technique intertwine to shape works of art. Moreover, fresco painting that covers walls, often large ones, is an overall adornment employed to enhance and enliven surface with color and form. Good fresco painting, like well-designed wallpaper, always emphasizes the flat, hard surface of the wall by decorating it with forms that complement and enhance its expanse and solidity, rather like mosaic [fig. 24].

Most frescoes also had a narrative function: they told stories containing figures, objects, and space in a simple, direct, easily comprehensible manner which nonetheless did not negate their overall decorative function. For his fresco of the *Lamentation*, Giotto had to find a balance between *narration*—the need to tell the story of the mourning over Christ's body after it was removed from the cross—and *decoration*—the role of this particular fresco in the overall decorative harmony of the chapel. His brilliant resolution of these often conflicting demands is seen in the *Lamentation* and in every other narrative fresco in the chapel.

In the *Lamentation* no single color is allowed to dominate. There are scattered and repeated notes of green, blue, and reddish pink, but all these colors are held carefully in check; none is allowed to overshadow the others. Instead the fields of color lead the eye across the painting, never overemphasizing a particular area of the surface.

This surface, the dense and flat wall on which the fresco is painted, is further stressed by the figures which, while substantial, are all confined to a narrow strip of ground extending back into the fictive space only to the rocky ridge. All the figures and actions are compressed into this narrow compass and are held close to the surface. The large expanse of blue sky, which seems to move up the surface rather than back into it, offers no escape into deep space beyond the figures and the ridge. Even the flying angels are held fast to the wall's surface. The *Lamentation*'s arrangement and adjustment of color, form, and space are calculated both to complement and decorate the wall's surface.

[29] Giotto, *Lamentation over Christ* (detail)

Each of the other frescoes in the chapel performs a similar function; together they form one of the most sublime decorative ensembles in the history of art.

The physical action of the *Lamentation*, like its form and color, develops across the surface of the painting. Every gesture, glance, and thought of the large, mourning figures centers on Christ, whose prone body is the linchpin of the scene. All the figures are physically and emotionally interconnected through Christ's body. They support it, touch it, gape at it, or, in the case of the standing figures at each side, act as brackets enclosing it.

Giotto depicts drama at the peak of its emotion. To delineate the compelling force of human passion in the simplest, most immediate way is always his overriding concern. This is accomplished here by the attitudes of the figures, each of which is sharply and individually characterized. John the Evangelist, who has just come upon the dead Christ, throws his hands back in a dramatic gesture of unbridled grief; the distraught Mary Magdalene numbly holds the feet of Christ, which she once washed, in her lap; and the Virgin, the most pathetic of all, searches frantically for some sign of life in her son's lifeless face [fig. 29]. The hunched bodies of the two faceless, boulderlike figures in the

immediate foreground become massive symbols of anonymous, generalized mourning.

This keen sense of human grief and desolation is echoed in the flinty ridge that descends toward the prone body of Christ. Devoid of organic life, punctuated only by a barren tree, the ridge is a perfect visual metaphor for hopelessness and despair. In the flat blue sky above the ridge, a flight of angels mourns the passing of Christ in a wild, aerial ballet. Twisting their bodies, tearing their hair, and flaying their arms, they give vent to their sorrow, their mouths contorted with cries of grief. These cries, and the sobs and wails of the little group below, seem to reverberate through the still air of this rocky, confined environment.

Giotto did not have a free hand for his work in the Arena Chapel. He was instead constrained to fashion a series of frescoes which had to be both narrative and decorative. The color, shape, and space of his paintings all had to conform to a limiting overall scheme to be executed in a demanding medium. But it was Giotto's particular genius that made virtue out of this necessity by using its limitations to fashion a series of dramatic compositions breathtaking in the power and immediacy of their human drama. No longer the symbolic scenes of so many of his medieval predecessors, these paintings are about men and women of flesh and blood. These frescoes, and Giotto's other paintings, were immensely influential. Their clarity, drama, and inventiveness were much admired and imitated, though seldom with Giotto's success, by generations of Renaissance artists. In many ways, Giotto's painted narratives served as the foundation for the great developments in Renaissance art that were to occur over the next two and a half centuries. It is not an exaggeration to say that without Giotto's painting, the art of the West would have developed in a very different way.

9. The Style of Heaven

Duccio: The Maestà

In the year 1311 an event of great importance took place in the Tuscan hill town of Siena. This was the procession which carried the recently completed altarpiece from the workshop of the painter Duccio di Buoninsegna (circa 1255–circa 1318) to its destination on the high altar of Siena Cathedral [fig. 30]. The procession is described in some detail by a contemporary document:

[30] **Duccio, *Maestà*, c. 1309–1311, front, Cathedral Museum, Siena**

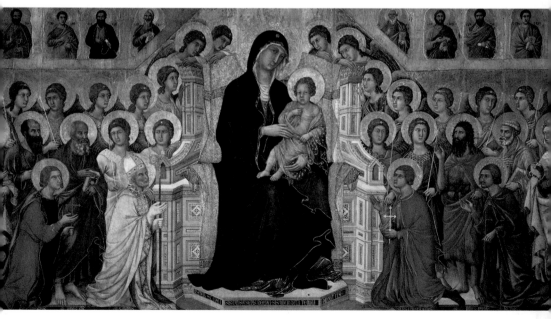

And on the day that it [the altarpiece] was carried to the Duomo [the cathedral] the shops were shut, and the bishop conducted a great and devout company of priests and friars in solemn procession, accompanied by the nine signiors, and all the officers of the commune, and all the people, and one after another the worthiest with lighted candles in their hands took places near the picture, and behind came the women and children with great devotion. And they accompanied the said picture up to the Duomo, making the procession around the Campo [the square in front of the town hall], as is the custom, all the bells ringing joyously, out of reverence for so noble a picture as is this. And this picture Duccio di Niccolò the painter made, and it was made in the house of the Muciatio outside the gate called Stalloreggi. And all that day they stood in prayer with great almsgiving for poor persons, praying God and His Mother, who is our advocate, to defend us by their infinite mercy from every adversity and evil, and keep us from the hands of traitors and of enemies of Siena.

Duccio worked on the great altarpiece between about 1309 and 1311, following the terms of a detailed contract drawn up between him and the authorities of the cathedral. Duccio was bound

to make the said panel, as well as ever he was able and knew how to and the Lord bestowed upon him—and to work continuously upon the said panel at such times as he was able to work on it—and not to accept or receive any other work to be carried out until the said panel shall have been made and completed. Moreover, the said Lord Jacopo, clerk of works…promised to give and pay the said Duccio, as his salary for the said works and labor, sixteen soldi of Sienese money for each day that the said Duccio shall work with his own hands on the said panel, except that if he should lose any part of the day there should be a deduction from the said salary….

Often prosaic records such as these shed important light on the history of works of art. The procession document demonstrates that the completion and installation of the *Maestà* was a process of major importance. The contract for the altarpiece reveals that Duccio, then the most important artist in Siena, was held to terms which, looking back from the twentieth century, seem incommensurate with his status. These terms were, however, perfectly acceptable, not only to him but to almost all artists up to the nineteenth century. Duccio, for

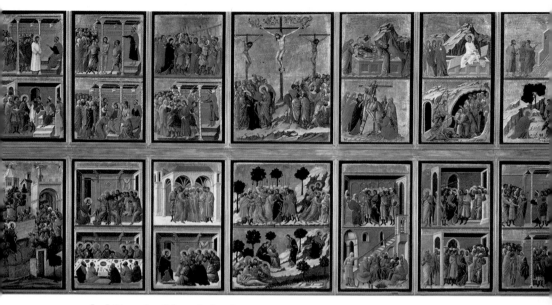

[31] Duccio, *Maestà*, back

instance, was not allowed to accept other commissions while working on the *Maestà*. This stipulation forced him to work exclusively in the employ of the cathedral. Moreover he was paid by the day. Such a payment arrangement, which seems demeaning to modern minds, was in fact often the way artists were then compensated. Yet Duccio was allowed to sign his name to the work in large letters at the base of the Madonna's throne, something quite extraordinary for the time. Also unusual in an age when artists always collaborated with their pupils on major projects was the authorities' stipulation that Duccio do all the work with his own hands: the patrons wanted value for their money.

Obviously the *Maestà* was no ordinary altarpiece. It was nothing less than the most important and one of the most sumptuous and costly paintings in the long history of Sienese art. It was commissioned to replace an ancient, much venerated older altarpiece of the Madonna and Child. The Sienese believed that this painting had miraculously delivered them from the hands of their dread enemies, the Florentines, during the battle of Montaperti in 1260. The Sienese cult of the Virgin dates from this time, and it was this particular devotion that

determined the subject of Duccio's painting: the Madonna and Child adored by saints and angels. This type of altarpiece is usually called a *maestà*, the Italian world for "majesty." From other documents it appears that the original commission for the altarpiece entailed only a *maestà*; but sometime after Duccio had begun work, it was decided to paint the back of the altarpiece with a series of small scenes devoted to the life of Christ [fig. 31]. Originally the main panel was surrounded by smaller ancillary paintings, but many of these have been lost or displaced.

The cathedral that housed Duccio's *Maestà* was both a religious and civic building. It was the city's principal church and the seat of its bishop. It was also a source of great civic pride and a monumental stone symbol of the commune that had contributed much money toward its construction. The intertwining of the sacred and the secular in the cathedral also character zes the imagery of the front of Duccio's altarpiece. Its center is occupied by the large Madonna holding the Child; because of the special Sienese veneration for her, she is given center stage [fig. 32]. Above are small, half-length figures of saints, while more saints and angels gather around the Virgin. These are arranged in three distinct rows: the uppermost consists of angels; the middle of angels and saints; and the third, and lowest, of four kneeling saints.

While for us it is difficult to name many of the saints, Duccio's contemporaries would have had no trouble identifying them. They would have easily known, for instance, that the cross-carrying man in the right middle row with a long, flowing beard, flamelike hair, and hair shirt was John the Baptist. In the same position, to the Madonna's left, they would have recognized Saint John the Baptist's counterpart, Saint John the Evangelist, by his bald pate, white beard, facial type, and book. They would also have known that the figure with the dark beard and sword next to Saint John the Evangelist was Saint Paul. The saint with whom Saint Paul is often paired, Saint Peter, distinguished by his short white beard and keys (the symbolic keys of heaven given him by Christ), is found in the identical position on the other side of the Virgin.

Saints played an important part in the Renaissance. As objects of intense personal devotion, they often were believed to intervene super-

naturally in their worshipers' lives in beneficial ways. It was thought that they protected children, watched over travelers, healed the sick, and taught the rewards of virtuous behavior and faith by example. Men and women of the Renaissance were named after saints, prayed to them, and saw their images everywhere. The lore of the saints was extensive and widely known. All the saints in the middle rank of Duccio's *Maestà* were part of the pantheon of Renaissance saints, and their images would have been recognizable throughout Europe, but the four kneeling figures closest to the observer are of a different order.

These four—Saints Ansanus, Savinus, Crescentius, and Victor—were all local figures who received special Sienese devotion and pride. Virtually unknown throughout the rest of the Italian peninsula, their appearance in the front rank of the *Maestà* gave a special civic meaning to the altarpiece. This was stressed by the inscription under the Virgin's throne: "Holy Mother of God grant Siena peace, and because he painted you thus, give life to Duccio." It is the Virgin, the special protector of the city, who is implored to give peace to the commune. The large Virgin, the inscription, the four local saints, and the setting of the altarpiece in the religious-civic setting of the cathedral all combine to make the *Maestà* a monument of unusual sacred *and* secular meaning.

From its size and cost, it is also evident that the Sienese wished to make the *Maestà* as physically impressive as possible. The sheer size of the painting (370 x 450 centimeters, about 12 x 15 feet) and the extensive use of gold leaf make it one of the largest, most majestic altarpieces of the Renaissance. One can imagine how awestruck visitors to the shadowy cathedral must have been when they glimpsed its gilded splendor on the high altar.

The golden luster of the *Maestà* is equaled by the enamel-like surface of its tempera paint. From the inception of painting in the late Middle Ages, tempera was the major painting medium in Italy for altarpieces until it was eclipsed by oil paint in the early sixteenth century. In tempera painting, the pigments are mixed with egg yolks and applied to a smooth, porous surface called gesso, which covers the wooden boards of which the altarpiece is made. Tempera painting is a process in which the paint is applied sparingly by small brushes and then quickly absorbed into the surface of the gesso. Such a laborious,

[32] Duccio, *Maestà* (detail)

slow process, unlike fresco painting [fig. 27], promotes detail. Because tempera paint is quite opaque, its use discourages the blending or glazing of colors. Tempera paintings such as the *Maestà* are characterized by their discrete, clearly separated fields of dense color. Duccio, like all superior artists, fully understood his medium and took maximum advantage of its possibilities. The result is that both the front and back of the *Maestà* display an unforgettable configuration of elegant, beautifully colored, detailed forms demarcated by wiry, sinuous line. Duccio was a colorist of considerable talent. His particular hues (including subtle orange, velvety green, and steely blues) and their uncommon, often daring, juxtaposition remain in the mind long after one has left the *Maestà.*

The social, spiritual, and artistic elements of Duccio's *Maestà* fuse to create a work of complex, interwoven meaning. It is a religious icon, a symbol of civic pride and wealth, a radiant display of technique and color, and, above all, a monument to the vision of its painter. That Duccio could weave together all these various strands into such a dazzling, seamless artistic fabric bespeaks the breadth of his genius. This genius was, of course, of a very different sort than that possessed by Giotto. Duccio was an artist concerned with the beauty of form and color. His images pleased the eye and comforted the soul with their resplendence. Giotto, on the other hand, was a minimalist whose pared-down, monumental painted narratives were designed for the display of maximum human drama. Although they were contemporaries and both worked in central Italy, their visions were of a diverse order. Duccio's sublime art was firmly rooted in his time while Giotto's pointed the way toward a new conception of Western art.

10. The Transmigration of Meaning

Donatello: Judith and Holofernes

It was in Renaissance Florence that Western sculpture was reborn. Sculpture had flourished throughout the Greek and Roman world until the early Middle Ages when, because of ever-increasing social and economic disruptions, commissions for carved and cast works in stone and bronze diminished drastically. With the reestablishment of urban life in Italy around 1200, opportunities for sculptors to furnish works for newly built churches, civic buildings, and homes increased many times over. It was, however, in affluent fifteenth-century Florence that there first appeared a group of artists ready to reinvigorate the art of sculpture. The earliest major sculptural commissions in the city date from the first half of the fourteenth century, but it was not until a hundred years later that Florentine sculpture developed its own singular artistic character.

The presiding genius of Florentine sculpture was Donato de' Bardi, called Donatello (circa 1386–1466), an artist whose long and productive career produced some of the major monuments of Western sculpture. His earliest works, which date from the first decade of the fifteenth century, are marked by a brilliant technical perception of material and a highly original, innovative approach to both form and subject. Throughout his long working life he created a series of strikingly inventive sculptures in marble, bronze, and wood, all stamped with the unmistakable imprint of his personality. The stylistic and interpretive nature of Donatello's sculpture made a decisive impact on

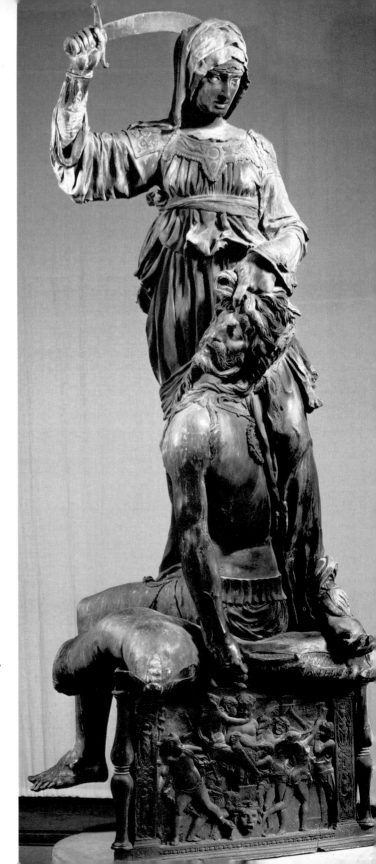

[33] Donatello, *Judith and Holofernes*, c. 1450, Palazzo Vecchio, Florence

his contemporaries and followers. Michelangelo, born less than a decade after Donatello's death, studied the older artist's sculpture in Florence with meticulous care and considerable discernment; what he learned he then incorporated into the foundations of his own art.

At the height of his artistic power and fame, Donatello was commissioned to make a bronze statue of *Judith and Holofernes* [fig. 33]. The earliest mention of the work places it in the palace of the Medici, the most powerful family of Florence. The statue is undated, but a comparison of it with other works by Donatello suggests that it was made rather late in his career, probably during the second half of the 1450s.

The apocryphal story of *Judith and Holofernes* was a popular subject in the Renaissance, especially for works intended for the home. The events of the story revolve around the siege of the Israelite city of Bethulia by the army of the Assyrian general Holofernes. Judith, a beautiful widow of the city, dressed "so as to catch the eye of any man who might see her," arrived with her maid in the Assyrian camp, pretending to be a deserter. She soon caught the wicked Holofernes' lustful eye and was invited to his tent for a feast during which he planned to seduce her. Instead he drank too much, lapsed into a stupor, and was then beheaded with his own sword by Judith, who passed through enemy lines carrying her grisly trophy in a sack. When the Assyrians discovered what had happened, they fled in panic and the city was saved.

This is an exciting story with much gore and action. As with most tales popular in the Renaissance, it was valued for the didactic and moral overtones that could be deduced from it. While Donatello's statue was still in the Medici palace, an inscription was affixed to it which in part stated: "behold the neck of pride severed by the hand of humility." And indeed, contemporary Florentines would probably have seen the statue as an illustration of the triumph of humility, in the form of Judith, over the prideful Holofernes.

Contemporary viewers would also have been able to deduce several other meanings from this statue. One of these would have been the victory of good over evil, as the widow Judith, who kept her virtue and chastity, slew the tyrant. This meaning, like the meanings of so many

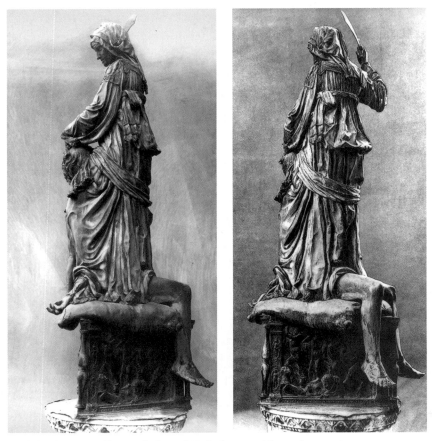

[34], [35] Donatello, *Judith and Holofernes*, side and rear views

of the stories chosen for illustration in Renaissance houses, was valued for the lessons it could teach. The story of Judith's virtue, courage, and chastity was meant to serve as a model of correct behavior for the girls and women of the household. Other stories with didactic or cautionary messages, such as the tales of Virginia, Lucretia, and Susanna, for example, all appeared with considerable frequency in the Renaissance home as visual agents of social control.

Donatello kept the story and its several meanings firmly in mind as he first planned and then fashioned his statue. The making of a bronze statue is an additive process, unlike the carving of marble,

which is subtractive. An exact, full-scale model is first made of clay or wax; from it, plaster molds are formed. These molds are then used to cast the molten bronze While statuettes could be cast whole, larger figures were usually constructed of a number of separate cast pieces; for the statue of *Judith and Holofernes*, eleven cast sections were used. The making of a large, freestanding bronze was a difficult process (see Cellini's account in Chapter 16). The design had to incorporate the various pieces, the model had to be made, the casts had to be taken and sent to the foundry for casting, and then the cast pieces assembled. When the bronze was finally cast, it was quite rough and needed much hand work to file and polish it to the desired finish.

Donatello's *Judith and Holofernes* is unprecedented in its overall configuration. Before it, figure sculpture in the round was conceived so as to have a limited number of views from which the body was fully comprehensible. The *Augustus of Prima Porta* [fig. 10], for example, is planned to be seen from the front. Other statues in the round have a front view, frequently two side views, and occasionally a back view. The *Judith and Holofernes* is revolutionary precisely because it has no principal views — no clearly defined front, back, or sides — but rather can be seen from an infinite number of points [figs. 34, 35].

The figures stand on a cushion upon a triangular base decorated with scenes of bacchic revelry (highly appropriate for a story in which drunkenness plays such an important part). The sculpture is not fully explicable from any side of the triangular base. In order to understand the interrelation of the figures, the viewer must walk around the statue. In so doing, the action unfolds through a multiplicity of different views, each affording some new information about the figures and their relationship. The statue is, in other words, conceived fully in the round. Instead of just several static principal views, its form and message continually unfold and change as the spectator circles it. During this dynamic, exciting transformation, the viewer comes to understand ever more fully the gruesome story told by the two bronze figures.

Attention is first focused on the figure of Judith towering above Holofernes. With her foot on his wrist and her hand jerking his head up for the fatal blow, she engulfs and dominates the Assyrian like some dread personification of Death itself. Her rigidity and force of move-

ment contrast sharply with his inert, insensate but sensuous body, a form expressive of Holofernes' lascivious wickedness. The intertwined closeness of the two figures—seen in many views, but most suggestively from the back of Judith—creates a strong sense of eroticism which heightens the drama. The mingling of eroticism and death which has often preoccupied artists is inescapably compelling here.

In 1495 all the personal and didactic messages of the *Judith and Holofernes* underwent a major transformation when the statue was taken out of the Palazzo Medici as a result of the expulsion of the Medici the previous year. Moved to a position in front of the town hall of Florence, the Palazzo della Signoria, Donatello's statue took on new meanings which were antithetical to the family that had commissioned it. Now the *Judith and Holofernes* story was seen as an example of the defeat of tyranny by virtue. Just as Judith had defeated the mighty but corrupt Holofernes, so had the righteous citizens of Florence expelled the powerful Medici tyrants. Moreover the *Judith and Holofernes*, like Michelangelo's *David* which was soon to be placed near it, was a warning to Florence's enemies, both within and without the city, that the small but virtuous republic stood ready to defend itself. The old messages of the statue had been transformed, turned back upon the Medici, and subsumed in the new view of Judith as Florence. Throughout the history of art, the migration of symbols has resulted in some strange new meanings, but none, perhaps, as ironic as this one.

11. Printed Images

Dürer: Knight, Death, and the Devil

Originality is the quality most prized in twentieth-century art. Artists who make art that has little relation either to the art of the past or to their own earlier efforts are lauded for their innovation. Replication or copying is, in the minds of many contemporary artists and critics, to be avoided.

In the past, attitudes were very different indeed. Until quite recently, artists borrowed freely from one another's works and were content to create variants or even copies of their own paintings and sculpture. Some mediums, such as bronze or plaster, were frequently used to make many copies of the same work.

Several important and related means of graphic replication—the printed book, the woodcut, and the engraving—were all invented and extensively utilized in the Renaissance. Around 1500, books printed with movable type and sold in many copies revolutionized the dissemination of information in the West. Contemporaneously Europe witnessed first the development of the woodcut and then the engraving. These graphic mediums were used for the replication of a broad range of subjects, including portraits of rulers, the latest works by renowned artists, or famous sacred images. Artists also used the woodcut and engraving process to make original compositions. These images could be printed in many copies and then distributed widely. Their means of production were quite reasonable, so prints were relatively inexpensive to make and affordable to buy. They were often bought by people of modest income who could afford no other works of art.

A woodcut is made when an artist cuts or gouges a design into a

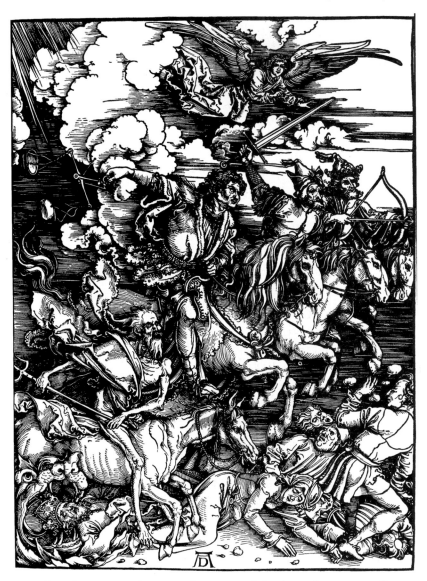

[36] **Albrecht Dürer**, *The Four Horsemen of the Apocalypse*, c. 1498

smooth block of wood using a metal tool. What remains of the original surface is inked, and the block is then pressed onto a sheet of paper. When the sheet is removed from the block, the dark, printed areas of the surface contrast strongly with the white, unprinted parts of the

paper, corresponding to the areas of the cut-away block. This is called the relief process. It fosters a dramatic, vigorous contrast between light and dark and lends itself to a bold compositional approach. A masterful example of a woodcut is Albrecht Dürer's *The Four Horsemen of the Apocalypse* (circa 1498) [fig. 36].

Dürer (1471–1528), born in Nuremberg, Germany, was a writer, theoretician, productive painter, and superb graphic artist. He evolved a highly personal idiom partially based on the paintings of Italian Renaissance artists whose work he had seen during two trips to Venice. But his greatest contribution to the history of art lies not in his many paintings and drawings but in his pioneering woodcuts and engravings. His numerous technical inventions and experimentation as well as his innovative imagery make him one of the most important graphic artists of the West.

Dürer's extraordinary skill is displayed in his engraving *Knight, Death, and the Devil* of 1513, which he dated and signed with his monogram on a tablet in the lower left corner [fig. 37]. An engraving is created by a technique known as the intaglio process, which is exactly the opposite of that used to produce a woodcut. To make an engraving, a metal plate, usually copper, is incised to create a series of lines which form the desired images. Because the image cut into the plate is reversed when it is printed, the engraver (and the woodcutter as well) must make the images on the block the mirror images of the final print.

When the cutting is finished, the plate is inked forcefully so that the liquid fills the incised lines. The ink is then wiped off the surface of the plate, but the lines remain ink-filled. The paper to be printed is then dampened and laid on the plate. Both are put into a press, and the paper is forced into the plate's incised, ink-filled lines. When the plate is removed, it is the lines below the surface that print black while the original surface of the plate remains white — exactly the opposite of the woodcut. Engraving is therefore a graphic medium in which the entire image is delineated by various combinations of lines of varying widths and lengths. The white of the paper also plays a crucial role in the creation and definition of form. The most accomplished engravers are extremely sensitive to the relation between the dark inked lines and the white paper on which they are printed.

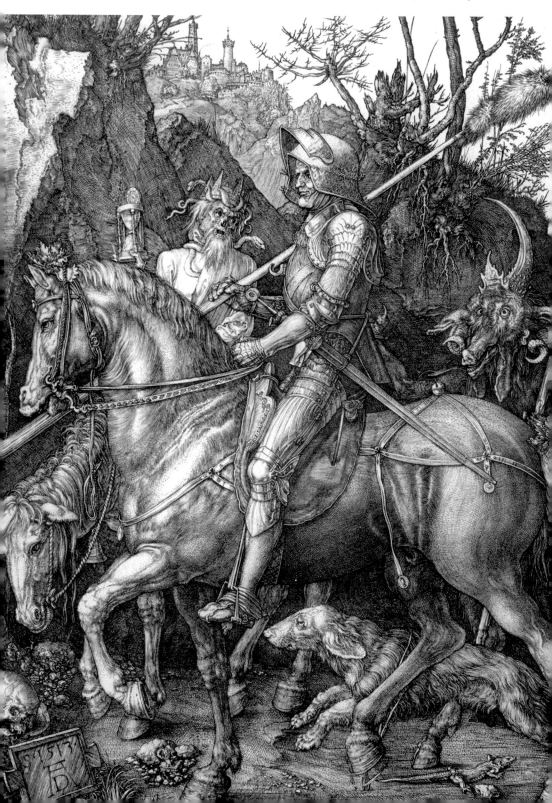

In Dürer's *Knight Death, and the Devil*, the deep shadow on the right sides of the hills n the middle ground is, for instance, created by swirling networks of l nes placed so closely together that most of the paper's whiteness is covered with dark ink. Conversely, the highlight and reflection on the knight's armor are achieved by creating an incremental transition from shadow—on the right side of the torso, for example—to brilliant illumination—along the full length of the left leg [fig. 38]. The volume of the horse is also constructed by the subtle alternation between a wide range of inked line and the white of the paper. Using a broad spectrum of delicate contrasts between the two-dimensional line and the paper's whiteness, Dürer established a remarkable, all-encompassing sense of three-dimensional depth and relief. This is clearly evident in the landscape of rugged hills dotted with stunted, leafless trees set before a walled hilltop city in the far distance, perhaps the knight's destination. By his employment of line and ink only, Dürer has infused a transient mood-creating light and atmosphere into this wild vista. Moreover he has used his medium to create a powerful image of the three protagonists: the fully armored knight accompanied by his faithful dog; the horned, decaying figure of Death mounted on a nag; and the long-snouted devil brandishing a spear—all interlocked in a strange, complex, physical and emotional dialogue.

The exact meaning of the print is unclear. Some scholars believe that Dürer is portraying the Christian Knight inspired by a passage from Saint Paul in his letter to the Ephesians. Paul urges the true Christian to don the "armor of God" and withstand "the wiles of the devil." It has also been suggested that the artist was inspired by the writings of Erasmus of Rotterdam (1466–1536). Dürer was also influenced by several Italian fifteenth-century bronze equestrian monuments erected to commemorate soldiers of fortune, which he saw on his visits to Italy.

Dürer's knight, it has also been claimed, symbolizes the Christian Knight armored with the faith of his religion as he rides resolutely and unscathed through the wilderness of evil and death. But recently other meanings for the print have been proposed, including one which pos-

[37] Albrecht Dürer, *Knight, Death and the Devil*, 1513

tulates that the knight is a portrait of a contemporary mercenary, Philipp Rinck, who is in league with Death and the devil.

The meaning of the *Knight, Death, and the Devil* will probably never be known with certainty. It is even possible that Dürer had no exact meaning in mind when he engraved the work; perhaps he wished only to convey a particular mood through the combination of figures and landscape interlocked by a brilliant design. Whatever his intent, he has transformed an engraved metal plate, ink, and paper into a mysterious and profoundly evocative work of art. By so doing, he established engraving as an important medium in the history of Western art.

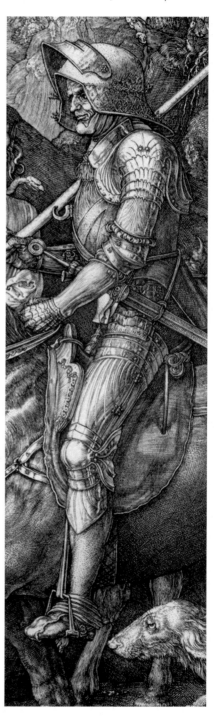

[38] Albrecht Dürer, *Knight, Death and the Devil* (detail)

12. Leonardo and Tradition

The Last Supper

Like his Mona Lisa, Leonardo da Vinci's *Last Supper* [fig. 39] has become an icon of popular culture. Both paintings have been reproduced so many times in so many different contexts that it has become difficult to understand them as the deeply innovative works they really are. With the *Mona Lisa*, Leonardo reinvented the portrait and thus profoundly influenced how men and women were portrayed for centuries. But in many ways his rethinking of the story of the Last Supper was his greatest gift to posterity.

Around 1494, Ludovico Sforza, Lord of Milan, decided to commission a fresco of the Last Supper for the refectory of the Church of Santa Maria delle Grazie in Milan. He chose Leonardo da Vinci (1452–1519), a Florentine artist already in his service, for this task. This was an important commission because the church was destined to be the burial place of Ludovico and his family and as such enjoyed the lord's special patronage. Ludovico had already employed Donato Bramante, the future architect of Saint Peter's in Rome, to rebuild Santa Maria delle Grazie; Leonardo's large painting would add even more luster and prestige to the structure.

Leonardo had come to Milan in search of work, not principally as an artist but as a military engineer, a skill that Renaissance patrons often prized more highly than artistic ability. His career had begun in Florence, where he was apprenticed to Andrea del Verrocchio, a leading sculptor and teacher of the second half of the fifteenth century. In Verrocchio's studio he learned to paint and carve. Through several important commissions he soon distinguished himself as a major artis-

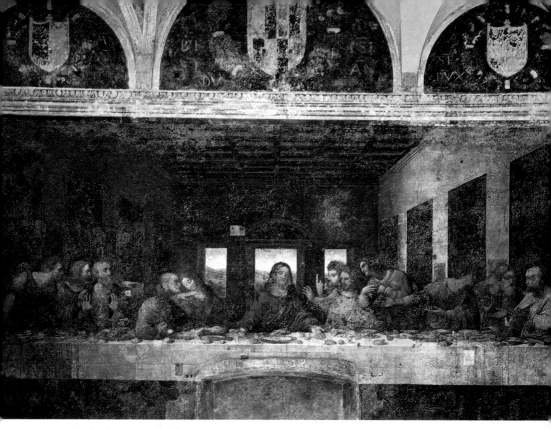

[39] Leonardo da Vinci, *Last Supper*, 1480, Santa Maria delle Grazie, Milan

tic force in Florence. Leonardo left for Milan in 1482, when he was thirty, an age by which most of his artistic contemporaries had already established themselves comfortably within the Florentine art world.

Probably in 1494, some twelve years after he arrived in Milan, Leonardo began working on the *Last Supper*. In Florence he had developed the technique of *sfumato,* an incremental use of light and dark to create a subtle network of shadow and mystery. He knew that traditional fresco technique, the sort used by Giotto in the Scrovegni Chapel [fig. 27], would not allow him to create these subtle light effects, so he experimented with new materials and methods on the *Last Supper.*

Using a type of tempera, he painted on a ground of cement, gesso, and other materials. This procedure allowed him to work and rework the surface (something impossible in traditional fresco technique) to achieve the pictorial effects he sought. An eyewitness account of

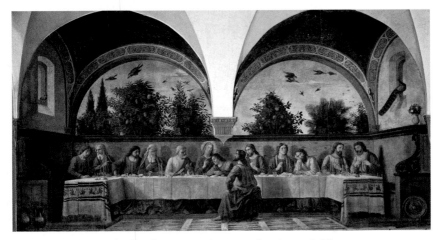

[40] **Domenico Ghirlandaio, *Last Supper*, Ognissanti, Florence**

Leonardo painting the *Last Supper* exists. Written by the monk Matteo Bandello, it allows us to see how Leonardo's new techniques perfectly suited his approach to painting:

> Many a time I have seen Leonardo go early in the morning to work on the platform before the *Last Supper*; and there he would stay from sunrise to darkness, never laying down the brush, but continuing to paint without eating or drinking. Then three or four days would pass without his touching the work, yet each day he would spend several hours examining it and criticizing the figures to himself. I have also seen him, when the fancy took him, leave the Corte Vecchia when he was at work on the stupendous horse of clay [a model for an equestrian monument for the Sforza], and go straight to the Grazie. There, climbing on the platform, he would take a brush and give a few touches to one of the figures: and then suddenly he would leave and go elsewhere.

Unfortunately Leonardo's experiment proved a failure. Almost immediately after the fresco was finished in 1498, the ground started coming off the wall, taking parts of the paint with it. The subsequent history of the fresco is a tragedy. Often repainted and ineptly restored, the *Last Supper*, which has just been restored once again, is a wreck. While some small parts of the original surface remain, much of what we see today is either repaint or damage. Nonetheless the design is still intact, and through it we can see the mind of Leonardo at work.

[41] Leonardo da Vinci, Preparatory drawing for the *Last Supper*, Royal Collection, Windsor Castle

The biblical story of the Last Supper had a long and well-codified pictorial tradition by the time Leonardo began to think about his fresco. The Last Supper, a common theme of refectory decoration, was well suited for such locations. It depicted the most important meal in the Christian drama, for it was at this event that Christ institutionalized the Eucharist, the central concept, rite, and miracle of the Mass.

Often frescoes of the Last Supper were painted on one of the short walls of the usually rectangular refectories. These paintings were planned so that Christ and the Apostles seemed to be actually in the same space as those eating in the room. In the *Last Supper* by Domenico Ghirlandaio, painted for the refectory of the Florentine Church of

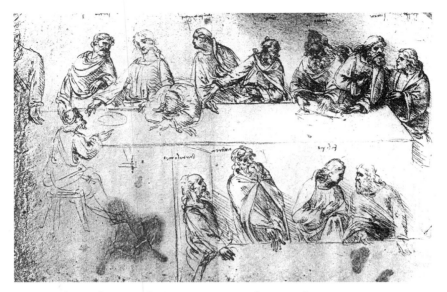

[42] Student of Leonardo ca Vinci, copy of Leonardo's preparatory drawing for the *Last Supper*, c. 1494, Galleria dell'Accademia, Venice

Ognissanti in 1480, the painted vaults of the fresco seem to be a continuation of the actual ceiling vaults of the room [fig. 40]. The lighting of the fresco comes from the same direction as the natural light sources of the refectory. Here and in many other refectories, the table occupied by the most important members of the religious organization would have been placed parallel to the painted table of the Last Supper. When the meal was taken, it would have seemed that Christ and his followers were sitting directly behind the head table.

These versions of the Last Supper by Leonardo's close contemporaries, such as those by Ghirlandaio, were well known to him. In them, he would have observed, the subject was treated in a rigid and formulaic way. Christ was placed at the center of the table, the Apostles were symmetrically lined up on either side of him, and the traitor Judas sat isolated across from him.

Leonardo surely thought about this configuration of the story and rejected it. Its disjointed nature did not allow the emotional and spiritual drama of the event to be fully and convincingly portrayed. He did, however, retain the traditional illusionism of the story. The perspective

of his fresco, which is also painted on one of the short walls of the refectory, seems to continue the space of the room and to make it appear that the Last Supper actually occurs in the dining hall. This realistic treatment was probably demanded by convention, but when it came to the arrangement of the figures, Leonardo stepped decisively outside tradition.

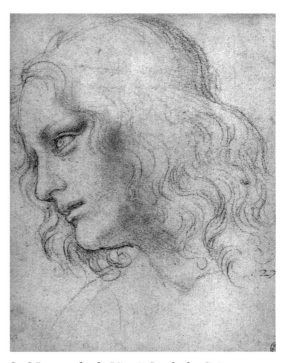

[43] Leonardo da Vinci, Study for Saint Philip, Royal Collection, Windsor Castle

Instead of arranging the figures around Christ in the regular, static fashion, Leonardo divided them into four interlocking groups on either side of Christ. The two outer groups, those at each end of the table, are the most regularly spaced, and the head of the outermost member of each is turned toward the center of the table. These two figures act as brackets, framing the scene and directing the spectator's attention toward Christ. The two inner groups, those directly flanking Christ, are more varied in nature and less regularly spaced than the outer groups. While each of the groups is a separate, intertwined entity, they are all linked by the gestures and glances of their members. Among these gesticulating figures, Christ appears as an island of calm amongst his agitated followers. Isolated by the space around him and enframed by the central light of the three windows of the room (perhaps symbolic of the Trinity) in which the supper takes place, he is the physical, psychic, and spiritual hub of the story.

This arrangement was not part of Leonardo's original idea, which

can be studied in an early preparatory drawing for the *Last Supper* [fig. 41]. Here we see that the Apostles have been arranged rather symmetrically and traditionally around Christ, and that Judas has been placed on the opposite side of the table. Leonardo rethought his ideas in a later drawing known to us only through a copy made by a member of his workshop [fig. 42]. In this later drawing Leonardo has abandoned the strict symmetrical arrangement and has begun to arrange the Apostles in groups. Judas, who in the fresco will be incorporated into the group immediately to Christ's right hand, still remains across from him. These two surviving drawings—Leonardo must have made many more as he struggled with the composition—offer us a rare glimpse into the transformative workings of the mind of a great and original artist.

Through his compositional innovations Leonardo dramatically and permanently redirected the representation of the Last Supper. He changed the representation of the event from a static to a dynamic one. The fervent reaction of the Apostles as they hear Christ's words is now the major element of the fresco. Instead of passively and reverently listening to Christ speak the words that will institute the Eucharistic ritual, they seem to be defending themselves from the charge of treachery that Christ also made, saying that one of their number would betray him. All vigorously protest their innocence and express their outrage, except for Judas, who knows himself to be the traitor. Leonardo, who was obsessed with the depiction of character, made scores of studies, some still preserved, for the individual Apostles [fig. 43]. In each he sought to define a particular emotion, such as fear, anger, guilt, or surprise. He has turned the Apostles from inert observers into active participants. Consequently he has converted the story from one of ritual observance to an earthly drama of the highest order. The scene, which now crackles with conflicting human emotion miraculously balanced and harmonized around Christ, has become the quintessential representation of the Last Supper. Despite the fact that it has been copied and reproduced countless times since its creation, the fresco still retains its compelling formal and emotional power to involve us in its action.

13. Michelangelo's *Pietàs*

On June 25, 1496, Michelangelo Buonarroti, aged twenty-one, set foot in Rome for the first time. Before him lay the vast ruins and broken marbles of the ancient and holy city which were to furnish major inspiration for his future art. The young Michelangelo was not in Rome to study but to work. He came furnished with a letter of recommendation from a powerful Medici patron and soon found a friend and benefactor in the Roman banker Jacopo Galli. Perhaps through Galli, Michelangelo was introduced to the French cardinal Jean Bihères de Lagraulas, who was residing in Rome. The cardinal commissioned Michelangelo to carve a *Pietà* (an Italian word meaning both pity and piety) [fig. 44], the contract for which is dated August 1498, just over two years after Michelangelo arrived in Rome. Jacopo Galli, who acted as intermediary and guarantor between sculptor and patron, assured the cardinal that the *Pietà* would be the most beautiful marble sculpture in Rome. The contract stipulated delivery of the work within one year, for the agreed-upon sum of 450 gold papal ducats to be disbursed periodically. The *Pietà* was destined for the cardinal's eventual burial place, the Church of Saint Petronilla adjacent to the south side of Saint Peter's. That Michelangelo's work was bound for such an important and prestigious location indicates that he was already a rising star in the art world of early-sixteenth-century Rome. Because we do not know exactly when the *Pietà* was finished, we cannot be certain that the cardinal, who died in 1499, ever saw it completed.

When the Church of Saint Petronilla was destroyed in 1517 to make way for the beginning of the rebuilding of Saint Peter's (a project in which Michelangelo was eventually to play a major role), the *Pietà* was moved to the chapel of the Madonna della Febbre, where the Renais-

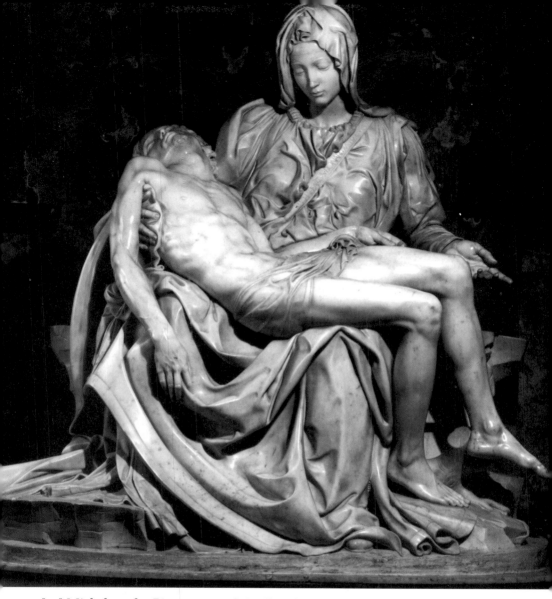

[44] Michelangelo, *Pietà*, c. 1500, Saint Peter's, Vatican City

sance painter and biographer Giorgio Vasari saw and admired it: "No sculptor, not even the most rare artist, could ever reach this level of design and grace, nor could he, even with hard work, ever finish, polish, and cut the marble as skillfully as Michelangelo did here, for in this statue all of the worth and power of sculpture is revealed."

What impressed Vasari was the remarkable veracity and skill of

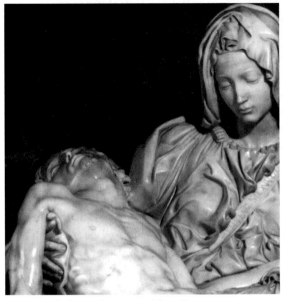

[45] Michelangelo, *Pietà* (detail)

design and execution. The overall shape of the group is roughly triangular, rising from the rocky base through the outer edges of the two figures to the Virgin's head at its apex. Placed across this stable form is a series of diagonals: the wide hem of the Virgin's mantle, the body of Christ, the outstretched right hand of the Virgin, and her slightly inclined head. All these forms, which are mainly confined in the overall triangular shape, are subtly interrelated and harmonized to create a mood of quiet equipoise.

All the pain and suffering traditionally associated with the death of Christ have been omitted here. The lithe body is marble miraculously turned into yielding flesh by Michelangelo's chisel—Vasari says, "let no one think for beauty of limbs and for artifice of body ever to see a nude so well analyzed for muscles, veins, tendons." One quickly sees that this body bears, aside from the lance and nail holes, no trace of suffering. Instead Christ seems to be sleeping, gently stretched across his mother's lap and supported by her arm [fig. 45]. Such an interpretation of easy death may have been exactly what the cardinal wanted for his own tomb.

Mary holds Christ's body with the utmost tenderness and reverence. Supporting him with her hands covered by the edge of her mantle so as not to irreverently touch his sacred flesh, she cradles the body of her son like the priest who carries the monstrance containing the Eucharistic host (the body of Christ) with the humeral veil during the

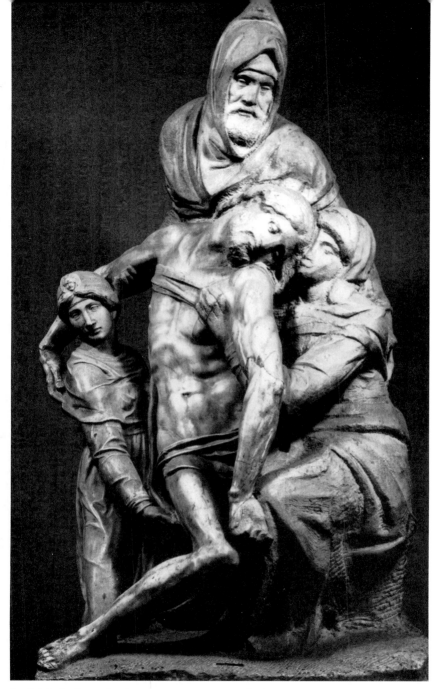

[46] Michelangelo, *Pietà*, c. 1550, Museo dell'Opera del Duomo, Florence

[47] Michelangelo, *Pietà* (detail)

Mass. The Virgin looks down on her son while her left hand gestures for us to do the same. Michelangelo presents Christ to us to contemplate and revere. We are asked to consider his sacrifice and the salvation it promises for humankind, avoiding, or forgetting, the grisly circumstances of his earthly death.

The Virgin, whose grief is restrained and dignified, is about the same age as her son. Vasari explained this by saying that "spotless virgins keep themselves young and their faces remain well preserved for a long time without any blemish whatsoever, while those who are afflicted, as was Christ, do the opposite." But there was probably more to it than Vasari's folkloric explanation. A copy of Michelangelo's Roman *Pietà* (carved around 1550 for the Florentine Church of Santo Spirito) is set above an inscription taken from a contemporary madrigal. This madrigal is also quoted by Vasari when he discusses Michelangelo's *Pietà*. It says:

Beauty and goodness,
And grief and pity, alive in dead marble,
Do not, as you do,
Weep so loudly,
Lest too early He should reawaken from death
In spite of Himself,
Our Lord and Father,
Only bride, His Daughter and Mother.

Mary as Christ's mother, daughter, and spouse is an old theological tenet which Michelangelo depicted so remarkably in this, his first version of the subject.

Nearly a half-century after the completion of the Roman *Pietà*, Michelangelo once again returned to the theme with both great and disastrous results. From the first edition of Vasari's *Lives* of 1550 we know that Michelangelo was at work on a second *Pietà* group by that date. Ascanio Condivi's 1553 biography of Michelangelo describes the group as a dead Christ, the Virgin, one of the Marys (Mary Magdalene), and Joseph of Arimathaea. The second edition of Vasari's book, published in 1568, tells us that Michelangelo had destroyed the work by that time "because of the importunity of his servant Urbino, who had urged him to finish it every day, and in hurrying he had removed a piece of the Virgin's elbow; he had come to hate it, and been much bothered by a vein, and losing patience he broke it and would have smashed it to atoms had not Antonio his servant asked for it." Antonio Bandini bought the group from Michelangelo's servant and arranged to have it repaired by the sculptor Tiberio Calcagni. Calcagni, using a model furnished by Michelangelo, replaced the broken pieces and completed the Mary Magdalene, seriously degrading this part of the sculpture through the introduction of his mediocre style. An examination of the work itself reveals that Michelangelo had indeed attacked the marble, cutting off Christ's left leg and parts of the bodies of the Virgin and Mary Magdalene [fig. 46].

According to Vasari, who probably heard it directly from Michelangelo, the group, like the Roman *Pietà*, was intended for a tomb, but this time it was for the tomb of the artist himself. Michelangelo was well into his seventies when he began work on this second

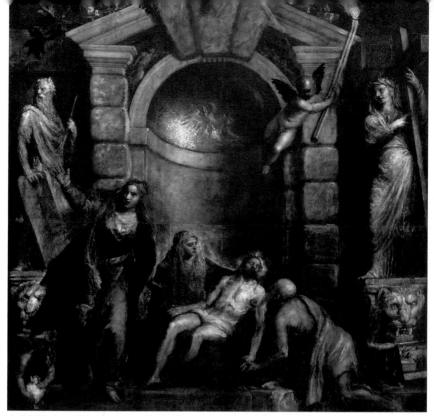

[48] Titian, *Pietà*, c. 1576, Galleria dell'Accademia, Venice

Pietà, and in the intervening half-century between the two *Pietàs*, his psyche and his approach to style and interpretation had undergone monumental transformations.

In the second *Pietà* (now called the Florence *Pietà* — it was brought from Rome to Florence in the middle of the seventeenth century), the quiet sorrow and equilibrium of the first *Pietà* is completely abandoned. The Florence *Pietà* group, which is roughly triangular in overall shape, now seethes with physical energy as the Virgin, Mary Magdalene, and Joseph of Arimathaea all struggle to support the massive, dead body of Christ. The physical reality of Christ's death is foremost here. The figures are brilliantly woven together around his massive body: Christ's arm is draped over the kneeling Mary Magdalene who in turn supports his leg with her right hand; Mary's left hand grips the back of Joseph of Arimathaea's right leg; and the Virgin holds Christ under the arm and presses her face against his flowing hair. Behind, Joseph of Arimathaea supports Christ's right arm with his right

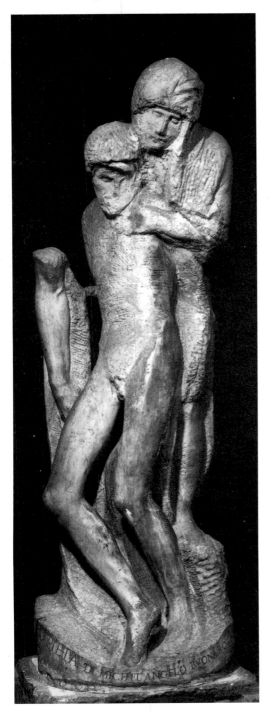

hand while his left hand holds the Virgin around the shoulder. This interweaving of the straining figures establishes a physical and psychological intimacy which unites them in their common grief. While the major expression of the group is conveyed through gesture and movement, the unfinished faces and bodies themselves evoke deep emotions, perhaps more so than would have been possible had Michelangelo finished them.

It has long been noted that the Joseph of Arimathaea is a self-portrait [fig. 47]. That Michelangelo should wish to depict himself as Joseph of Arimathaea, the disciple of Christ who was given permission by Pilate to bury Christ in his own tomb, is most appropriate. Some twenty years later the Venetian painter Tit-

[49] Michelangelo, *Rondanini Pietà*, c. 1564, Castello Sforzesco, Milan

ian, then in his nineties, painted an altarpiece for his tomb. The subject of this painting was also a *Pietà* and likewise included a self-portrait, though Titian depicted himself as Saint Jerome rather than as Joseph of Arimathaea [fig. 48]. In both works by these aged men, the physical and spiritual enormity of Christ's death is conveyed with a force rarely expressed in the history of art.

Just days before his death in 1564, Michelangelo was carving yet another *Pietà*, now called the *Rondanini Pietà* [fig. 49] after the family that once owned it (in 1952 it was sold to the city of Milan). This *Pietà* is one of the sculptor's most enigmatic works because the viewer sees not one but several versions of the subject—it is a sculpture still in the process of gestation. Michelangelo first carved a standing Virgin supporting the dead Christ. This was a configuration that had interested him deeply since the Roman *Pietà* some seventy years earlier. But this first version, which seems to have been brought nearly to completion, displeased Michelangelo, and he erased it by cutting more deeply into the block to create new and necessarily smaller figures—only Christ's right arm, which was eventually meant to be cut away, remains from the first version. The suggestive unfinished figures, which had begun to take shape under the blows of Michelangelo's chisel, are very attractive to modern eyes attuned to value the throes of artistic creation. But there can be little doubt that Michelangelo intended to bring the *Rondanini Pietà,* like its counterpart in Florence, to a finished state.

In this his last essay on the theme of Christ's death, we see Michelangelo radically rethinking a subject which clearly meant much to him. Like all artists of genius, he was never content simply to repeat his previous inventions, no matter how brilliant. In the *Rondanini Pietà* the spectral, emaciated figures evoke neither the reverence of the Roman *Pietà* nor the torsion and grief of the *Pietà* in Florence; instead this work creates profound feelings of pity, tragedy, and loss. The death of Christ is no longer a sacramental rite or a weighty physical fact. In Christ's frail humanity resides divinity. His human death and divine resurrection must have provided hope and comfort to the old Michelangelo as he struggled to finish the *Pietà* during his own last days on earth.

14. A Late Work by an Ancient Master

Titian: The Flaying of Marsyas

For many people, beauty is often considered a necessary characteristic of art. When they think of paintings they imagine, for instance, lovely landscapes filled with color and light, or graceful dancers in striking poses. And in fact these pleasing images are frequently the subject of memorable works of art. But, as in the case of Giotto's *Lamentation* or Michelangelo's *Pietàs*, superior art often—perhaps most often—depicts less pleasant themes which focus on human tragedy. Such subjects allow both artist and spectator to probe into the deepest, most complex, and subtle aspects of the human psyche.

The painting of *The Flaying of Marsyas* by the Venetian Renaissance artist Titian (circa 1490–1576) is not about beauty or pleasure [fig. 50]. It is, on the contrary, the depiction of a tragedy, a horrid tale of pain, sadism, and death. The story itself is an ancient one. Like so many of the mythological tales beloved by the Renaissance, it comes from the Roman writer Ovid, whose stories of the gods and goddesses were so popular during that time. Marsyas was a satyr, a lustful half-goat, half-human, who found a flute that, unbeknownst to him, was cursed. His pride in his skill as a flute player angered the god Apollo, who challenged him to a music contest: Marsyas's flute against Apollo's stringed lyre. A serious wager was laid on the outcome, with the winner able to punish the loser in any way he saw fit. Because the judges were already on Apollo's side, Marsyas never had a chance and,

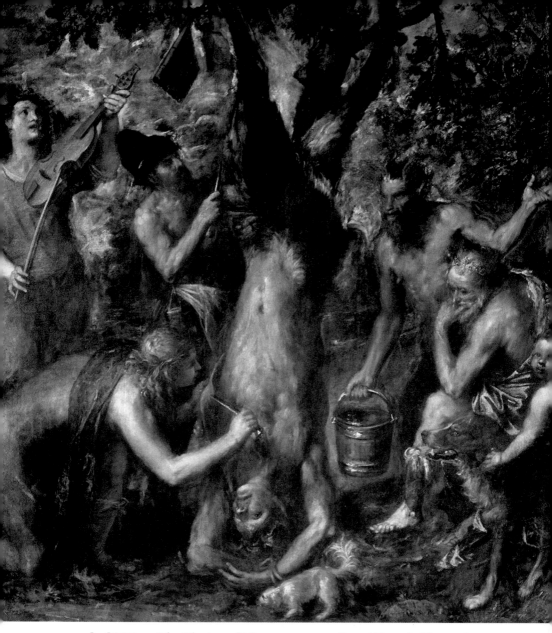

[50] Titian, *The Flaying of Marsyas*, c. 1570, Statni Zamek, Kromeriz

as his victor's prize, Apollo flayed Marsyas alive. It is this flaying that forms the subject of Titian's great painting.

The Flaying of Marsyas dates from just a few years before Titian's own death in 1576. Probably it was still in his workshop when he died at the age of ninety, and it may, in some minor areas, remain unfin-

ished. Most of Titian's works, especially those from late in his life when he was the most famous painter in Europe, were done for important patrons, such as Philip II, the king of Spain. Many of these works, like *The Flaying of Marsyas*, illustrated mythological subjects. Titian had painted such stories from a very early

51] Titian, *The Flaying of Marsyas* (detail)

period in his career, but it is only in his late mythological paintings that he began actively and deeply to explore the tragic elements that so many of Ovid's tales contain (this interest in the tragic is something one can see in the work of the old Michelangelo). Titian's early works are often sunny, sometimes erotic evocations of a golden, peaceful age of gods and goddesses. But many of his late pictures revolve around the tragic fate of innocent victims.

Such is certainly the case with the hapless Marsyas, who in Titian's painting is strung up like a side of beef. His last painful moments are without a shred of dignity as he is flayed before an excited group of onlookers gawking at the horrible spectacle unfolding before them. Only the seated man with the ass's ears (possibly King Midas, a figure also associated with the story) seems to ponder the meaning of what is taking place.

Titian executed *The Flaying of Marsyas* in oil paint. In this medium, pigment is mixed with oil, often linseed oil, then the mixture is applied to the primed canvas support. Unlike the laborious, meticulous process of tempera painting, in which, as in Duccio's *Maestà* [fig. 30],

small amounts of pigment are carefully applied by a little brush to the gesso ground with the fast-drying vehicle of egg yolk, oil painting is a much more spontaneous process. The oil vehicle dries so slowly that it can be worked and reworked as the artist changes his mind and direction. And with oil the artist can modify color and texture by working one layer of the translucent oil, often mixed with turpentine, into another, a process called glazing. Oil painting also allows a much greater range of tonality—the spectrum from dark to light—and color and surface variations. Although the medium had been known for centuries, oil paint did not come into fashion until around 1500, when it supplanted the tempera technique. Titian, one of the earliest artists to work almost exclusively in oil, defined its boundaries. His brilliantly painted works inspired and instructed generations of young artists who, through his influence, made oil the most important painting medium in Western art.

The full range of Titian's handling of oil paint is revealed in *The Flaying of Marsyas*. By its broad range of lights and darks, ranging from the starkly illuminated arm of Apollo flaying Marsyas to the deep shadows out of which the figures emerge, the painting obtains depth, volume, and relief. Each object is further defined by subtle, incremental gradations of tone and color through Titian's delicate glazing. Often shape, texture, and surface are suggested rather than carefully defined. The painting is like an armature that takes its final form not on the canvas but in the viewer's imagination. Everywhere is evidence of Titian's hand. One sees his brush and fingers attack the canvas, covering it with hundreds of small strokes of hue which create a network of broken, scattered color [fig. 51]. Only the bright pinkish red of the *lira da braccio* (treble viol) player stands out; the rest of the canvas is painted with rich though somber colors, among which the flesh tones emerge from the darkness surrounding the fearful deed. Palma the Younger, one of Titian's pupils, left a graphic description of how the artist actually painted a work like this:

> ...he blocked in his pictures with a mass of colors, that serves as the ground ...upon which he would then build. I myself have seen such underpainting, vigorously applied with a loaded brush, of pure red ocher, which

would serve as the middle ground; then with a stroke of white lead, with the same brush then dipped in red, black, or yellow, he created the light and dark areas that give the effect of relief.... For the final touches he would blend the transitions from highlights to half-tones with his fingers, blending one tint with another, or with a smear of his finger he would apply a dark accent in some corner to strengthen it, or with a dab of red, like a drop of blood, he would enliven some surface—in this way bringing his animated figures to completion.... In the final stages he painted more with his fingers than with the brush.

Confronted with the majesty of Titian's *Flaying of Marsyas*, it is surprising to learn that its inspiration comes from a rather insignificant painting by his friend Giulio Romano (1499–1546). This is a fresco of *The Flaying of Marsyas* in the Palazzo del Te in Mantua, finished some thirty years before. When Titian began to think about his own version of the subject, he must have remembered Giulio's fresco. He may have been given a preparatory drawing of the fresco by Giulio, or

[52] Giulio Romano, Drawing for *The Flaying of Marsyas*, Musée du Louvre, Paris

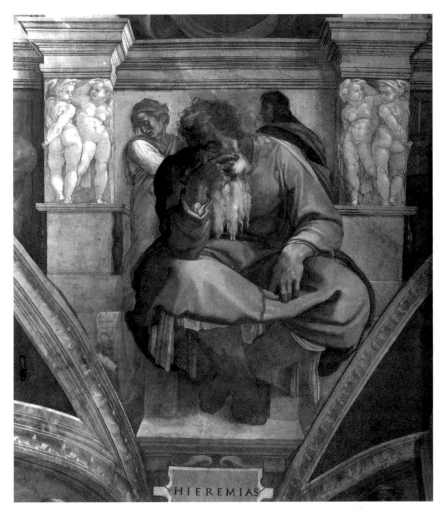

[53] Michelangelo, *Prophet Jeremiah*, c. 1512–1518, Sistine Chapel, Saint Peter's, Vatican City

he himself may have sketched the painting when he was in Mantua [fig. 52]. During the Renaissance all artists took freely from their contemporaries because, unlike today, borrowing was considered a perfectly acceptable way to enrich one's style. Yet the great artists of the period, and indeed of all epochs, often transform and elevate what they appropriate.

Such was the case with Titian's reutilization of Giulio Romano's

composition which, while it furnished the basis for *The Flaying of Marsyas*, was radically modified. The most substantial change was the reorientation of Marsyas's body, from a side view to a nearly full frontal view, so that in Titian's version the horror of the flaying is increased by its completely exposed, inescapable position. And by bringing all the figures nearer to Marsyas and moving them closer to the spectator, Titian has intensified the drama of the scene, thereby making it more immediate.

He has also altered many of the other poses, including that of the so-called Midas. This figure has been turned in space while moving his hands from over his eyes to his chin, so that he no longer recoils from the flaying but rather contemplates its meaning. This image by Giulio may have reminded Titian of Michelangelo's prophet Jeremiah on the ceiling of the Sistine Chapel, one of the most famous images of the Renaissance [fig. 53]. And in fact Titian's Midas, seemingly a self-portrait, is indeed indebted to this monumental figure, which he probably saw during his one and only trip to Rome in 1546. Titian has also added a boy and a dog to the composition in the lower right corner and, as a particularly hideous touch, another little dog who eagerly laps the stream of blood issuing from Marsyas's flayed body.

There are a number of seeming contradictions in Titian's *Flaying of Marsyas*. Both the subject and Titian's bloody realization of it are repellent, yet they form the core of a compelling work of art of great seriousness and depth. The painting, created by one of the most original minds of the Renaissance, is based on the work of two other painters, one of whom, Giulio Romano, is considered a minor master. Yet, passed through the fine sieve of Titian's imagination, *The Flaying of Marsyas* is magically transformed through innovation of the highest order, and all these apparent contradictions are somehow made meaningless by the surpassing intellectual and formal profundity of Titian's genius.

15. The Clash of Cultures

El Greco's Burial of the Lord of Orgaz

Throughout the Middle Ages the seafaring Republic of Venice extended its influence eastward through the Mediterranean. Venice acquired Crete in the thirteenth century and attempted to impose its culture on the island's inhabitants. Yet the highly developed, indigenous Byzantine painting style of the area was only superficially influenced by the art of Venice. Trained in the mannered, elegant, and schematic pictographic traditions of Byzantine art, the Cretan artists were unable, and unwilling, radically to change their ways. The difference between the Cretan and the Venetian idioms became ever more pronounced after the middle of the fourteenth century, as Venetian art grew increasingly realistic and corporeal and thus further removed from the Byzantine idiom.

In 1541 Domenikos Theotokopoulos was born in Candia, Crete's capital and home to a number of Venetians. In his teens he trained to be a maker of icons, but we find no trace of him until 1566, when his name first appears in Cretan documents as a master painter. He was twenty-five in 1566 and therefore an artist fully formed in the traditional Byzantine style of the island. All this would be rather unremarkable if Domenikos had not migrated to Venice, where he is documented in 1568. In Venice the young man, whom we now call El Greco (the Greek), would have met several of his compatriots and probably other artists from the eastern Mediterranean who were producing Byzantinizing devotional images in considerable quantities for various clients in the city, probably also hailing from the eastern Mediterranean. But El Greco was not interested in business as usual. He was in Venice to

learn something new. He soon apprenticed himself in the shop of one of the many masters who were working in the bustling art trade of the city. Exactly whose shop this was is unknown, but we can see from El Greco's earliest Italian paintings that the influence of Titian, the city's leading painter, as well as Tintoretto and Veronese, the two next most important artists, helped the young man transform his style.

Two fascinating paintings of the same subject, the *Purification of the Temple* [figs. 54, 55], date either from El Greco's time in Venice or from his stay in Rome, which seems to have lasted from 1570 until around 1577, when he left Rome for Spain. These pictures, with their monumental architectural stage sets and knots of figures placed in complicated postures, depend on Venetian prototypes. Much of the architecture and a number of the figures have in fact been copied from paintings by Titian, Tintoretto, and Veronese. Yet El Greco still retained ties with his past, apparent in both the small size of the paintings and the use of tempera in one picture (by the middle of the sixteenth century the then old-fashioned tempera technique was almost unknown in Venice). The unpolished application of the paint and the character of color and brushwork are also not Venetian. In the lower right corner of one of the paintings [fig. 55], usually adjudged to be the later of the two, El Greco declared his artistic allegiances by including portraits of four artists: Titian, Michelangelo, Giulio Clovio (an artist friend of El Greco in Rome), and Raphael.

During his Roman sojourn, El Greco must have studied the works of Michelangelo and Raphael and those of his own Roman contemporaries as he vainly sought major commissions in the city. His lack of success and his hopes of obtaining work at the court of Philip II led him to leave Rome for Spain, probably in 1577. We first hear of him in that same year working in Toledo on a large picture for the vestry of the cathedral. In 1580 he was given his one and only commission by the king, who viewed the resulting painting with disfavor. But the artist found much work outside the court, especially in Toledo, where he established his workshop. It was in 1568 for the small Church of Santo Tome of Toledo that he painted what is arguably his masterpiece.

For Santo Tome, El Greco was required to paint an event that had occurred in the fourteenth century, the burial of Gonzalo de Ruiz,

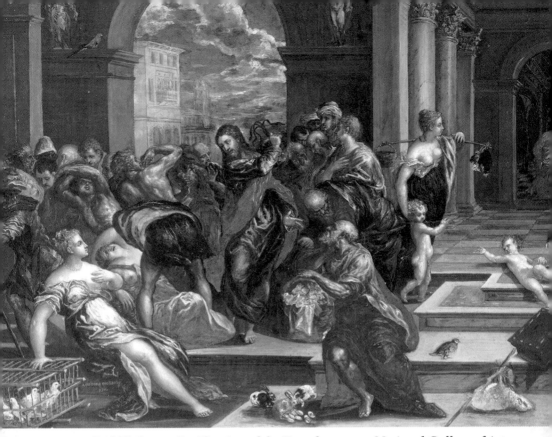

[54] El Greco, *Purification of the Temple*, c. 1575, National Gallery of Art, Washington, D.C.

Lord of Orgaz. Ruiz, according to legend, had been rewarded for his munificence toward the church by the miraculous appearance of Saints Augustine and Stephen, who descended to earth to assist at his burial. This was to be a very large painting (16 feet x 11 feet, 10 inches) and was intended to be placed above Ruiz's tomb in a small chapel in the church [fig. 56]. The contract for the work is quite specific about what El Greco was to do:

> On the canvas, he is to paint the scene in which the parish priest and other clerics were saying the prayers, about to bury Don Gonzalo de Ruiz, Lord of Orgaz, when Saint Augustine and Saint Stephen descended to bury the body of this gentleman, one holding the head, the other the feet, and placing him in the sepulchre. Around the scene should be many people who are looking at it and, above all this, there is to be an open sky showing the glory [heaven].

El Greco's instructions are not detailed, but they clearly state that the painting was to have two realms: below, the burial of Ruiz, and above, the depiction of heaven. Aside from these specifications, the painter could invent freely.

Because there were no painted prototypes for the burial of Ruiz, El Greco, like any Renaissance artist, turned to scenes similar in subject. The most frequently painted of these was the Entombment of Christ, and from it El Greco borrowed the basic configuration of the burial. He certainly had seen many examples of the subject in Italy and Spain, including a famous version by Titian in the Spanish Royal Collection which probably set the artistic standard to which he aspired [fig. 57]. But El Greco did not simply copy. Inspired by these examples, he made what he borrowed his own, just as Leonardo had done in the *Last Supper* [fig. 39].

The central passage of the painting, where the saints lower Ruiz

[55] El Greco, *Purification of the Temple*, c. 1575, Minneapolis, Minneapolis Institute of Art

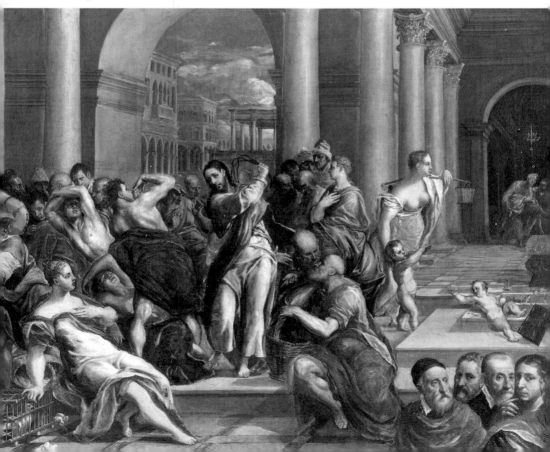

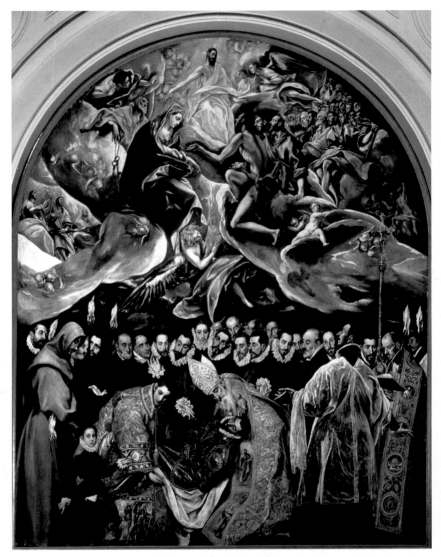

[56] El Greco, *Burial of the Lord of Orgaz*, 1586, San Tome, Toledo

into the tomb, their bodies forming a protective halo-arch over the armor-clad figure, is undiluted El Greco. Here there is much communication with the spectator: Ruiz's head is the closest element in the painting to the observer, the saints look out of the picture, and the small boy, traditionally identified as El Greco's son Jorge Manuel, gazes out

at us and directs our attention to the burial itself. At either end the composition is bracketed by two tall standing figures whose heads face inward. Behind, the composition is screened off by the rather rigid line of dark-clad men whose faces, many of them portraits of the citizens of Toledo (it is interesting to note that El Greco has made the scene take place in the Toledo of his day), are enframed by their fashionable white ruff collars. These figures look and point toward the miracle taking place in their midst.

The bottom half of the painting is earthbound, as all attention is fixed on the entombment. Ruiz was indeed buried in the wall itself, so the painting makes it appear that he is being placed in his actual sepulchre. In depicting the burial, El Greco's brush creates a dazzling display of painterly pyrotechnics. Each of the long slashing brushstrokes that blend one color into another magically recreate the material world. The brilliant play of light on Ruiz's armor, the resplendent gold-encrusted robes of the saints, the delicate ruffs and soft beards of the onlookers, and the diaphanous stole worn by the priest looking toward heaven—all seem so palpable that the onlooker is effortlessly drawn into the scene as though it were actually unfolding in front of him.

All this changes as the spectator's attention turns from the earthly realm to heaven opening above it. The two domains are rather rigidly divided by the line of heads. Only a few earthbound figures seem to see

[57] Titian, *Entombment of Christ*, 1559, Museo del Prado, Madrid

what is occurring above, most notably the priest, who looks upward while gesturing toward Ruiz. This priest is the counterpart of the young boy who looks out at the spectator and points to the burial—but it is not clear if he is really privileged to see heaven or just looks imploringly skyward. El Greco, like any subtle painter, likes to leave much to our imagination.

The object of the priest's gaze is a phantasmagorical depiction of heaven. In this realm scores of saints and angels are supported by swirling sheets of clouds composed of commingled greys, greens, and reds. The light, color, and the very shape of this ghostly, turbulent heaven and its spectral occupants create a stark contrast with the earthly dominion below.

It is from this lower sphere that Ruiz has been called to dwell among the blessed. Nestled in the arms of an angel dressed in a splendid lemon robe shaded with olive tones, his protoplasmic soul is borne toward a gaunt John the Baptist who intercedes on his behalf with the Virgin. Towering above both figures is the brilliantly white-robed Christ who presides over heaven from the very apex of the painting.

El Greco is much indebted to Titian's great *Gloria*, a depiction of heaven commissioned by Philip II and probably seen by him in the Royal Collection [fig. 58]. But no one would ever mistake El Greco's vision of heaven for Titian's or, for that matter, for the work of any other Italian Renaissance painter. In this remarkable heaven, the Byzantine underpinnings of El Greco's style, which he had worked so hard to change, are evident in the preternatural elongations of the figures, in the clash of colors, and in the pictographic nature of the clouds. El Greco, faced with the task of representing the supernatural, found the realistic conventions of the Renaissance, so evident in the lower part of the *Burial*, wanting. Consequently he recalled and reutilized, albeit in much modified form, the highly stylized, unreal, and often hallucinatory art of his own Byzantine past, which he found, quite correctly, a superior vehicle for making the supernatural manifest.

[58] **Titian, *Gloria*, c. 1550, Museo del Prado, Madrid**

16. The Making of Cellini's *Perseus*

In his *Autobiography* the goldsmith and sculptor Benvenuto Cellini (1500–1570) describes how a conversation with Duke Cosimo de' Medici in Florence led to the commissioning of a masterpiece of Renaissance art. The duke brought up the subject by saying, "If you are disposed to work for me, I will treat you in a way that will astonish you, provided the fruits of your labor give me satisfaction, of which I have no doubts." Cellini's response was enthusiastic and characteristically self-confident:

> I, poor unhappy mortal, burning with desire to show the noble school of Florence that, after leaving her in youth, I had practiced other branches of the art than she imagined, gave answer to the Duke that I would be willing to erect for him in marble or in bronze a mighty statue on his fine piazza [the Piazza della Signoria]. He replied that, for a first essay, he should like me to produce a Perseus; he had long set his heart on having such a monument, and he begged me to begin a model for the same.

This conversation set the stage for Cellini's masterpiece, the bronze *Perseus* still in the Piazza della Signoria in Florence [fig. 59]. Cellini had just returned from France where he, along with a number of Italian artists, had worked for the king, Francis I. Cellini was, as he says, anxious to prove himself in his native Florence (where he had worked only sporadically), especially through a commission from Cosimo, the absolute ruler of the city and its principal arbiter of taste. The son of an ivory worker and amateur horn player who wished him to become a musician instead of an artist, Cellini had trained as a goldsmith in Florence and Pisa. Although he already had a successful

career in this profession and also as a medal-maker and sculptor, he had yet to make his mark in his native city.

Much about the circumstances surrounding the making of the *Perseus* is contained in Cellini's revealing, detailed, and absorbing *Autobiography*. In fact, through this book we know more about his life, work, and character than we do about any other artist of the sixteenth century. Although not a professional writer, Cellini's direct, conversational style (the book was dictated to one of his assistants), narrative skill, and wealth of revealing stories make the *Autobiography* essential, exciting

[59] Cellini, *Perseus*, completed 1554, Loggia dei Lanzi, Piazza della Signoria, Florence

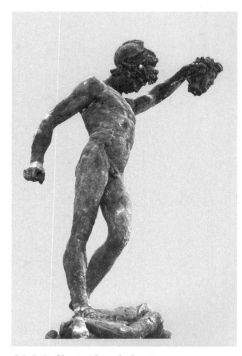

[60] Cellini, Sketch for *Perseus*, c. 1545, Bargello Museum, Florence

reading for anyone interested in the life and work of a great artist.

Cosimo's wish for a *Perseus* in the Piazza della Signoria presented several sizable challenges to Cellini. As the artist says, he would have to prove himself in his native Florence, especially in light of the proposed location of his first major work in the city. The Piazza della Signoria, the square in front of the town hall, was the primary civic space in Florence. Here stood Donatello's *Judith and Holofernes* [fig. 33] and Michelangelo's *David*, two celebrated works of art, both much admired by Cellini. The sculptor also needed to please Cosimo in the hope of further commissions. And, last but not least, Cellini would have to fabricate and cast a large bronze statue, an extremely difficult task even for an experienced sculptor such as him.

Exactly why Cosimo wanted a statue of Perseus is unclear. Certainly he wanted to make his own contribution to the famous piazza, but why a statue of Perseus? Perhaps he thought the depiction of a virtuous hero—the son of Zeus who defeated and decapitated the deadly Medusa—would be an appropriate companion to other statues by Donatello and Michelangelo. Such a depiction would also furnish a mythological complement to the Old Testament hero and heroine. Or perhaps Cosimo saw himself as a sort of latter-day Perseus (later he would have himself portrayed as Perseus). Like Perseus, he would be a hero, the virtuous defender of Florence and the slayer of all tyrants— or Florentine republicans!—who would oppose his ducal rule.

Cellini began preparation for the *Perseus* in the customary way. He first made a sketch in the form of a small wax model, which fortunately still survives [fig. 60]. Such models allowed the sculptor to think through the many problems involved with large three-dimensional sculpture, including how to articulate and compose the figure and how to plan its principal views or sides. (Cellini said that a good figure had to have eight views, all of them of equal importance. Donatello's breakthrough into the continuous depiction of views was not yet understood.) Cellini's model shows not only Perseus but the slain Medusa upon whose body, twisted into a square around the base, he stands. In his uplifted left hand he displays her severed head.

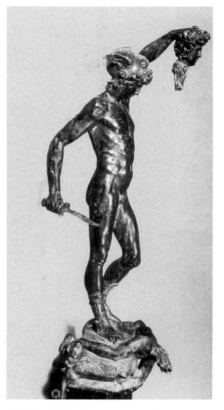

[61] Cellini, Bronze cast after a model for *Perseus*, c. 1545, Bargello Museum, Florence

Cellini tells us that he showed the model to the duke—"no sooner had he seen it than he expressed much pleasure and extolled it to the skies." The duke then exclaimed, "If you could only execute this little model, Benvenuto, with the same perfection on a large scale, it would be the finest piece in the piazza." To this Cellini answered, "Most excellent my lord, upon the piazza are now standing works by the great Donatello and the incomparable Michelangelo, the two greatest men who have ever lived since the days of the ancients. But since your Excellency encourages my model with such praise, I feel the heart to execute it at least thrice as well in bronze."

After such encouragement, Cellini further refined his ideas

through a series of wax models. None of these survive, but a bronze stat-
uette, which must have been cast after one of Cellini's last wax models
is, like the first wax model, now in the Bargello Museum of Florence
[fig. 61]. The differences between the original wax model and the
bronze statuette reveal much about how Cellini's thoughts evolved.
The wax model already contains the nearly fully worked-out deposition
of both figures: Perseus standing on the body of Medusa, his weight
resting on his stiff right leg, his left leg bent forward. His right arm,
which once held a short sword, is flexed and taut. In his left hand
Perseus holds aloft the decapitated head of Medusa.

The bronze statuette contains some substantial modifications
which make the group more dramatic and tense. The left arm is held
farther from the body and bowed more at the elbow, the right arm
bends back farther, and the position of the right leg is slightly shifted.
The musculature is also much more fully developed, more sinuous and
better resolved throughout. One other important change between the
bronze and the wax models is the addition of a pillow, which provides
a smoother transition between the base and the figures—here Cellini
was thinking more closely about the actual stone support on which the
full-sized bronze would be placed. On the whole, the changes make
the finished statue more dramatic and elegant. The transitions between
the various views of the figures are also resolved in a more masterful
way.

After the approval of the wax model, the duke furnished a house for
Cellini in the Via della Pergola and supplied materials for the build-
ing of a workshop and furnace in the garden—this house, in which
Cellini died, still stands today. But because this was a state commission,
the artist soon found himself entangled in the creaky and labyrinthine
bureaucratic machinery of the Medici government on which he had to
rely for funds. Much of the section on the making of *Perseus* in the
Autobiography is filled with Cellini's complaints, seemingly justified,
about the petty and vindictive bureaucrats with whom he had to deal.

Cellini began work on the full-scale bronze by first casting the
Medusa—because of the size and complexity of the group, it would
have been impossible to cast the two figures together. Shortly after the
completion of the Medusa, Cellini fled to Venice because he feared

[62] Cellini, *Perseus* (detail)

being accused of pederasty with one of his assistants. These charges were threatened by the boy's mother who, according to Cellini, had been put up to making the accusation by one of the artist's enemies in the government.

When he returned to Florence, after seeing much of the work of his Venetian counterparts, Cellini began the difficult and dangerous task of casting the *Perseus*. During the initial stages of the arduous casting process — Cellini gives a riveting, valuable, and highly detailed account of the event — the artist overworked himself: "I could at last bear up no longer, and a sudden fever, of the utmost possible intensity, attacked. I felt absolutely obliged to go and fling myself upon my bed." With a fair amount of trepidation, Cellini left, turning the work over to his assistants. But as he tossed and turned in his fevered state, disaster struck:

> While I was thus terribly afflicted, I beheld the figure of a man enter my chamber, twisted in his body into the form of a capital S. He raised a lamentable, doleful voice, like one who announces their last hour to men doomed to die up the scaffold, and spoke these words: "O Benvenuto! your statue is spoiled, and there is no hope whatever of saving it." No sooner had I heard the shriek of that wretch than I gave a howl which might have been heard from the sphere of flame. Jumping from my bed, I seized my clothes and began to dress.

Cellini discovered that the molten bronze had curdled, or, as he calls it, caked. He ordered his helpers to add a store of young oak wood to the fire, making it hotter. Soon "the cake began to stir beneath that awful heat, to glow and sparkle in a blaze." Suddenly there was an explosion and flame. The cap of the furnace had blown off. Cellini discovered that the intense heat of the fire had destroyed the base alloy of his molten bronze.

To save his statue, Cellini sent for his pewter dinner plates and bowls from the house and threw about two hundred of them into the furnaces and casting channels. He tells us:

> This expedient succeeded, and every one could now perceive that my bronze was in most perfect liquefaction and my mould was filling; whereupon they [his workmen] with a heartiness and happy cheer assisted and obeyed my bidding, while I, now here, now there, gave orders,

[63] Cellini, *Perseus Rescuing Andromeda*

helped with my own hands and cried aloud; "O God! Thou that by Thy immeasurable power didst rise from the dead, and in Thy glory didst ascend to heaven!"...even thus in a moment my mould was filled; and seeing my work finished, I fell upon my knees, and with all my heart gave thanks to God.

One wonders if Cellini is here comparing his resurrection of the *Perseus* to that of Christ—not a far-fetched thought, given the artist's enormous ego! After the casting was finished, Cellini ate a plate of salad and at long last retired to bed.

After two days of cooling, the *Perseus* was uncovered and was found to have been perfectly cast. But even the best cast is rough and needs much chasing and polishing before it is ready for display. This chasing is highly important because through it the sculptor creates the surface of the bronze and the final delineation of facial features, hair, and other aspects of the figure. The chasing on the body of the *Perseus*, probably done in part by Cellini's assistants, has created an extraordinarily smooth and sensuous sense of flesh.

Cellini also constructed an elaborate marble base for the group.

This contained niches which house small, extremely elegant bronze figures of Jupiter, Minerva, Danaë with the youthful Perseus, and Mercury [fig. 62]. There is also a bronze relief of *Perseus Rescuing Andromeda*, a feat Perseus performed after he killed Medusa [fig. 63]. Cellini tells us that he took the figures to the Palazzo Vecchio, where he displayed them "raised somewhat above the line of vision, so that they produced a magnificent effect." The duke and duchess appeared, took seats, and for several hours praised the statues. According to Cellini, "The Duchess was wrought to such an enthusiasm that she cried out: 'I do not like to let those exquisite figures be wasted on the pedestal down there in the piazza where they will run the risk of being injured. I would much rather have you fix them in one of my apartments, where they will be preserved with the respect due to their singular artistic qualities.'" To forestall the duchess's desire, Cellini waited until the royal couple were out riding, retrieved the statues, and then soldered them into their niches on the base of the *Perseus*, thus ending any debate about their location.

Today Cellini's *Perseus* is considered one of the masterpieces of Mannerism, a highly stylized, elegant, and self-conscious idiom which flourished in Europe during roughly the last seventy-five years of the sixteenth century. In many ways, in fact, the *Perseus* is a child of its times, although Cellini, as he says, thought himself a disciple of those earlier masters Donatello and Michelangelo. It is clear from his work and from his *Autobiography* that he revered those artistic ancestors, but he also felt a tremendous sense of rivalry with them as he made the *Perseus*. That the statue earned Cellini a prominent place in the long history of Florentine sculpture cannot be doubted, for the *Perseus*, the story of which we can follow in rare detail in his *Autobiography*, is a worthy companion to the *Judith and Holofernes* and the Michelangelo *David*, two icons in the history of Western sculpture.

17. Reality Rearranged

Caravaggio: The Contarelli Chapel

Not far from the Pantheon stands the Roman Church of San Luigi dei Francesi, the French national church in Italy. Founded in 1518 by Giulio de' Medici, later Pope Clement VII, San Luigi was consecrated only in 1589 after a lengthy delay in construction. This delay, it can be seen in hindsight, was fortunate, for the last years of the sixteenth century in Rome witnessed the gathering of an exceptionally talented and innovative group of painters and sculptors who were to reinvigorate much of European art and create the style known as Roman Baroque.

Michelangelo Merisi da Caravaggio (1571–1610) was one of the principal figures of this group. Named after his birthplace in the north of Italy not far from Milan, he received his first training from a pedestrian Milanese painter. By 1592 Caravaggio was in Rome, where at first he seems to have made his living painting still lifes in the employ of the Roman painter Cavaliere d'Arpino. In 1599, eight years after he had established himself in Rome, Caravaggio was given a major commission: the decoration of the Contarelli Chapel (dedicated to Saint Matthew, the patron saint of Matteo Contarelli, the chapel's donor) in San Luigi dei Francesi [fig. 64].

The decoration of this chapel was originally begun several years before by Caravaggio's employer, Cavaliere d'Arpino, but the commission for two large paintings of the *Calling of Saint Matthew* [fig. 65] and the *Martyrdom of Saint Matthew* [fig. 66], to be placed on the chapel's side walls, was given to Caravaggio. Three years later he was also asked to paint the chapel's altarpiece. All three of Caravaggio's paintings for the chapel are revolutionary because they reject the

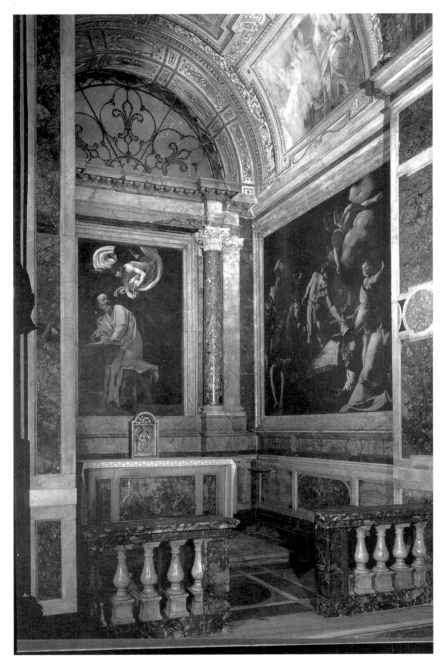

[64] Contarelli Chapel, San Luigi dei Francesi, Rome

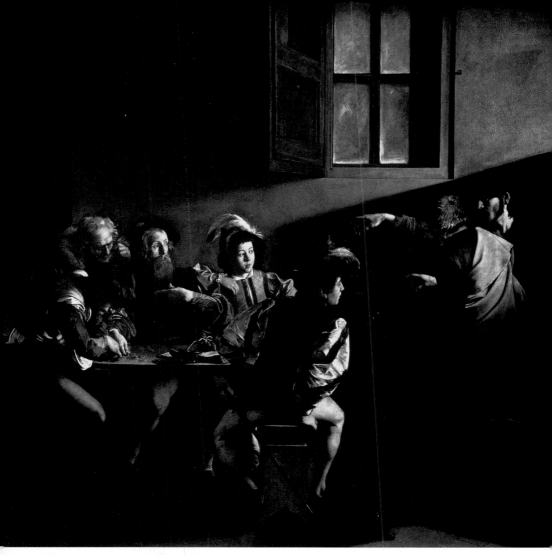

[65] Caravaggio, *Calling of Saint Matthew*, 1600, San Luigi dei Francesi, Rome

pompous, rhetorical character typical of much of the Mannerist art of the late sixteenth century, replacing it with a style notable for its unvarnished directness, high drama, and, occasionally, capacity to shock.

Caravaggio seems to have painted the *Martyrdom of Saint Matthew* first. This was a complex painting demanding a number of figures in action. X-rays of paintings look behind their surface and often reveal how artists changed their minds as they worked. In the case of the *Martyrdom* they show that Caravaggio first painted a number of fig-

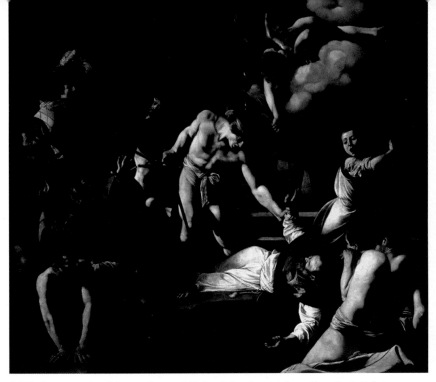

[66] Caravaggio, *Martyrdom of Saint Matthew*, 1600, San Luigi dei Francesi, Rome

ures, including the executioner and bystanders, which he then paint-ed over [fig. 67]. The figures of Caravaggio's first attempt are much smaller than those of the finished painting and seem dwarfed in the x-rays by the large surrounding space. Caravaggio, who was probably not used to painting in this size, realized his mistake and then greatly enlarged and modified the figures. X-rays also demonstrate that the background was originally occupied by parts of a large building with an arch and entablature, but this too was overpainted, perhaps because of Caravaggio's lack of experience with perspectival construction and his inability to adjust and stitch together the figural and architectural parts of his composition. He solved this problem creatively by plunging his background into darkness, which not only unifies the picture but makes it more mysterious.

When Caravaggio realized that his first scheme for the *Martyrdom* was unworkable, he turned for help to a picture that he may have remembered from a visit to Venice: Titian's famous *Martyrdom of Saint Peter Martyr* (now destroyed), one of the most dramatic martyr-

[67]
Hypothetical
re-creation of the
first version of
the *Martyrdom
of Saint Matthew*
based on the
x-ray

dom paintings of the Renaissance. Caravaggio did not need to leave Rome to restudy the work, for it was recorded in a number of engravings, one of which he himself may have owned [fig. 68]. He borrowed the principal figures of the executioner, the saint, and the fleeing man from Titian's painting, but he did not simply copy them. Instead he transformed them and their setting into something entirely different (such creative copying has already been seen in Titian's own *Flaying of Marsyas* [fig. 50]).

In many of Caravaggio's paintings, the contrast between spotlit figures and inky backgrounds creates a sense of drama and excitement seldom rivaled in the history of art. Called *chiaroscuro*, this sharp alternation between light and dark is, in fact, one of Caravaggio's major characteristics and an aspect of his painting that appealed widely to European artists of the seventeenth century. In the *Martyrdom of Saint Matthew* the movement and corporeality of the bright protagonists is heightened by their stark contrast with the murky background. This lighting is so effective that at first it seems real, but closer observation reveals that it is not the illumination of the natural world but that of the theatre, designed to select and heighten drama.

At first glance the spatial setting of the *Martyrdom* also seems plausible until one looks further and discovers that it is entirely artificial.

[68] Engraving after Titian's *Martyrdom of Saint Peter Martyr*

Behind the struggling saint is an altar approached by steps before which the martyrdom takes place. But the saint's left hand hovers over a deep void out of which the foreground figures mysteriously emerge. The spatial setting of this painting, like much of Caravaggio's art is, despite its surface appearance, illogical.

The *Calling of Saint Matthew*, Caravaggio's second painting for the Contarelli Chapel, depicts the moment when Christ called

Matthew: "Jesus saw a man named Matthew at his seat in the custom-house; and he said to him, 'Follow me.' And Matthew rose and followed Him" (Matt. 9:9). This terse description is all the Bible says about the event, but in Caravaggio's fertile imagination the story assumes a particular and definitive reality, not in some distant time and place but in the streets of late-sixteenth-century Rome itself. The action takes place in a room whose unglazed window is covered by paper shades affixed by strings—Caravaggio is an acute, loving observer of detail. Like the window, the table, chair, and stool are commonplace objects which would have been familiar to every contemporary who visited the Contarelli Chapel. Likewise the protagonists, even Christ and Saint Peter at the far right, are far from idealized; rather they are just the sort of rough-hewn characters one may still see on Roman streets. The costumes of those seated at the counting table are also contemporary, and only Christ and Saint Peter are dressed in the togalike robes reserved for holy figures.

Caravaggio, however—and this is his particular genius—has transformed the commonplace into riveting drama. Just below the window is the beckoning hand of Christ (borrowed from the Adam in Michelangelo's *Creation of Adam* on the Sistine Chapel ceiling [fig. 69]), around which the drama revolves (x-rays reveal that the body of

[69] **Michelangelo,** *Creation of Adam* **(detail), c. 1510, Sistine Chapel, Saint Peter's, Vatican City**

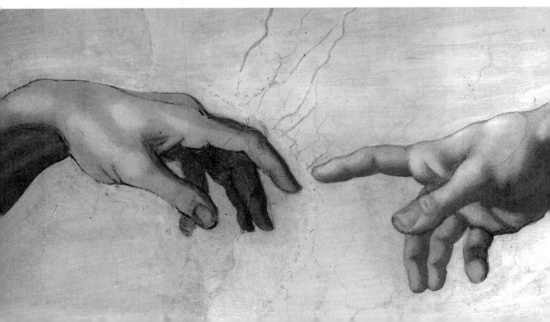

Peter in front of Christ was a later addition). Just above Christ's hand, a shaft of light streams toward the men seated around the table. This is not natural light (the window plays no part in this) but a divine, purifying radiance which will illuminate both the body and soul of Matthew. Traditionally the saint is said to be the pointing man in the middle of the table, but one wonders if this figure is not really pointing to the young man at the end of the table, the only figure still in darkness. If this man, who is as yet unaware of the holy presences around him, were Matthew, it would give the painting an additional ironic and suspenseful element entirely characteristic of Caravaggio.

Caravaggio's narrative paintings are deceiving; they seem simple, but they are works of considerable compositional and emotional sophistication. In the *Calling of Saint Matthew* the figures at the table form a tightly interlocked frieze of carefully constructed forms: the three closely grouped men at the left, the boy behind the table, and the swordsman who leans toward Christ and Peter seem somehow in perfect, immutable balance and equipoise. To their right one sees a spatial void broken only by the dramatic, beckoning hand of Christ extended beneath the lightless window. And then from the darkness at the extreme right emerge Christ and Peter. It is quite possible that Caravaggio learned much about the grouping of figures from an extended study of Leonardo's *Last Supper* [fig. 39], which he may have seen in Milan or known through drawings or engravings.

The Contarelli Chapel *Calling of Saint Matthew* and the *Martyrdom of Saint Matthew* are, like almost all of Caravaggio's other works, an absorbing mixture of the world and the stage; the mundane and the miraculous are intertwined to form unique and compelling drama. Art has rearranged, transformed, and heightened reality, stripping away everything not absolutely essential. Seldom in the history of art has such artificial painting seemed so real and compelling.

18. The Dwarfs of the King's Painter

Velázquez

The sixteenth-century painter Diego Velázquez (1599–1660) spent most of his life at the rigidly hierarchical and fanatically ceremonial Spanish court in Madrid Like Titian and Rubens (both of whom also worked for the Spanish nobility), he was employed mainly to paint portraits of his royal employers and their important associates. Success at court was often predicated on one's ability to flatter one's superiors. But the court artist also had to make images that ennobled and glorified people who were often not very noble or glorious.

Velázquez found relatively easy and early success at the court, which he first entered in 1623 at the age of twenty-four after training with his father-in-law. From then on, he was to be the only artist allowed to paint the young king, the eighteen-year-old Philip IV, who had just recently ascended the throne. Philip's power was great. His empire, although faltering, was vast, stretching from northern Europe to the Far East to South and Central America. Until Velázquez's death in 1660, the lives of the king and the painter were inextricably connected, as the artist made a series of distinguished images of the monarch and his court which would earn him increasing power and position and eventually a knighthood, an honor which the artist eagerly sought to ennoble himself.

Because they worked with their hands, artists were considered to be of low social rank and were usually deemed ineligible for high social orders. By the sixteenth century, however, this situation was chang-

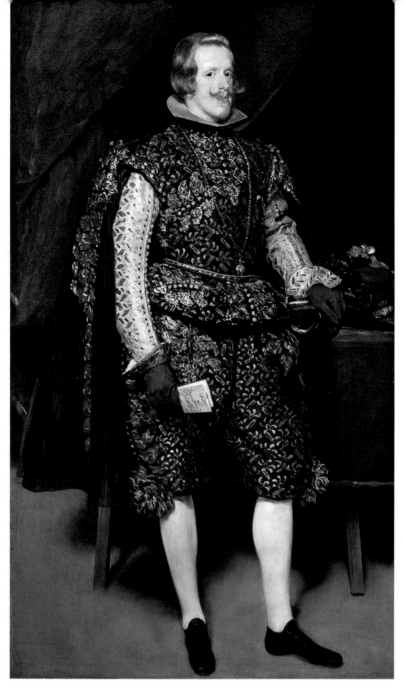

[70] Velázquez, *Philip IV*, c. 1632, National Gallery, London

ing—Titian was knighted by Charles V, and Velázquez's contemporaries Sir Peter Paul Rubens and Sir Antony van Dyck were given titles of knighthood by the English king, Charles I. These were glaring exceptions from the norm, and one has to remember that as late as the eighteenth century Mozart, for example, was often forced to take his meals with the servants of his aristocratic patrons.

The glorification of the kingly personage is embodied in a portrait of Philip originally destined for a royal palace and now housed in the National Gallery, London [fig. 70]. Often such portraits would have been replicated and sent out from the court as the official images of the ruler, somewhat in the same way that a photograph of the reigning president is now placed in post offices and other government buildings.

[71] Titian, *Charles V*, c. 1533 (?), Museo del Prado, Madrid
[72] Titian, *Philip II*, c. 1550, Museo del Prado, Madrid

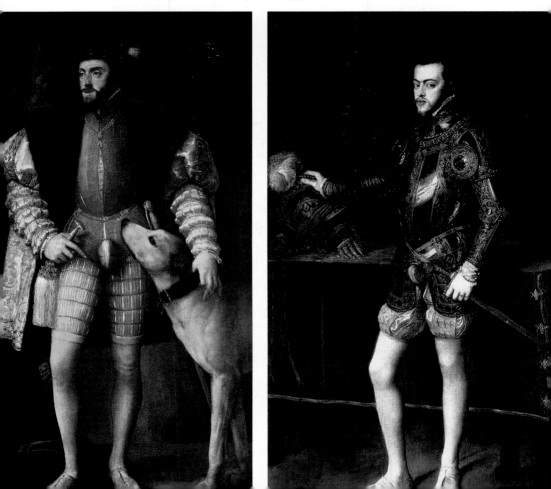

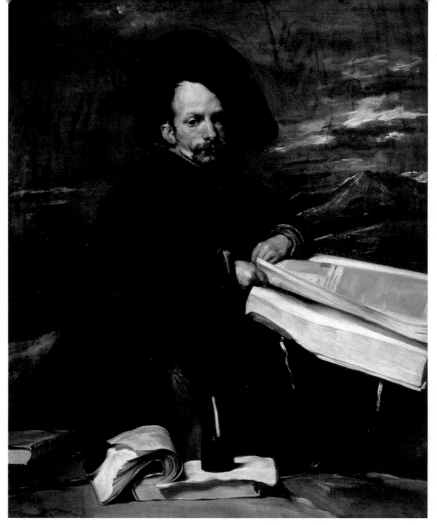

[73] Velázquez, *Don Diego de Acedo*, c. 1640, Museo del Prado, Madrid

The full-length format of the king standing before a curtain, his hand resting on a table, is taken from types much used by Titian for the portrayal of the king's great ancestors, Charles V and Philip II [figs. 71, 72]. Just the very pose and props of Philip IV's portrait would have recalled these royal icons to the minds of Velázquez's contemporaries. Yet in Velázquez's variant of the type, the easy but confident stance of Philip and the idealization of his face presents us with an image not of great power but of cool aloofness and command. The dazzling flurry of silver, brown, and black brush strokes that magically shape the various fabrics of the king's clothes and the sketchy swag of red drapery behind

create a richness and sumptuousness most appropriate for such a state portrait. In his gloved right hand the king holds a petition addressed to him from the painter. This reference to the act of asking royal favors through such documents further reinforces both the official nature of the image and the king's power over his subjects. This is certainly a recognizable and magnificent portrait of a ruler, but it is equally an icon of rulership.

Much of Velázquez's artistic production centers on such images: depictions of members of the court and other nobles whom he needed, and wanted, to paint. There are, however, a series of portraits of quite another order which Velázquez made as court painter. These

[74] Velázquez, *Francisco Lezcano*, c. 1640, Museo del Prado, Madrid

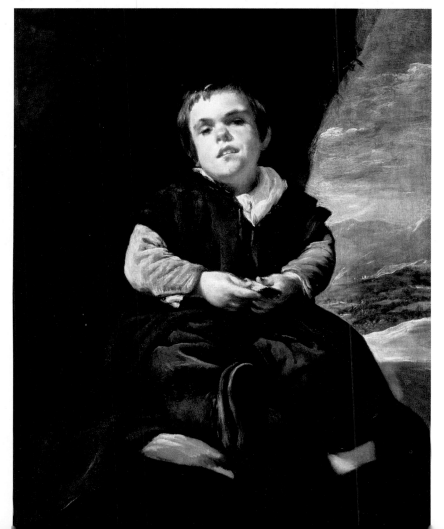

represent the various jesters, dwarfs, and fools who also formed part of the royal entourage and whom the court wished to have recorded in paint.

From our twentieth-century perspective it seems hard to imagine, but such men and women had been an integral part of court life for centuries before Velázquez's time. They provided welcome relief from the often suffocating ordeals of court ritual and stylized behavior. Their stunted bodies or dull minds made certain members of the court seem more beautiful and intelligent by comparison, and for this reason some of these unfortunate creatures were introduced into portraits of their noble masters. Dwarfs and midgets were also deemed suitable play-mates, "playthings" for aristocratic children.

Many images of dwarfs and jesters were made before Velázquez's time, but few, if any, are as searching and sad as his. Perhaps of all the paintings by Velázquez of this type, the closest to his aristocratic por-traits is the *Don Diego de Acedo,* called El Primo [fig. 73]. In Spanish, El Primo is a nickname meaning "cousin," and in this case it refers, perhaps, to a relative connected with the court. Don Diego served at court from 1635 until his death in 1660. He was a courtier and played a role in the office of *la estampa,* the office that affixed the king's fac-simile signature to documents. He had, in other words, some part in the court's business, and it is as an alert, intelligent, and busy person that he is portrayed in this portrait of circa 1640 by Velázquez.

Set on a diagonal across the picture's surface so that the shortness of his legs (partially masked by his clothes) in comparison to his head and trunk is somewhat hidden, Don Diego turns the pages of a large book which both covers and overshadows his small body. He is also sur-rounded by symbols of his occupation and education—more books, a pen, and an ink pot. He glances out toward the spectator, but his intel-ligent face, framed by his floppy black hat, is full of reflection and med-itation rather than recognition or even awareness of the viewer. Clearly an active, animated personality is depicted here. There is no hint of self-pity, nor is the quiet figure, dressed in sober black and gray, much different, aside from the seated, stunted body, from many other Velázquez portraits of important figures.

In the case of another dwarf, however, a different tale is told by a

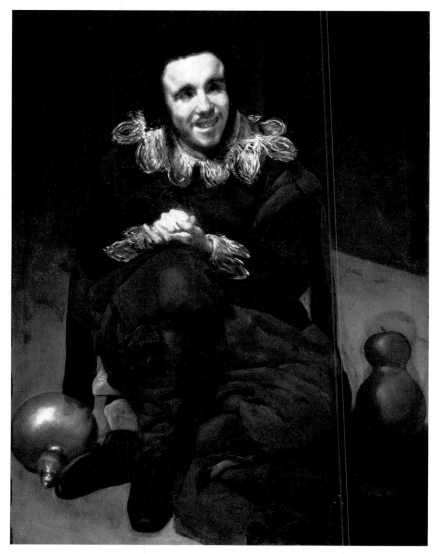

[75] Velázquez, *Calabazas*, c. 1639, Museo del Prado, Madrid

Velázquez portrait. This is of Francisco Lezcano, the court dwarf of
Prince Baltasar Carlos, the king's son [fig. 74]. Probably painted about
1639, this portrait, unlike that of Don Diego, dwells on the infirmities
of the subject. Set before the indistinct, perhaps not fully finished,
background of a dark hillock and mountainous landscape, Francisco,

dressed in olive green and white, is placed nearly frontally, his stunted right leg and foot directly confronting us. Our eyes are led immediately and inexorably to the large head with its close-cropped red hair. Lolling backward as though incapable of support, the face with its slack jaw and uncomprehending, bewildered eyes provokes a sense of deep sadness as we regard this seemingly vulnerable, helpless, and innocent man with pity.

In yet another of this series of portraits, which was probably originally hung in the Torre de la Parada, the royal hunting lodge near Madrid, we see the most pathetic representation of them all, the likeness of the court fool Calabazas, a jester in the king's service until 1639 [fig. 75]. In the corner of a bare room—the term "cornered" seems apt here—Calabazas sits on a low stool, surrounded by gourds. These are obvious symbols of mental emptiness: in Spanish the nickname *calaba* (gourd) also means a dull or ignorant person. His hunched and awkward body seems nervous and uncomfortable as he seeks to understand what is going on around him. Protruding from a fancy ruff collar, the misshapen face of Calabazas, his eyes crossed and vacant, is distressing to contemplate. His smile looks forced and unknowing, as though he makes it to please the observer without really understanding what is happening around him. His hands are nervously working together, seemingly without much coordination from his brain.

These paintings of dwarfs, jesters, and fools, unlike the royal portraits that Velázquez had to do year in and year out, make little or no judgment on their sitters. Except for the court official El Primo, they neither attempt to hide deformities of mind or body nor to dwell on them. They present us with the facts as Velázquez saw them, skillfully arranged and exquisitely painted, set down with as much objectivity as a great artist may bring to the painting of such subjects. But they are more than just magnificent reportage; because of their honesty they are inescapable images of human distress which once seen, indelibly imprint themselves on our minds. They, rather than the magnificent, often pompous, portraits of royalty, are the artist's true and enduring legacy to us.

19. Art Without Boundaries

Bernini's Saint Teresa

Occasionally artists create works of art that reshape preexisting concepts in substantial ways. The Cornaro Chapel is such a work [fig. 76]. In its overall design and material structure, this creation of the sculptor Gian Lorenzo Bernini (1598–1680) defies the sort of categorization and vocabulary easily applied to other art of the seventeenth century.

Bernini, like so many Renaissance artists, was born into the trade. Art was then, in fact, a business carried out by workshops composed of

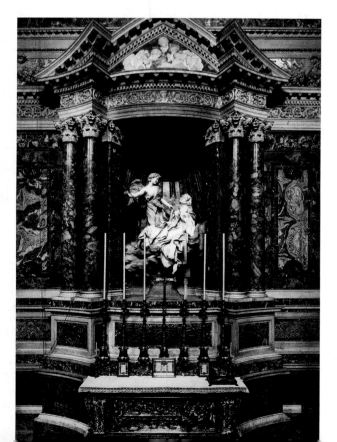

[76] Bernini, Cornaro Chapel, c. 1644–1650, Santa Maria della Vittoria, Rome

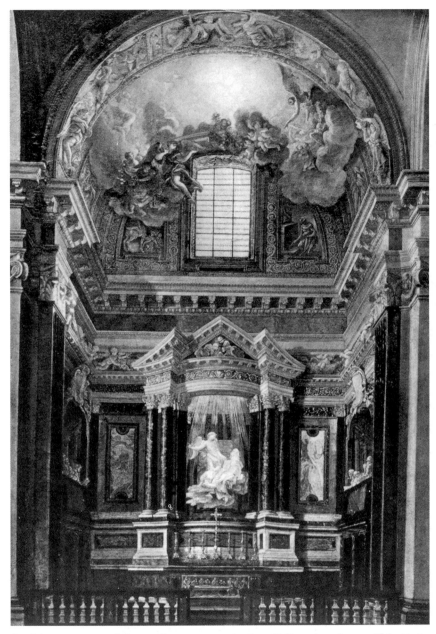

[77] Anonymous eighteenth-century painting, Schwerin, above; Abbatini, *Adoration of the Holy Trinity*, c. 1644–1650, Cornaro Chapel, Santa Maria della Vittoria, Rome

apprentices working under the direction of a master artist. Bernini studied with his father, Pietro Bernini (1562–1629), a modestly successful artist who trained in Florence, worked in Naples, where his son was born in 1598, and then moved to Rome, where he participated in the burgeoning ecclesiastical patronage in that city under Pope Clement VIII.

Gian Lorenzo Bernini was one of the most naturally gifted sculptors in the history of art. His ability to carve brilliant marble portraits and mythological and religious statues earned him early and lasting fame, not only in his adopted city of Rome but throughout Europe. His position as the leading sculptor of Rome, of the pope, and of the Curia was solidified when his patron, Cardinal Maffeo Barberini, was elevated to the papal throne in 1623 as Urban VIII. Many of Bernini's largest and most famous works were done for Saint Peter's—including the great Baldacchino, the Throne of Peter, and the enormous colonnade in the piazza in front of the church. It was Bernini who gave much of the shape and substance to the style of art now called Baroque which still dominates Rome. In his pictorial ideas he is in many ways the counterpart of Caravaggio, who died twelve years after Bernini was born. Throughout his life Bernini studied with care the works of his remarkable predecessor.

According to contemporary sources, Bernini said that among all his works he most prized the Cornaro Chapel; perhaps this was because the commission allowed free rein to so many aspects of his imagination

[78] Bernini, *Members of the Cornaro Family*, c. 1644–1650, Cornaro Chapel, Santa Maria della Vittoria, Rome

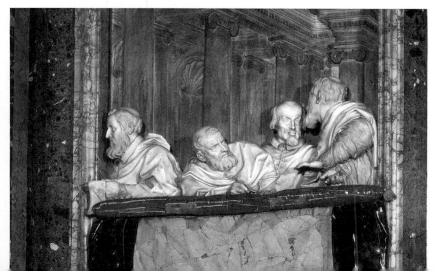

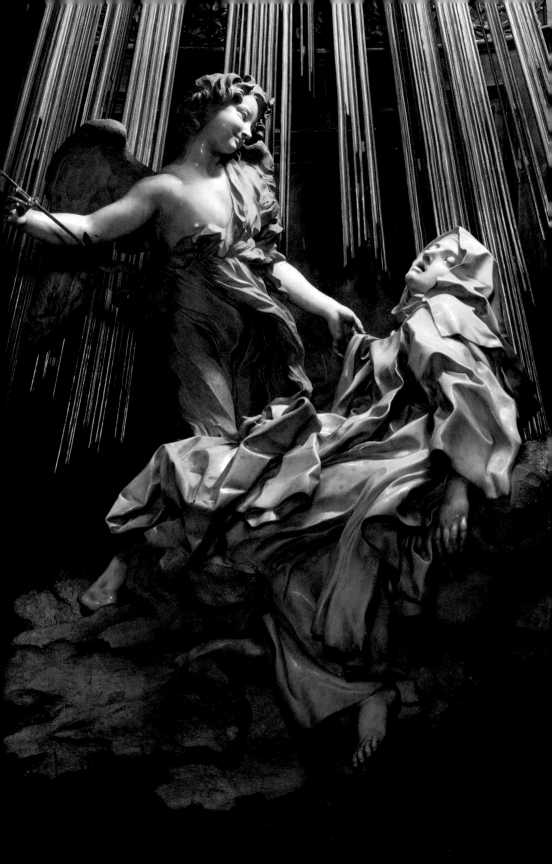

and talent. Unlike anything he had created before, Bernini's work here is neither pure architecture, sculpture, nor painting; rather, it is an inseparable unity of all three of these arts.

The Cornaro Chapel is in the left aisle of the Church of Santa Maria della Vittoria in Rome. Begun about 1644 and completed some six years later, the chapel was owned by a member of a prominent Venetian family, Cardinal Federigo Cornaro, who was then living in Rome. Like so many other superior works of art, including Michelangelo's Roman *Pietà* [fig. 44] (much admired by Bernini) and El Greco's *Burial of the Lord of Crgaz* [fig. 56], Bernini's commission was for a burial chapel, to be a monument to Federigo Cornaro and to his piety and fame.

The shallow chapel consists of several interlocking elements. A fresco by Guidobaldo Abbatini on the chapel's ceiling depicts the *Adoration of the Holy Trinity in Heaven* [fig. 77]. Here some of the clouds are made of plaster and thus, by their three-dimensionality, extend into the chapel's real space, making it appear as though the spectator were actually looking into Paradise itself. On either of the chapel's short walls are small theatre boxes. Each of these contains relief-sculpture portraits of members of the Cornaro family, some of whom had died a century before. The portraits are set before a vaulted room whose columns recede far into the background, making the figures seem to look out from another part of the church adjoining the Cornaro Chapel [fig. 78].

In the center of the wall, directly across from the entrance, is the chapel's centerpiece and focus: Bernini's most famous sculptural group, the life-sized *Ecstasy of Saint Teresa* [fig. 79]. Saint Teresa was the founder of the order of the Discalced Carmelites (so-called because this order of Carmelite nuns wore sandals). Teresa, who died in 1557, was a tough, determined reformer who, in the face of tremendous obstacles, succeeded in establishing a series of reformed Carmelite convents dedicated to a simple, rigorous, religious life. At the same time she was given to mystical visions in which she saw and spoke to

[79] Bernini, *Ecstasy of Saint Teresa*, c. 1644–1650, Cornaro Chapel, Santa Maria della Vittoria, Rome

heavenly figures, including Christ. She encouraged her followers to imagine an immediate, direct spiritual experience which brought them into close contact with Christ and the saints. Such emotional and physical closeness between the worshiper and heavenly figures was very much part of her spirituality.

Her most famous vision, often referred to as a transverberation, occurred when an angel descended from heaven and repeatedly pierced her body with a spear of Divine Love. It is this supernatural act which forms the core of the Cornaro Chapel. In her autobiography Teresa vividly describes the experience:

> It pleased the Lord that I should sometimes see the following vision. I would see beside me, on my left hand, an angel in bodily form—a type of vision which I am not in the habit of seeing, except very rarely. It pleased the Lord that I should see this angel in the following way. He was not tall, but short, and very beautiful, his face so aflame that he appeared to be one of the highest types of angel who seem to be all afire. They must be those who are called cherubim: they do not tell me their names but I am well aware that there is a great difference between certain angels and others, and between these and others still, of a kind that I could not possibly explain. In his hands I saw a long golden spear and at the end of the iron tip I seemed to see a point of fire. With this he seemed to pierce my heart several times so that it penetrated to my entrails. When he drew it out, I thought he was drawing them out with it and he left me completely afire with a great love for God. The pain was so sharp that it made me utter several moans; and so excessive was the sweetness caused by this intense pain that one never wishes to lose it, nor will one's soul be content with anything less than God. It is not bodily pain, but spiritual, though the body has a share in it—indeed, a great share. So sweet are the colloquies of love which pass between the soul and God that if anyone thinks I am lying I beseech God, in his Goodness, to give him the same experience.

Bernini depicts that split second when the angel removes the spear (here shown as an arrow) and is about to thrust it into Teresa's body once again. The angel's swaying upright form makes a strong contrast to the saint, whose body and face are contorted in a spasm of painful ecstasy [fig. 80]. The orgasmic imagery and the mingling of pain and pleasure, both of Teresa's vision and Bernini's representation of it in

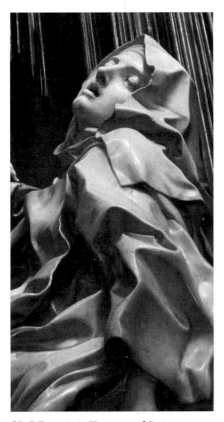

[80] **Bernini,** *Ecstasy of Saint Teresa* **(detail)**

her face, body, and gestures, cannot be ignored: it is one of the most compelling aspects of the work.

The more carnal aspects of Bernini's interpretation of the *Ecstasy*—especially the saint's sensuous, swooning face—have been much commented on and often depreciated as inappropriate for a sacred image. An eighteenth-century observer noted, "If this is divine love, I know what it is!" Although the erotic charge is considerable, it is inseparable from Teresa's and Bernini's belief that the saint's experience was a genuine merging of her soul with God's in a mystical moment of spiritual ecstasy and divine revelation. Bernini, who was a sincere, practicing believer, has here brilliantly depicted the complex moment of religious fervor and physical pain and pleasure that Teresa experienced in the throes of a religious experience of great profundity and meaning. And in fact he has consciously diminished the carnality of the drama by both hiding much of the saint's body in an explosive cascade of free flowing drapery and by making the heavy marble—both figures and the clouds are carved from a single block!—seem to hover, as though weightless as a feather.

The *Ecstasy* is illuminated by divine light. Behind the figures is a burst of golden, heavenly rays—behind these rays is a window glazed with yellow glass which, especially in the afternoon, allows light to flood the figures. The niche enclosing Saint Teresa and the Angel is open to the painted skies of the chapel's vaults. From above, the light

of the firmament pours in, bathing the group in a supernatural aura, the pure, untainted light of the realm of angels. Framed by dark columns and pilasters of molted grey and black marble, the radiant white saint and angel are the brightest elements in the chapel. They immediately command the spectator's full attention. It is as though the entire chapel is a theatre and they are spotlit center stage.

The theatrical nature of the chapel is further developed on the side walls by the two theatrelike boxes containing portraits of the Cornaro family [fig. 78]. These men are not transfixed by the sight of the *Ecstasy* but seem to be debating its meaning, like the audience at an absorbing play.

Bernini's drama, his use of striking, sweeping forms, and, above all, his striking, theatrical lighting are strongly indebted to Caravaggio, whose works Bernini, a talented painter as well as sculptor, admired and studied. The intensity of Caravaggio's Contarelli Chapel, with its striking illusionism and stark *chiaroscuro*, underlies many of Bernini's most fundamental artistic conceptions [fig. 65]. But in the Cornaro Chapel, Bernini had to deal not only with painted decoration but with sculpture—both in full round and in relief—and extensive marble revetment as well. Before the Cornaro Chapel, each of these mediums was thought of as a discrete entity, even when all were used together in the same location. But in Bernini's hands, all these elements are fused into a single dramatic whole, unlike anything seen before. The Cornaro Chapel is really sui generis: it is not pure painting, pure sculpture, or pure. Each element—material, illumination, and figure—is enlisted in the creation of a single miraculous moment which unfolds directly before the startled eyes of the onlooker. As in Caravaggio's Contarelli Chapel, the skillful manipulation of art creates a dramatic fiction that seems more real than reality itself.

20. Depicting Divine Right

Van Dyck: Charles I on Horseback

Sometimes in the history of art an intelligent and discerning patron is lucky enough to find an artist capable of perfectly transforming his ideals and ideas into major works of art. Pope Julius II and Michelangelo, for instance, were able to create images—the frescoes of the Sistine Chapel ceiling, the statue of Moses—that characterize and immortalize them both. In Velázquez, Philip IV found a maker of images perfectly suited to his aspirations. Such a mutually beneficial relationship also existed between Charles I (1600–1649), king of England, and the Flemish painter Anthony van Dyck.

Van Dyck (1599–1641) was born in Antwerp, where he studied with Peter Paul Rubens, one of the most famous artists of the seventeenth century. In 1620 van Dyck made his first trip to England but stayed only several months. He left Antwerp again in 1621, this time for Italy. There he remained for six fruitful years, working for noble patrons and studying the paintings of the Italian Renaissance, especially those of Titian, the sovereign portrait painter of that age. It was in Italy that van Dyck's own considerable skills as a portraitist were polished, in a series of paintings which ennobled and glorified his aristocratic sitters. After returning to Antwerp, van Dyck again left for England in 1632, where he remained until his death nine years later.

In England he was appointed court painter to Charles I, who gave him the series of important commissions that eventually led to his knighthood. Van Dyck's sophisticated and elegant art swept away the provincial English style that had been the staple at the courts of Charles and his father, James I.

137

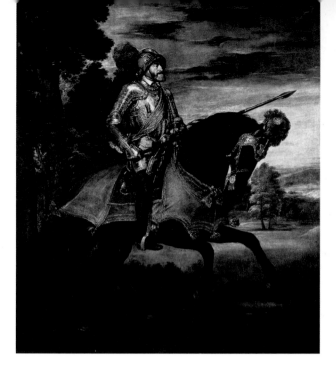

[81] Titian,
*Emperor Charles V
at Mühlberg*, 1548,
Museo del Prado,
Madrid

Even before van Dyck arrived in England for his second stay, Charles I had developed a strong affinity for the grand manner of his art. During a trip to Spain in 1623, Charles I had seen the Royal Collections, with their unmatched holdings of Titian and other major Venetian Renaissance paintings amassed in the previous century by the Holy Roman Emperor Charles V (1500–1558) and his son, His Catholic Majesty Philip II (1527–1598), the king who was to send the Armada against England. Charles I, who considered himself king by divine right and divine in his own nature, was immediately drawn to Titian's majestic depictions of Charles V; he must have looked with particular awe on Titian's equestrian portrait of the emperor, painted to commemorate his victory over the German Protestants at Mühlberg in 1547 [fig. 81]. In these works Charles saw how Titian was able to ennoble his sitters while depicting them as natural and easy aristocrats. Following his return to England from Spain, the king as well as many members of his court became active collectors of Venetian paintings. Agents were sent out to Italy to buy individual pictures and statues or, if possible, whole collections: the greatest of these, the collection of the dukes of Mantua, was purchased for Charles by 1628.

In van Dyck, Charles found an artist perfectly capable of express-

ing his self-image through a series of superb portraits. The most infor-
mal, and thus most revealing of the king's personality, was made
around 1635, to be sent to the foremost Roman sculptor of the period,
Gian Lorenzo Bernini (see Chapter 19). This painting, which depicts
Charles in three views, was to serve as a model for a marble portrait
bust, now unfortunately destroyed [fig. 82]. Looking at the three views,
Bernini is rumored to have called the face "doomed" and to have said,
"Never have I beheld features more unfortunate"—but this comment
may have been made only after the king's execution in 1649. The face
depicted in the van Dyck portrait is extremely sensual and alert. From
its delicately defined features emanates a sense of natural intelligence
and innate dignity. This and other painted faces of the monarch by van

[82] Van Dyck, *Charles I in Three Views*, c. 1635, Royal Collection,
Windsor Castle

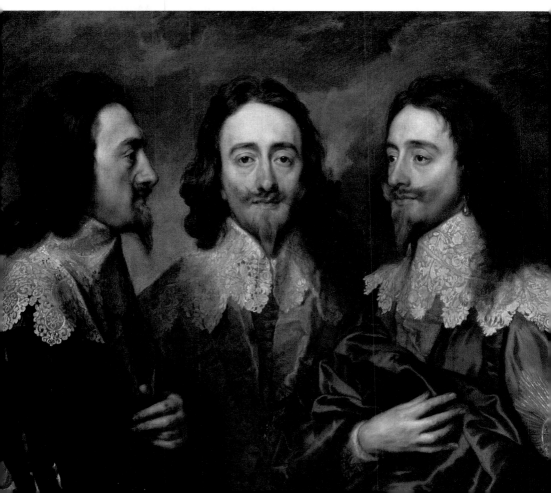

Dyck created, and have perpetuated to this day, the physical and emotional image of the king's persona.

Van Dyck's more formal images of Charles are centered on issues of his monarchy. *Charles I on Horseback* [fig. 83], circa 1637, depicts the king, accompanied by a groom, riding through a landscape. He seems to have just emerged from a rocky forest into the panorama of a tree-dotted plain set before a luminous sky filled with billowing clouds [fig. 83]. Holding his baton of command and authority, he rides easily in complete command of his horse, himself, and, seemingly, everything around him.

Western art has long associated the man on horseback with authority. From the Greeks and Romans down through the knights of the Middle Ages to the Renaissance and Baroque periods, figures of great power, such as Dürer's *Knight* [fig. 37], were depicted on horseback. Van Dyck and Charles knew a number of these images but were probably most impressed by Titian's *Emperor Charles V at Mühlberg*—Bellori, a contemporary Italian critic and historian, claimed that van Dyck was inspired by the work, though the artist may have known the painting only through copies.

Van Dyck's painting encapsulates two ideals: the divinely ordained ruler, so tenaciously held by Charles, and the seemingly easy, hauntingly beautiful depiction of ideal nobility and power, given form by van Dyck. Everything in the painting, from the landscape to the face of the king, is rendered in a seemingly effortless manner by sweeping, fluid brushstrokes; the physical process of the painting is as graceful and as relaxed as the subject. In reality, a long series of preparatory drawings of the king and his horse were made for the painting. The actual painting itself was a meticulously planned, laborious process, but it was van Dyck's particular skill that made it all look spontaneous and simple. This elegant, confident appearance of both monarch and painting is exactly what van Dyck and Charles wanted.

Van Dyck's portraits of Charles and of other members of the royal family and the court were viewed with much suspicion by the king's numerous enemies, many of whom were strongly opposed to the idea of divine, absolute monarchy which Charles espoused. The glorification of the king in paintings such as *Charles I on Horseback* confirmed

[83] Van Dyck, *Charles I on Horseback*, c. 1637,
National Gallery, London

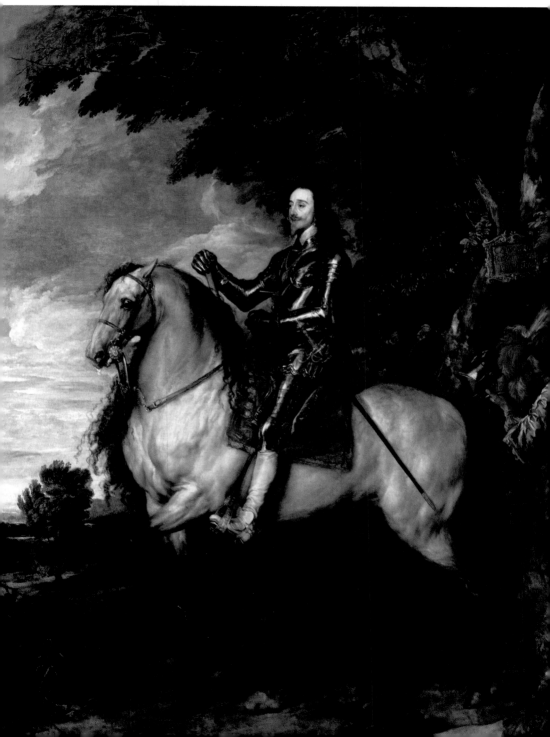

the worst fears of this powerful and influential group. Even worse, the king, who was head of the Church of England, was suspected of being sympathetic to the dreaded Church of Rome: his wife was a French Roman Catholic who brought her Catholic priests to England. This fear led many people, especially the Puritans, to worry, with some justification, about a revival of papism. The king's considerable outlays of money, for both collecting and commissioning works of art, also incited much disapproval and anger among his subjects.

There can be no doubt that Charles's artistic patronage and his collecting were contributing factors to the disastrous civil war in which he was first defeated and then dethroned. After a humiliating trial the king was sentenced to death, the first and only such sentence in English history. In 1649 he stepped onto a platform erected in front of the Banqueting Hall. There he bravely awaited the headsman's axe just a few feet away from a series of ceiling paintings by van Dyck's master Rubens, whom Charles had commissioned to glorify the ideals of kingship in which he fervently believed and for which he was about to die.

21. The Painter as Prince

A Self-Portrait by Rembrandt

The self-portrait holds an important place in the history of European painting. It first appears with frequency in the Italian Renaissance and parallels the rise of the status of the artist from craftsman to creator. Around 1500 artists began to take a new, more introspective interest in themselves as individual personalities. They started to paint and carve their own likenesses for posterity. For the first time they and the society in which they lived felt a sense of their own importance. On a more mundane level, the artist was his own best and least expensive model, always available in the mirror for study and practice.

Many artists have painted themselves in an attempt to understand both their art and their character, but few have done so with more probing intensity and skill than Rembrandt van Rijn (1606–1669). Over the course of his life he produced around sixty self-portraits; these paintings are among the most profound meditations by any artist on his or her own individuality. By studying them, one experiences an unceasingly candid dialogue between the artist and his ever-changing face and soul.

One of the major and most endearing characteristics of all Rembrandt's art is its honesty. He always eschews the sometimes grandiloquent, sometimes silly, and often pompous imagery of contemporary painting in favor of a much more earthy, direct style which, by the appeal of its forthright humanity, has made his name synonymous with painting worldwide. This approach is seen clearly in his self-portraits. In 1631, when he was just twenty-five and newly arrived in Amsterdam (where he would work for the rest of his life) from his native city of Leiden, he painted a full-length likeness of himself [fig. 84]. In this paint-

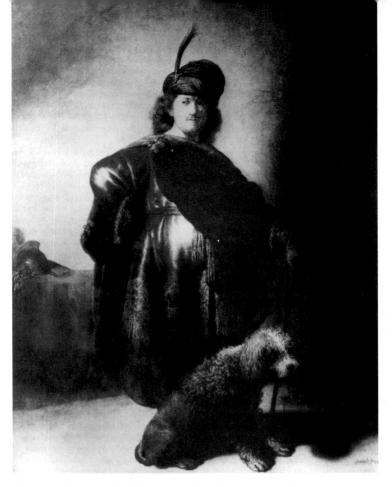

[84] Rembrandt, *Self-Portrait*, 1631, Petit Palais, Paris

ing he wears exotic dress, a sort of Near Eastern fantasy of flowing, embroidered, shimmering satin robes and tassels, and a turban complete with feather. The showiness of these ornate clothes is complemented by Rembrandt's rather consciously swaggering stance. With his right hand on his hip and his elegantly extended left hand holding a walking stick, he strikes a pose for the viewer.

This image of the artist as an elegant, worldly gentleman was the goal of many artists' self-portraits of the time. One of the most remarkable examples of this type is by Rubens (painted just one year after Rembrandt's self-portrait), the teacher of van Dyck and an eminently successful painter, diplomat, courtier, and scholar [fig. 85]. Such portraits were certainly known to Rembrandt, and they may have influ-

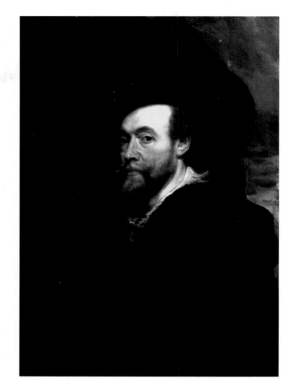

[85] Rubens, *Self-Portrait*, 1632, Royal Collection, Windsor

enced him, but he could never accept their rhetorical, self-aggrandizing nature.

Instead, as in the 1631 work and in other early self-portraits, Rembrandt refused to take himself so seriously. A second glance at this portrait of him in fancy dress reveals that he looks a little lost and uncomfortable in all those clothes. Moreover the face, framed by an abundance of unruly curly hair, is strikingly plain and at odds with the exotic costume and pose. Rembrandt is surrounded by a halo of brilliant spotlit illumination, a type of dramatic lighting which he learned from works by Caravaggio and his followers that he saw in Amsterdam. In scale to his most inelegant, shaggy dog in the foreground, Rembrandt looks rather short and stumpy and very unlike the typical pretentious self-portrait of the period. There is a thinly veiled self-mockery here, a form of poking fun at oneself which makes Rembrandt "the man" very human and simultaneously delights the viewer.

In 1658 Rembrandt painted the *Self-Portrait with Maulstick*,

[86] Rembrandt, *Self-Portrait with Maulstick*, 1658, The Frick Collection, New York

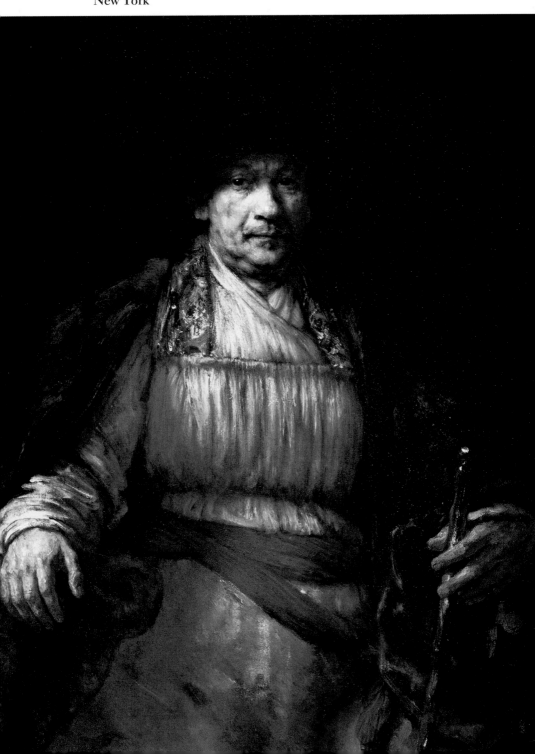

arguably one of the supreme examples of this type in Western art [fig. 86]. In the decades between it and the 1631 self-portrait with a dog, the artist relentlessly examined his face and the character it expressed. Now, in his fifty-second year, he presents himself to the onlooker at the height of his artistic maturity. Once again his dress is sumptuous: golden robes, a white linen shirt, and a gold-encrusted stole around his neck. His waist is encircled by a deep red cummerbund, a fur pelisse is draped over his shoulders, and his head is crowned by a large, floppy hat seemingly made of black velvet. These are not the drab, dark clothes of mid-seventeenth-century Amsterdam. Rather, like those of the 1631 self-portrait, they are fanciful and extraordinary, but here they seem regal. Although he is seated on a simple armchair on which he rests his left hand, Rembrandt appears enthroned. In the same hand he lightly holds what at first looks like a scepter but is in fact a maulstick, a wooden stick used by painters to steady their painting hand. Here Rembrandt depicts himself as a painter-prince, ennobled by his own art created by the very hands that are so prominently displayed. But the face that looks out from the sumptuous clothes betrays no arrogance or

smugness, nor is it in any way idealized. Instead Rembrandt unflinchingly presents himself as he was, with a plain face that has begun to pucker and sag, and with knowing eyes that have seen much, perhaps too much, of the world. Once again the face seems to belie the clothes and pose. Here, however, it is no longer self-conscious but modest and wise.

The clothes and face have been created by the prodigious power of Rembrandt's brush. Painted in

[87] Rembrandt, *Self-Portrait* (detail)

oil on canvas, the 1658 self-portrait reveals the artist's exceptional understanding of his medium, an understanding based upon, and equaling, the elderly Titian's *Flaying of Marsyas* [fig. 50]. Everywhere one sees the mark of Rembrandt's hands as they push the heavily laden brush across the front of the robes or swirl the paint along the right arm to form a sleeve. Elsewhere, as in the stole and the left hand, he seems to have employed the palette knife and his fingers more than the brush [fig. 87]. There arises from these marks on the surface a feeling of action and spontaneity, a sense of the artist in the magical act of creation.

Rembrandt never lets the viewer forget that what he sees is illusion, an image of striking power created out of simple pigment, oil, and varnish. If, for instance, one looks at the glittering stole around the painter's neck, it seems to be actual cloth stiff with gold embroidery. Yet at the same time the viewer is made aware by Rembrandt that the stole's realism arises from the physical nature of the paint, from the brilliant placement of glazed and impastoed pigment. As in Donatello's *Judith and Holofernes* [fig. 33], there is a continual tension between illusion and material that is manipulated to make that illusion. Rembrandt continually reminds the onlooker that what he sees is the artistic transubstantiation of material into seeming reality. In this case the reality provides precious and instructive insight into art while furnishing an unforgettable image of the aging artist's face and psyche.

22. Chardin's Living Still Lifes

The *Toilet of Venus* by François Boucher (1703–1770) is a paragon of mid-eighteenth-century French painting [fig. 88]. Signed and dated (1751), it depicts the beautiful, nearly nude goddess of love surrounded by attendant putti (winged infants) who help arrange her hair and select jewelry from a silver tray in the shape of a shell, the attribute of Venus. Open and dynamic shapes are composed by the long, echoing diagonals of the bodies of the goddess and her attendants, and by the drapery. Boucher's skillful, fluid brushwork—which forms the soft, luminous flesh, the physical and emotional core of the painting—creates Venus's youthful sensuality. The sumptuous, erotic nature of the goddess is further developed by the setting in which she is placed. Everywhere are luxurious things of great price: the elaborately carved, gilded settee on which she sits; the billowing, shimmering green silk drapery framing her body; the golden brocaded material on which her feet rest; the wine-colored velvet pillows against which she reclines; and the gold vase and smoking incense burner in the painting's foreground.

The strongly erotic and sensual nature of the *Toilet of Venus*, so characteristic of Boucher and his French contemporaries, is especially apt here. This painting was commissioned by Madame de Pompadour, the mistress of King Louis XV, for the home she had built for them both. In subject and technique, the *Toilet of Venus* is a dazzling reflection of aristocratic French society before the Revolution.

There was, however, one contemporary of Boucher who, while also fascinated by the material nature of the world, confined himself to subjects that revealed humbler truths. This was Jean-Baptiste-Siméon Chardin (1699–1779). Born in Paris, the son of a maker of billiard

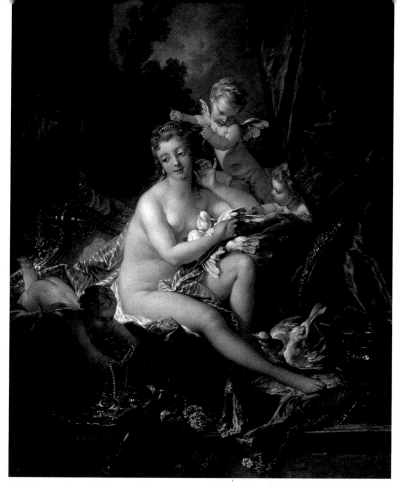

[88] Boucher, *Toilet of Venus*, 1751, The Metropolitan Museum of Art, New York

tables, Chardin was given his first official recognition in 1728 when he was accepted into the Academy of Saint Luke, the painters guild named after the Evangelist who was believed to have painted a portrait of the Virgin.

During his long and productive career, Chardin concentrated mainly on paintings of domestic life and on still lifes composed of food and game. He did not, therefore, paint the subjects—biblical stories, historical scenes, mythological themes—that, in the strict hierarchy of eighteenth-century art criticism, were considered the most worthy and morally uplifting. Instead his much more unassuming works relegated him to the lower ranks of painters, far below the much more grandiose

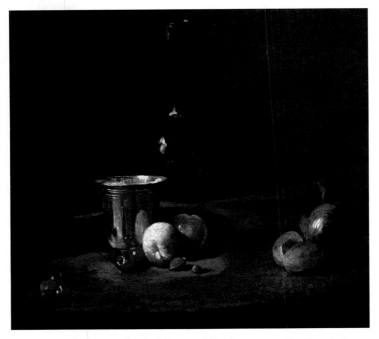

[89] Chardin, *Carafe, Goblet, and Fruit*, c. 1730, St. Louis Art Museum, St. Louis

Boucher and many of his other contemporaries. Chardin was in fact accepted into the Academy. but only as a painter of pictures of animals and fruit.

But the unpretentious subjects of Chardin's paintings only thinly belie their power. One of his early still lifes, *Carafe, Goblet, and Fruit*, painted around 1730, is comprised of only a few rather simple elements: a glass carafe, a small silver goblet, five cherries, three peaches, two peach pits, and a green apple [fig. 89]. At first it appears as though these objects were placed casually upon the stone ledge, but further observation reveals that this is far from the case. Instead they have been grouped by Chardin with extraordinary care, employing the same sort of meticulous, distilled thought involved in writing a poem or sonata. The deposition and spacing of the objects across the picture's surface, their massing into four separate groups, and the subtle network of proportional and color relationships of each group are accomplished with the masterly skill and sensitivity of the sort employed by Leonardo in

the *Last Supper* [fig. 39]. A hierarchy of size leads the eye up from the lateral cherries and apple to the goblet and attendant peaches, then backward to the carafe, which by its dignified shape and height is the painting's central focus.

The shape, texture, and color of each object is lovingly depicted. One senses the moist softness of the cherries, the apple's firm skin, the downy feel of the peaches, the metallic hardness of the goblet, and the weight of the glass carafe. The way each object either holds or reflects light is brilliantly analyzed and painted: the green apple's shine, the dullness of the peaches, and, most wondrous of all, the silver goblet whose sloping sides both mirror and distort the surrounding fruit while glowing softly in the ambient light. All the objects are set upon a stone ledge and against a stone wall. The stone surfaces are remarkable because they make the onlooker feel their roughness and density, a sensation so different from the soft, yielding sense of the fruit.

All of Chardin's still lifes exude an almost sacramental, transcen-

[90] Chardin, *The House of Cards*, c. 1740, National Gallery, London

dental quality. The various humble objects become monumental, ennobled; each is graced with a dignity that makes the onlooker view them in a new, more meditative light. In Chardin's hands, the modest still life becomes a profound microcosmic exploration of and meditation on the structure and essence of the world. Such paintings became a source of inspiration to many artists, but it was Paul Cézanne (1839–1906) who most fully understood Chardin's study and consecration of the everyday world. Cézanne, in turn, developed a probing analysis of the underlying structure of nature which was profoundly to influence much of twentieth-century art.

In addition to still lifes, much of Chardin's time was devoted to painting scenes of everyday life. As in his still lifes, he dwelt on the domestic and the ordinary, but again he made the commonplace extraordinary. One of the most endearing of these compositions, of which he painted several versions, is *The House of Cards*. Here a young, well-dressed boy leans on a table while building a house of cards (the backs of eighteenth-century cards were left plain [fig. 90]). The painting is a symphony of carefully harmonized warm browns, olive browns, blue-greens, greens, and glowing flesh tones punctuated by notes of white around the boy's collar and in the cards. A steady, pure light illuminates and sanctifies all it touches. There is an absolute stillness here (Chardin was a master of painted silence); the youth and the things around him seem as eternal and true as the goblets and fruit of Chardin's still lifes. They are also as meticulously organized. The relation between the diagonal shape of the boy's body and the horizontals of his hands and the table creates the same sort of formal affinities seen in the *Carafe, Goblet, and Fruit*. All the objects—the polished walnut gaming table with its open drawer and green felt top, the boy's long, curly hair, and the stiff cards—are skillfully and lovingly depicted.

The House of Cards is ultimately a moralizing subject. The viewer is to understand that human life is sometimes as insubstantial as the boy's fragile structure and as open to chance as games played with cards. Yet the strongest impression that one carries away from this painting is not of the vagaries of fate but rather of the transcendental order of Chardin's finely structured, luminous world.

23. Images of Sacrifice

David's Death of Marat

Jacques-Louis David's *Death of Marat* is both a sovereign work of art and a personal political statement [fig. 91]. David (1748–1825), who painted it in 1793 during the bloody Reign of Terror following the French Revolution, was an artist who held passionate, often changing, political and moral beliefs. These beliefs were reflected in many of his works.

A mediocre student in school, David began to study painting at the age of sixteen. He had wanted to be apprenticed to François Boucher, his grandmother's cousin, but Boucher was then too old to accept pupils. Instead, in 1764, David entered the shop of Joseph-Marie Vien, an artist who was already moving away from the elaborate, luxurious style of Boucher (the author of *The Toilet of Venus* [fig. 88]) toward a simpler, more austere idiom. David learned much from Vien and soon developed his own style based on many of his master's reformist ideas.

In 1774, after four repeated and embitteringly unsuccessful attempts to win the prestigious first prize in the competition held by the Royal Academy of Painting and Sculpture, David finally triumphed. Awarded on the basis of a submitted painting, the prize included a three-year stay at the French Academy in Rome. In 1776 he left for Italy, where his intense study of the sculpture and architecture of ancient Rome radically influenced his work and furthered his already nascent interest in classical art. For David, the majestic, often severe art of Rome, especially that of the Republic (established around 500 B.C. and ended some five hundred years later when the Emperor Augustus [fig. 10] came to power), stood as an example of formal and moral rec-

[91] David, *Death of Marat*, 1793, Musées Royaux des Beaux-Arts de Belgique, Brussels

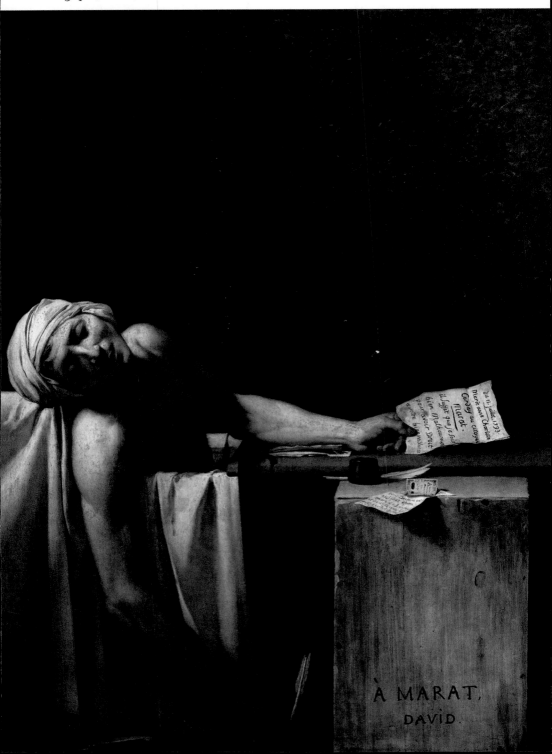

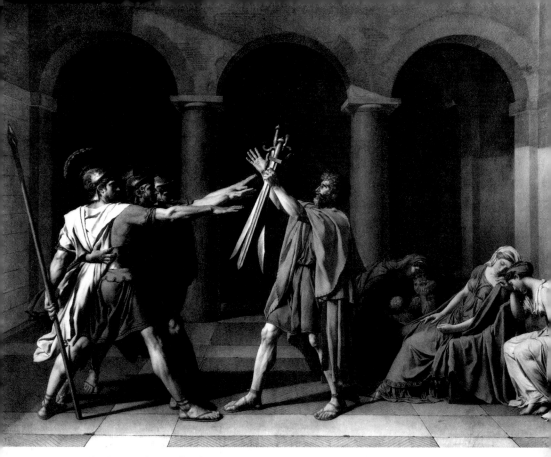

[92] David, *Oath of the Horatii*, 1784, Musée du Louvre, Paris

titude, values he found sorely lacking in the painting and society of
France on the eve of the Revolution. In practice, however, David's
high moral convictions did not prevent him from willingly working for
wealthy aristocrats, many of whom were soon to be obliterated in the
coming conflagration by those republicans who shared David's revo-
lutionary beliefs.

During a second stay in Rome in 1784, David completed a paint-
ing which helped establish his reputation: the *Oath of the Horatii*,
which depicts an episode in the early history of Rome [fig. 92]. A dis-
pute between the cities of Rome and Alba was to be settled through
armed combat by three brothers from each city. The Horatii and the
Curiatii families were chosen to fight for their respective cities. At the
end of the battle only one man was left alive: Horatius of the Horatii.
After discovering that one of his sisters was betrothed to a Curiatii, Hor-

atius killed her as well. What attracted David to this story, apart from its early Roman setting, were its themes of heroism and altruistic sacrifice, even of one's family, for the communal good.

The *Oath of the Horatii* is an example of how form and content are inextricably linked in great works of art. David has placed this harsh story in an austere setting where the figures inhabit a world of great severity. They are located in a stone court set before three arches carried on Doric columns. The almost brutal dourness of this unadorned place serves as a perfect visual metaphor for what is occurring within its rugged boundaries. One need only contrast this setting with the softness of those by Boucher and his contemporaries to see how far David's rebellious, reforming spirit had taken him.

Moreover the construction and deposition of the figures, here heavily influenced by the paintings of Raphael and Poussin, two earlier artists admired by David, further amplify the story's moral. Each of

[93] David, *Brutus*, 1789, Musée du Louvre, Paris

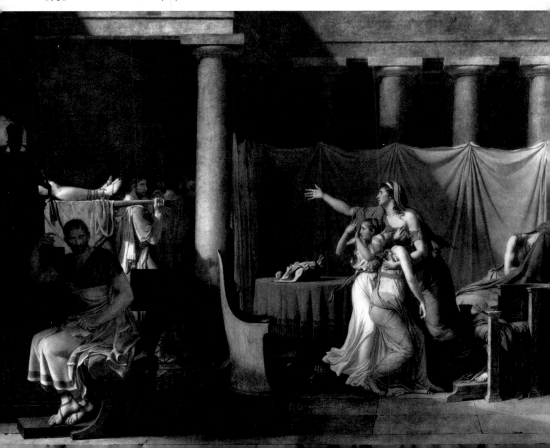

the arches roughly frames an important figurative element of the action. Before the middle arch is the father, whose blood-red cloak marks the center of both the composition and the drama. His three sons stand in front of the leftmost arch, rigidly reaching for the swords held by him as they swear an oath to Rome.

Interestingly enough, this ritual does not occur in the story but is a brilliant invention by David which transforms the scene into a solemn, sacramental act. The men's tense, extended arms and legs are very different from the curves of the pliant bodies of the women framed by the rightmost arch. Here David's formal language underscores the difference he finds between the resolute, heroic men and the women weeping in anticipation of the forthcoming battle. The rigor of the composition's geometry is very far indeed from the soft, luxurious world of Boucher [fig. 88].

The theme of heroic sacrifice around which the *Oath of the Horatii* revolves appears again in David's *Brutus*, painted in 1789, the year in which the Bastille fell [fig. 93]. In this work one sees an episode from the story of Lucius Brutus, first consul of Rome, who condemned his own sons to death for having plotted against the Roman Republic. Like the *Oath of the Horatii*, this painting is organized with exceptional precision. The Doric column divides the picture in half. To the left, shrouded in shadow, Brutus sits meditating on his terrible deed; in the darkness just behind him looms a statue of Roma, for whom he has made this sacrifice. Just behind the statue, the bodies of the sons are being brought into the right side of the room where the women await them. This space is filled with light and occupied by the same sort of supple, swooning female figures seen in the *Oath of the Horatii*. In this area David has carefully, almost archaeologically, recreated the furnishings of a Roman room.

By 1793, four years after completing the *Brutus*, David had become passionately and deeply enmeshed in the events and new politics of the Revolution. Consequently, when Jean-Paul Marat, one of the new heroes of the Revolution, was stabbed to death on July 13, 1793, it was David who was asked to paint a record of the event. David admired Marat, a planner of the awful events of the Terror which had sent many to the guillotine, and he had even visited him the day before he was

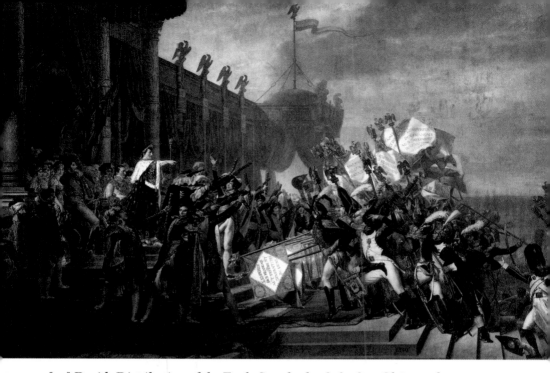

[94] David, *Distribution of the Eagle Standards*, 1808–1810, Château de Versailles, Paris

killed. Marat was plagued by a painful skin disease from which he sought relief by soaking in a bathtub. It was there that he was assassinated by the aristocrat Charlotte Corday, who had gained admittance by pretending to be a deserving petitioner and informer.

David made the death of Marat into a sacrifice equaling those of the Horatii and Brutus. But now, because of the overthrow of the monarchy, there was no longer any need to cloak dangerous republican ideals in the guise of ancient Rome; instead the spectator is here confronted by a contemporary event of great significance. Using much that he had learned from his previous paintings of heroes, David has turned the brutal death of a zealot into holy martyrdom for the Revolution. Marat's charity is graphically depicted by the bill of currency meant for a poor widow and her five children which lies on his rough-hewn writing box. This box, like the mended sheets, was a symbol of his austere simplicity—both the writing box and tub were displayed at Marat's funeral, organized by David himself. The perfidy of Charlotte Corday and the aristocrats is seen in her false petition held by Marat and her bloodstained knife on the ground.

But these attributes pale in comparison to the haunting image of the hero dead in the bloody water of his tub. His body is set close to the spectator and is both isolated and compressed by its confinement to the lower half of the picture. David has made Marat's body consciously evoke the *Pietà*, the image of the dead Christ. Similar images by Raphael, Michelangelo [fig. 44], and other artists have been recalled by David and employed here to sanctify his hero.

David has also remembered Caravaggio. The dramatic lighting that illuminates Marat's body, and the shadow on the right half of the vigorously brushed-in background, owe much to that earlier artist as well [fig. 65]. But the beautiful, measured juxtaposition of the soft, sprawling diagonals of Marat's arms and head, and the rigid horizontals and verticals of the wooden box and the tub create a compositional interrelation of surpassingly subtle beauty that is all David's own.

Five years after the *Death of Marat*, David found a new charismatic hero, Napoleon Bonaparte, whom he idolized and glorified with as much intensity as Marat in the grandiose *Distribution of the Eagle Standards* [fig. 94]. In 1816, one year after the final defeat and abdication of Napoleon, David and the other regicides who had voted to execute the king were banished from France. He spent the rest of his busy life in Brussels. When he died there in 1825, the *Death of Marat* was still in his studio.

24. The Horrors of War

Goya's The Third of May 1808

To modern eyes accustomed to seeing the searing images of battle in photographs and film and on television, war and those who wage it often seem less than glamorous. Ever since the shocking photographs of the carnage of the American Civil War, the first to be widely photographed, war's grim reality has been inescapable. Yet until the early

[95] Goya, *The Third of May 1808*, 1814, Museo del Prado, Madrid

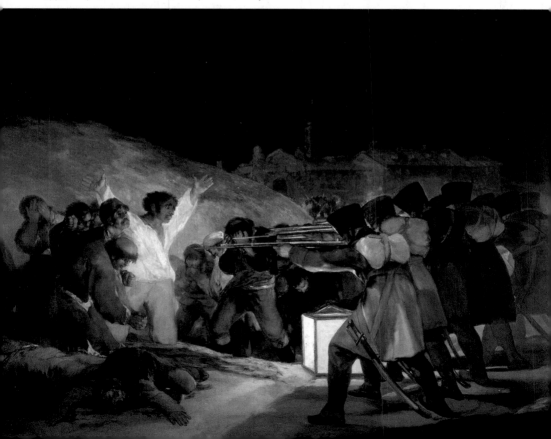

years of the nineteenth century, war and those who fought it were seen in quite a different light, especially in the visual arts.

From the Renaissance to the early nineteenth century, war was often idealized and idolized. These attitudes are embodied in Jacques-Louis David's enormous canvas of the *Distribution of the Eagle Standards* [fig. 94]. Painted between 1808 and 1810, it shows Napoleon, newly crowned emperor, distributing standards (Roman-inspired insignias of the various units) to his army. This was the depiction of an actual event of 1804: Napoleon stood before a sort of stage set erected on the front of the École Militaire (the French Military School) as the commanders of his troops swore fidelity to him. David's picture, which in both the gesture and the meaning of the oath-taking is reminiscent of his *Oath of the Horatii* [fig. 92], is pompous and pretentious. Its histrionic drama, created by the upward movement of the near-pyramidal grouping of the figures with the godlike emperor at its apex, and by the rigidly outstretched arms swearing allegiance, seems utterly false today.

In 1808, the year in which David began work on the *Distribution of the Eagle Standards*, an event occurred which was to become the subject of a painting offering a radically different interpretation of the soldier. This event, the May 3 uprising of the citizens of Madrid against the French forces occupying the city, is portrayed in Francisco Goya's *The Third of May 1808* [fig. 95].

Goya (1746–1828), born near Saragossa in Spain, was the son of a gilder. Like so many other artists, Goya first made his reputation with beautiful and often insightful portraits. In 1773 he left his native Saragossa for Madrid. By 1786 he had become painter to the king, and thirteen years later he was made First Court Painter. His series of striking portraits of the royal family and their court is especially notable for originality of color and brushwork, and for a frequently unvarnished, sometimes unflattering depiction of character. He was a worthy heir to his artistic ancestor Velázquez.

In 1808 Goya was living in Madrid where, on May 2, he may have witnessed an uprising of Spanish patriots against the French troops stationed there. The French were in Madrid to buttress King Joseph Bonaparte, recently installed on the Spanish throne by his brother

Napoleon. This revolt was rapidly and brutally suppressed; by that same afternoon, four hundred Spaniards were dead. A military tribunal was established to deal with citizens—many completely innocent—who had been caught in the French dragnet. About forty-five of these were judged guilty and the next day (May 3) were taken to a hill just outside of the city and shot by a French firing squad. The uprising and executions of May 2 and 3 soon came to have symbolic importance because they were seen as the opening episode of the long war of Spanish Independence against the French (the Peninsular War).

In 1814, six years after the event, Goya asked the government to commission two commemorative paintings from him: *The Second of May 1808*, a depiction of the heroic uprising, and *The Third of May 1808*, a portrayal of the executions. He must have had conflicting feelings about these events, for though he was closely connected with the Spanish court, he also seems to have admired and been influenced by

[96] Goya, *The Second of May 1808*, 1814, Museo del Prado, Madrid

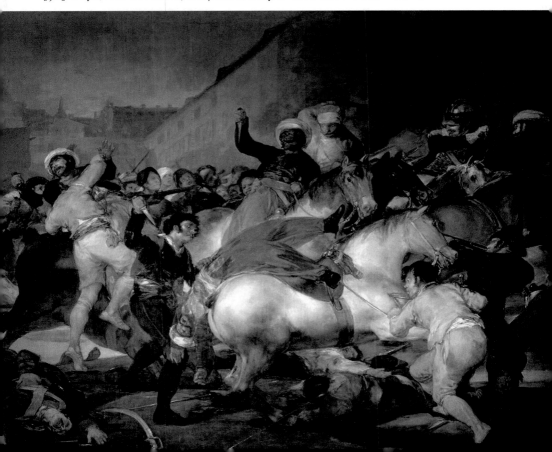

many of the egalitarian ideals of the French Revolution. Whatever he
may have thought, his two paintings dwell exclusively on the heroic
struggle and appalling fate of the Spanish patriots.

The Second of May 1808 is an exciting, marvelously designed, but
rather conventional painting [fig. 96]. It depicts the clash between the
Spaniards and the French soldiers (several of whom are Mamelukes,
Egyptians in the service of the French army) in the standard heroic
mode. This type of painting was first established by Leonardo da Vinci
in a famous, but now lost, fresco for the town hall of Florence. The
theme was developed further by seventeenth-century artists, most espe-
cially by the Flemish master of action painting, Peter Paul Rubens
(1577–1640). A number of Rubens's canvases in the Spanish Royal Col-
lections seem to have influenced Goya's conception of *The Second of
May 1808*.

[97] Goya, *Disasters of War*, 1808–1814

Estragos de la guerra

The Third of May 1808 is, however, very different. In many important respects the work is highly unconventional. Goya had been meditating on the horrible, unheroic aspects of war before he started this painting, and he had already begun to depict them in a series of eighty-two etchings entitled *The Disasters of War* (1810–1814) [fig. 97]. These are justly famous for their stark and terrifying portrayals of the pillage, carnage, and rape of Spanish civilians by the French troops. Military actions play almost no part in this series, so they are not about war in the conventional sense. Instead the spectator is presented with an unflinching view of war's grisly consequences for often helpless and innocent citizens. Never before had such graphic, brutal aspects of war been depicted. These prints are a far cry indeed from the glorious idealizations of war and military power seen in David's *Distribution of the Eagle Standards*. Goya's etchings are arguably the first great anti-war images. As such, they merit special importance in the history of Western art and thought.

Goya further developed this new vision in *The Third of May 1808*. Influenced by works by Caravaggio [fig. 66], which he saw in Rome as a young man, Goya made light and darkness the most expressive formal elements of his painting. The square lamp that lights the center brilliantly illuminates the white shirt of the patriot, whose outstretched arms recall those of the crucified Christ. The light—greater than that which could possibly be provided by the lantern, and therefore seemingly supernatural (light is often used to symbolize truth)—also reveals the bloody corpses of those already executed, those just about to be shot, and those waiting to be herded before the firing squad. Goya has reserved the painting's brightest and warmest colors for the victims: stark whites, vibrant yellows, browns, greens, and blood red. Beyond the martyrs, the light and color fade, as darkness engulfs the grey and black soldiers and the buildings and spires of Madrid looming in the background; light sanctifies and reveals purity, darkness cloaks evil.

The contrast between good and evil is also apparent in the two groups. The patriots register horror, defiance, and helplessness; their group is disorderly, contorted, and vulnerable. Opposing them are the faceless soldiers whose rigid bodies and glinting rifles form a mechanistic, heartless killing machine. Some of the most basic building

blocks of style—light, shape, space, and color—are used to make a universal statement about life and death.

Although *The Third of May 1808* depicts a real event, one which Goya may actually have witnessed, the scene is represented in a deliberately unspecific manner. The city is not painted with topographical accuracy, the surrounding hills are featureless, and the faces of the victims are generalized, not portraits in the conventional sense. The soldiers' uniforms, while clearly French, are painted in an almost summary fashion. Throughout the picture, images are blocked in by Goya's bold and confident brush strokes (he seems to have used a split cane to apply some of the paint). The large, synthetic forms are suggestive rather than definitive; much is left to the spectator's imagination. Although *The Third of May 1808* depicts a specific event in time and space, Goya has transformed it into something greater and more profound: a timeless image of brutality, heroism, and sacrifice. Unlike David's *Distribution of the Eagle Standards*, it glorifies not the power of a dictator but the struggle for freedom by powerless people everywhere.

25. Space and Color as Emotion

Van Gogh's Night Café

In the second half of the nineteenth century, the café became a popular subject for painters. It was not a new theme in European art. Interiors of taverns and inns had already been depicted in the seventeenth century, usually as moralizing illustrations of carousing low life. But nineteenth-century artists, especially those living in Paris, were more interested in ordinary citizens who, like themselves, frequented the cafés to gossip, drink, and to see and be seen. The growing fascination of these artists with almost all aspects of everyday life, especially what might now be called leisure (something made possible by the Industrial Revolution), accounts partially for this new interest in the café; but Parisian night life itself was an important part of society now deemed worthy of depiction.

During the last decades of the nineteenth century, the café formed the subject of several masterpieces, each with a very different vision. Edgar Degas's (1834–1917) *Glass of Absinthe*, painted in 1876, depicts a man and a woman sitting before a marble-topped table on which rests a glass of absinthe [fig. 98]. Absinthe is a powerful spirit composed of, among other ingredients, alcohol and wormwood, an addictive plant which can cause deliriums and hallucinations. (Because of its deleterious effects, absinthe was banned in France in 1915.) It is the drink, and its effects, that form the hub around which Degas's painting revolves. The effects of the absinthe are evident in the face of the dazed young woman with glazed eyes sitting limply before the glass. The hal-

lucinatory nature of the drink is given its visual metaphor by the sharply angled perspective of the room and the disturbing diagonals of the tabletops which seem to float in space. Moreover, by restricting his palette to a limited range of subdued browns, greys, and whites, Degas has made the very atmosphere of the dreary café reflective of the depressed, stupefied state of the absinthe drinker.

When Degas's contemporary Édouard Manet (1832–1883) began his famous café painting *A Bar at the Folies-Bergère* in 1881, he too was fascinated by the people inhabiting such places [fig. 99]. The center of his composition is occupied by the barmaid leaning against the marble counter on which are arrayed brilliantly colored bottles of champagne, beer, and liquor. What at first seems like a deep space behind her is in fact a large mirror which distortedly reflects her back, the crowded café which she faces, and the man wearing the top hat upon whom she is waiting. The Folies-Bergère, unlike Degas's squalid little café, is a glamorous, bustling place, but one sees reflected in the barmaid's face the boredom and weariness often induced by such places of artificial gaiety. And because she is working, she cannot join the revelers but can only serve them and look on as they entertain themselves.

Feelings of a rather different, more passionate sort are the subject of the *Night Café* by Vincent van Gogh (1853–1890) [fig. 100]. Born in a small Dutch town, in 1869 van Gogh began work in an art gallery from which he was forced to resign some years later. He then taught in England, tried unsuccessfully to take holy orders, became an ardent preacher to poor miners in Holland, and finally, in 1880, began study- ing art. In 1888, after a two-year stay in Paris, he left for Arles in the south of France. There he would help establish an artists' colony, to be directed by his painter friend Paul Gauguin (1848–1903). Nothing ever came of the colony, but during three successive September nights in 1888 in Arles, van Gogh painted the café over which he lodged. He describes the circumstances of the painting in a letter:

> Then to the great joy of the landlord, of the postman whom I had already
> painted, of the visiting night prowlers and of myself, for three nights run-

[98] Degas, *Glass of Absinthe*, 1876, Musée d'Orsay, Paris

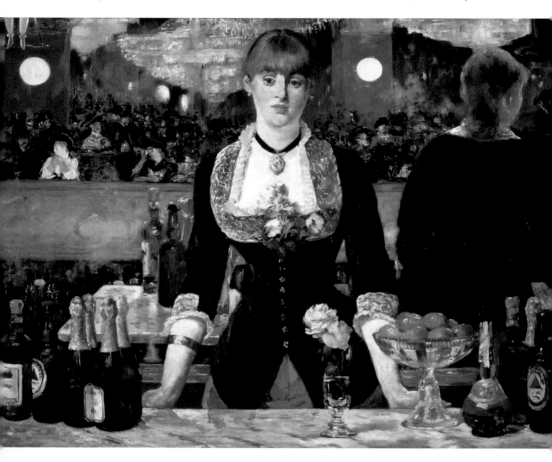

[99] Manet, *A Bar at the Folies-Bergère*, 1881, Courtauld Institute
Galleries, London

ning I sat up to paint and went to bed during the day. I often think that
the night is more alive and more richly colored than the day.

A prolific and intelligent letter-writer, Vincent often discussed his
work in progress. The record he has left of the *Night Café* is both fas-
cinating and singularly informative:

In my picture of the *Night Café* I have tried to express the idea that the café
is a place where one can ruin oneself, go mad [in December 1888 Vincent
had his first breakdown] or commit a crime. So I have tried to express, as
it were, the powers of darkness in a low public house, by soft Louis XV

green and malachite, contrasting with yellow-green and harsh blue-green, and all this in an atmosphere like a devil's furnace, of pale sulphur.

I have tried to express the terrible passions of humanity by means of red and green. The room is blood red and dark yellow with a green billiard table in the middle; there are four citron-yellow lamps with a glow of orange and green. Everywhere there is a clash and contrast of the most disparate reds and greens in the figures of little sleeping hooligans in the empty, dreary room in violet and blue. The blood-red and the yellow-green of the billiard table, for instance, contrast with the soft tender Louis

[100] **Van Gogh,** *Night Café*, **1888, Yale University Art Gallery, New Haven**

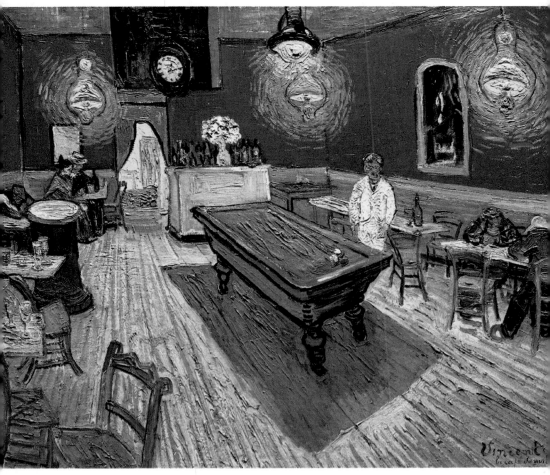

XV green of the counter, on which there is a pink nosegay. The white coat of the landlord, awake in a corner of that furnace, turns citron-yellow or pale luminous green....

The *Night Café*, unlike the nearly contemporary café paintings by Degas and Manet, does not revolve around the visible emotions of the café's occupants, who are now small and nearly faceless. Instead its expression is made through color. It is clear from van Gogh's words that he wished to use color—"harsh blue-green, blood-red, the clash and contrast of the most disparate reds and greens"—above all else to express "the dangerous passions of humanity" incited by the café. In some ways the *Night Café*, like Chardin's *House of Cards*, is a moralizing picture. The intense, burning reds, yellows, and greens do, as van Gogh says, combine to form a disturbing and alarming interior.

Space is also used to further express feeling. The room, like Degas's café, rapidly recedes at a sharp angle away from the viewer. Its furnishings, especially the billiard table, seem uncomfortably situated in its space. The whole interior is disorienting.

Further disquiet is created by the way the painting's forms and colors have been brushed in. Van Gogh has laid in the paint with a thick impasto in a series of short, quick, highly visible strokes which reveal how he attacked the canvas during those three nights in September [fig. 101]. These strokes also fracture the painting's surface and add a further tactile, even frenzied note of agitation.

Often the *Night Café* is cited as an indication of van Gogh's worsening mental condition. While it is true that he had his first major breakdown just three months after he finished painting it, one must be careful not to assume that its imagery is therefore an illustration of madness. Since van Gogh's death he has become a symbol of the unsung genius, a major talent completely unrecognized by his contemporaries, forced to live on his brother's charity, spurned by women, a failure in everything he attempted except his painting, ultimately descending into madness but still driven by the catharsis of art. It is not surprising that through this romantic lens his painting is often seen as a direct reflection of his disturbed mental state. This is an overly simplistic and degrading view, for in both his letters and his painting van Gogh is clearly not a deranged artist but rather one who, most notably in the *Night Café*, is brilliantly and logically searching for the visual equivalents of feelings. Here he finds these not in the traditional vehicle—the depiction of men and women—but in the juxtapositions of abstract color and space. Fifty years after his death in obscurity, the expression of emotion through color and space alone has become a major characteristic of art, partially due to van Gogh's passionate and prophetic paintings.

26. The Devolution of Heroism

Rodin and the Burghers of Calais

Public monuments are found in almost all cultures and epochs. From the Egyptian pyramids [fig. 4] to our own times, monuments of every size, shape, and material have been erected to make important religious and civic statements. More than the words of kings, politicians, and statesmen, these monuments reveal the real beliefs of the society that made them.

By the nineteenth century the public monument had achieved widespread popularity. The civic spaces and parks of even the smallest cities in Europe and the United States were dotted with memorializing statues erected to honor heroes and momentous events. To present-day eyes these monuments often seem pretentious affairs, depicting their subjects in overblown, sometimes strident ways. A remarkable example is François Rude's (1784–1855) *Departure of the Volunteers of 1792 (La Marseillaise)* of 1833–1836 on the Arc de Triomphe de l'Étoile in Paris [fig. 102]. This huge triumphal arch, built in imitation of Roman examples, was erected during Napoleon's reign to celebrate the triumphs of the French Revolution and the victories of the French army.

In Rude's colossal sculpture, the bodies of brawny men dressed in Roman armor (the sort of figural and classical allusion seen in the contemporary paintings of Jacques-Louis David [fig. 92], with whom Rude left Paris for exile in Brussels) are urged onward by a huge, muscular, winged Victory brandishing a sword. This figure, much influenced by

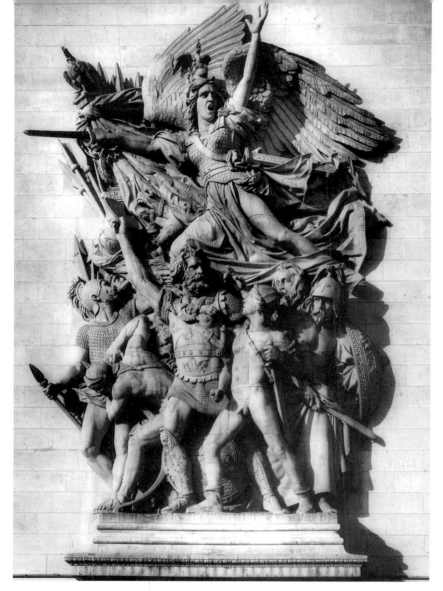

[102] Rude, *Departure of the Volunteers of 1792 (La Marseillaise)*,
1833–1836, Arc de Triomphe. Paris

Greek sculpture, wears the Phrygian cap, a symbol of both Paris and
the Revolution. The whole ensemble is a surging, struggling mass of
striding legs, gesticulating hands, and stern, courageous faces. As a
monument, it was meant to inspire its onlookers with the same sort of
patriotic fervor and French nationalism demonstrated so ardently by
these eager Volunteers.

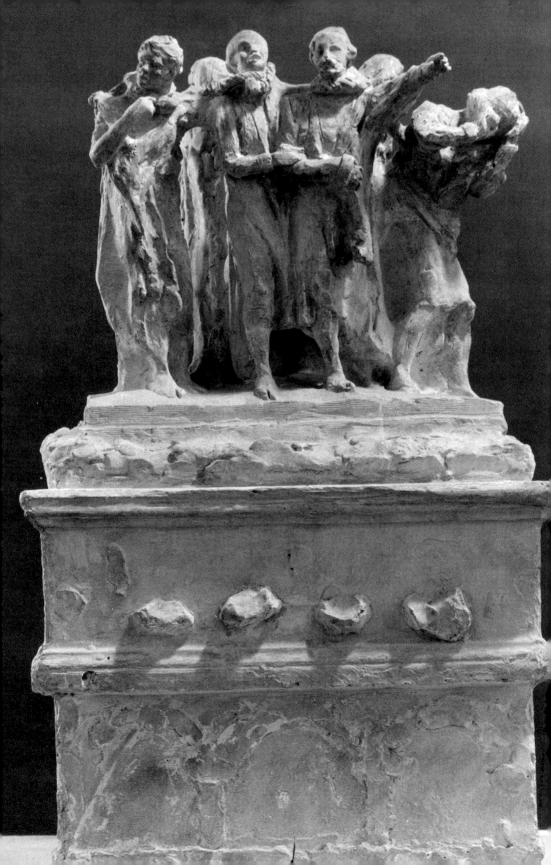

Some three decades after the completion of Rude's sculpture, France was decisively defeated by the Germans in the Franco-Prussian War. Not only did the enemy besiege and then occupy Paris, but in the peace treaty of 1871 France was forced to cede territory and pay the Germans a large indemnity. This humiliating defeat became a rallying point for French nationalism and for revenge. After the war, monuments to French heroism began to be erected in increasing numbers. These were frequently meant to remind the French of their glorious and valiant past and to inculcate in them a renewed sense of pride in their heritage and culture.

In 1884 the French city of Calais voted to raise funds, through a national subscription, to erect a monument to commemorate and honor six citizens who in 1347 had offered to sacrifice their lives for the city. This episode, as recounted in the medieval *Chronicles* of Jean Froissart, took place during the year-long siege of Calais by the English king, Edward III. Edward agreed to lift the siege if six of the most prominent and wealthy citizens would surrender to him; otherwise the king would starve the city to death. The citizens were to appear "with their heads and their feet bare, halters around their necks and the keys of the town and castle in their hands." With these men, the king said, "I shall do as I please, and the rest I will spare." Six men, led by one Eustache de Saint-Pierre, volunteered to surrender for the good of the city. Although the captives were eventually spared by Edward thanks to the intervention of his wife, Queen Philippa, their courageous and altruistic self-sacrifice was just the sort of stirring patriotic example that France so desperately sought in the aftermath of the Franco-Prussian War.

Several sculptors competed for the proposed monument of Calais, but in 1885 the commission was given to François-Auguste-René Rodin (1840–1917), a promising young sculptor. Rodin had influential friends in the city, but it was his overall idea for the monument that swayed the mayor, who told him: "You have rendered the idea in an original and completely heroic manner.' But the choice of Rodin was not without risk. He was relatively unknown, and he lacked official academic train-

[103] *Burghers of Calais*, First Maquette, 1884, Musée Rodin, Paris

ing; he had in fact been rejected by the École des Beaux-Arts (the School of Fine Arts) three times. Although he eventually studied with several famous artists, his rejection left him embittered against the French art establishment and the sort of sculpture it produced. In 1875 he had visited Italy, and the two months he studied there were crucial for the formation of his style. He later claimed: "I owe my liberation from academics to Michelangelo."

After he was chosen, Rodin prepared a terra-cotta maquette (model) for the approval of the commission in charge of the monument [fig. 103]. This depicted the burghers (citizens) raised high upon a pedestal, about which Rodin wrote: "The pedestal is triumphal and has the rudiments of a triumphal arch in order to carry, not a quadriga [a chariot of victory which often surmounted triumphal arches], but human patriotism, abnegation, and virtue." The six figures who stand on a low base atop the pedestal are centered on and led by Eustache de Saint-Pierre, whose staunch pose and defiant raised arm create a strong contrast with his trembling companions.

[104] *Burghers of Calais*, Second Maquette, 1885, Musée Rodin, Paris

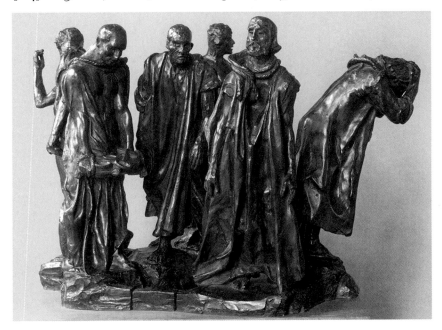

After this maquette had been accepted by the Municipal Council, Rodin began to rethink and radically modify his ideas for the monument. He soon rejected the idea of a tall base which would raise the figures well above street level, thereby abandoning the references to the triumphal arch which had been so important in the first maquette. These changes, obviously made to make the monument less imposing and grandiose, were accompanied by similar modifications in the figures, reflecting Rodin's anti-academic bent. The compact group led by Eustache de Saint-Pierre was divided. Each burgher now became an isolated physical and emotional entity. In fact, in his second maquette Rodin formed each of the figures separately and assembled them only when they were displayed in the Town Hall in Calais in 1885 [fig. 104].

This bronze maquette excited much disapproval because it did not depict the figures in the closely packed, dramatic, and unified arrangement of most contemporary monuments, including, to a certain extent, Rodin's first model. Rather, it was composed of an assemblage of diverse individuals, all of the same height, set only upon a low base. The second maquette was, in short, highly realistic and unheroic in the conventional sense; it was not the charged, unified group of the first maquette but a more disparate, probing study of individual character and behavior.

Despite the objections to his new, less conventionally heroic ideas, Rodin, with the help of several influential supporters in Calais, was able to begin work on the monument. As he worked he made many significant modifications to the figures, but he did not alter the essential nature of the second maquette. The figures were finished by 1888, but it was not until June 3, 1895, that the monument, with the burghers now cast in bronze (the whole weighing five thousand pounds), was dedicated with great festivity in the presence of some thirty thousand citizens of Calais [fig. 105]. But to Rodin's disappointment, the monument was placed on a high pedestal in the city's public gardens. Later he said:

> I did not want a pedestal for these figures. I wanted them to be placed on, even affixed to, the paving stones in front of the Hôtel de Ville [Town Hall] in Calais so that it looked as if they were leaving in order to go to the enemy camp. In this way they would have been, as it were, mixed with

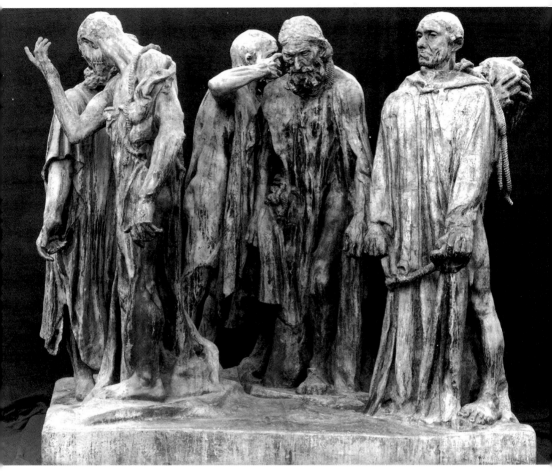

[105] *Burghers of Calais*, 1888, Musée Rodin, Paris

the daily life of the town: passersby would have elbowed them, and they would have felt through this contact the emotion of the living past in their midst....

It is clear from this statement that Rodin's ideas about the *Burghers of Calais*, and the very nature of the commemorative monument, were revolutionary. Instead of the false bombast and histrionics of so many contemporary monuments, he depicts men unsure of the depth of their own will and courage. They are, he said, "still questioning themselves to know if they have the strength to accomplish the supreme sacrifice—their soul pushes onward, but their feet refuse to walk." The figures of the final version of the *Burghers of Calais*, unlike those on contemporary monuments which are detailed and literal, are conceived in bold, highly expressive masses of bronze. Thin and sinewy from starvation, they wear generalized costumes which bear but slight reference to the historical past. Their bodies radiating poignant gestures of fear, doubt, and sorrow must have seemed shockingly realistic to eyes accustomed to the highly finished academic sculpture of the late nineteenth century

Rodin's conception of authentic heroism as a complex and subtle human action in which fear and self-doubt are overcome was prophetic, as was his stress on the senseless tragedy of war in general. Just nineteen years after the *Burghers of Calais* was installed, the ferocity and horror of World War I forever shattered the romantic, unexamined stereotypes of heroism that Rodin, like Goya before him, had already so brilliantly rethought in his remarkable monument at Calais.

27. The Birth of Modern Architecture

The Wainwright and Carson Pirie Scott Buildings

The revival of past styles is a common feature in Western art. The Romans, as we have seen in the *Augustus of Prima Porta* [fig. 10], imitated the Greeks whose civilization they admired. In the Renaissance, sculptors and architects emulated Roman statues and buildings because Roman civilization was much esteemed. Artists of the nineteenth century, especially architects, borrowed a wide variety of styles from the Egyptian, Gothic, and Renaissance eras. In each case of imitation, the imitator wished to endow his work of art with some of the conceptions (in reality, often popular misconceptions) of the culture from which he was borrowing. Thus the Romanesque and Gothic architectural styles, with their romantic association of the cloister with medieval learning, were considered highly appropriate for many of the colleges and universities built in the nineteenth century. In order to express their seriousness of purpose, banks, government buildings, and civic monuments were likewise decorated with the majestic columns and capitals borrowed from the sober, solid world of ancient Rome.

In architecture the borrowing and grafting of styles from the past reached its apex during the second half of the nineteenth century in the classicizing architectural style known as the Beaux-Arts, so-called because of its origin in the teachings of the influential and internationally renowned École des Beaux-Arts in Paris. Actually the term *style* is a misnomer, because the practitioners of this type of architecture, many of whom were American, utilized Classical, Gothic, and

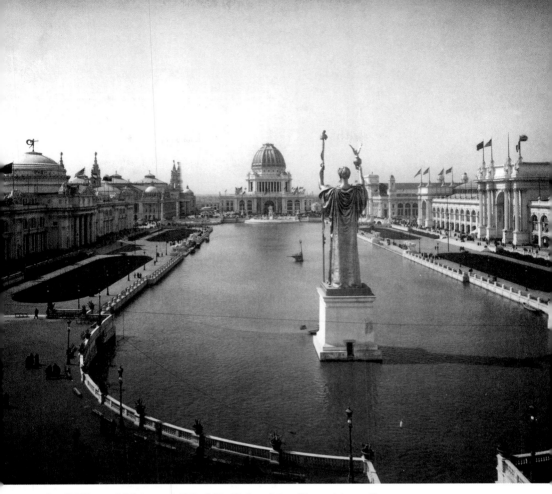

[106] View of Chicago's World's Columbian Exposition, 1893

Renaissance, among other styles, in a bewildering array of combinations, often in quite illogical and fantastic ways. One of the high points of the Beaux-Arts style was the Chicago World's Columbian Exposition of 1893, held to commemorate the four hundredth anniversary of Columbus's discovery of America. The planners of this exposition, a sort of world's fair, specified that its many buildings were to be Neoclassical in design. These huge colonnaded, historicizing buildings, constructed of impermanent material, were considered the acme of architectural sophistication and taste at the time. Their influence on subsequent American monumental architecture was vast [fig. 106]. Yet in 1890, three years before, the Chicago architect Louis Sullivan

(1856–1924), who designed the Exposition's Transportation Building, had begun a structure in St. Louis which was decidedly to alter many of the architectural ideas so loftily embodied in the buildings of the Chicago Exposition.

Sullivan's structure was the Wainwright Building, a ten-story edifice built to house offices and shops [fig. 107]. In 1890 this was a very tall building indeed, one of the first skyscrapers. After the Civil War the soaring cost of land in the heart of major American cities made it nec-

[107] Sullivan, Wainwright Building, 1890, St. Louis

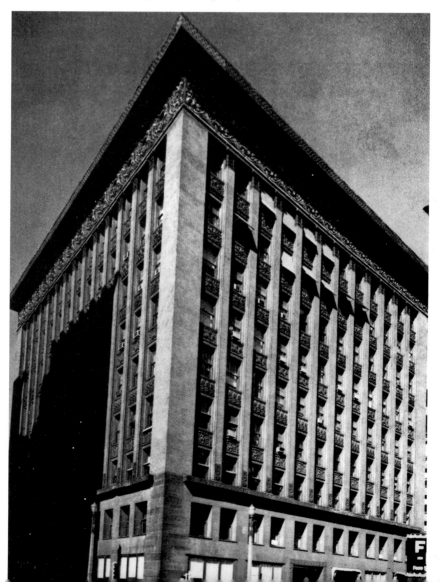

essary to build vertically instead of horizontally. Tall buildings were made possible by the newly invented elevator and by the use of steel as a building material. The limited tensile strength of masonry construction would not allow the erection of tall edifices, but structures of many stories could be built by using the new steel frame, a cage of interlocking horizontal and vertical members whose piers were sunk deep into the earth and surrounded by footings of reinforced concrete. With the steel frame, the walls were no longer load-bearing and could therefore be hung on the cage and opened to the outside with large windows [fig. 108].

Louis Sullivan was well prepared to utilize these new advances in the Wainwright Building. After a year of study in his native Boston, he began his career in 1872 as a draftsman in the firm of the well-known Philadelphia architect Frank Furness. During the depression of the next year, Sullivan was laid off. In 1874 he left for Paris with the intention of studying at the École des Beaux-Arts. He quickly learned French and passed the difficult entrance examination, but he soon found the school's proscribed study of styles and architectural orders unsatisfactory. After only six months in Paris, he left for Chicago, where he arrived in 1875. He later said that his study at the École had given him a good foundation in the logic of building, but, like Rodin, he was to rebel against the basic tenets of academic art.

In 1879 Sullivan began working for the brilliant Chicago architect Dankmar Adler, becoming a partner in Adler's office two years later. Before the firm of Adler & Sullivan dissolved in 1895, it had designed a number of novel and exceptional buildings, including the Chicago Auditorium and the Wainwright Building. For several years Sullivan had as his chief draftsman the young Frank Lloyd Wright, who was himself to become one of America's most notable architects.

Sullivan's Wainwright Building is divided into three major sections: a two-story sandstone base; a vertical shaft of seven floors; and a broad, ornamented terra-cotta frieze set under a protruding cornice. The plan of the inside of the building, which is U-shaped to allow the introduction of a naturally illuminated court in its center, is rationally and efficiently organized. Outside, the steel skeleton of the frame is clearly expressed by the piers and spandrels of the shaft. By contempo-

[108] View
of the
construction
of "The
Fair"
building by
William
LeBaron
Jenney,
1890–1891,
Chicago

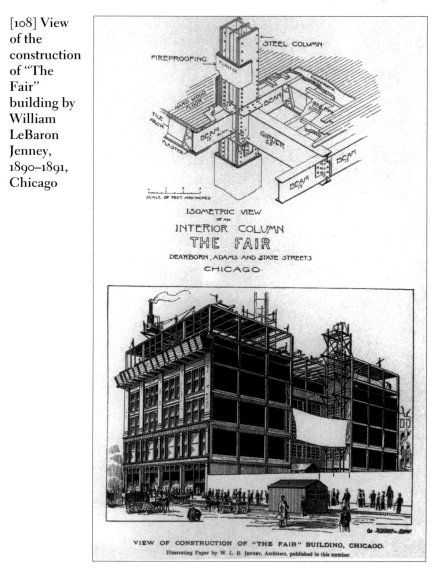

VIEW OF CONSTRUCTION OF "THE FAIR" BUILDING, CHICAGO.
Illustrating Paper by W. L. B. Jenney, Architect, published in this number.

rary standards the entire building, from its severe base to its cap of frieze and cornice, must have seemed strikingly stark and free from historical idiom and association. This was a new type of structure, built with new materials in a new style. In his autobiography, Sullivan wrote:

> He [Louis Sullivan] felt at once that the new form of engineering was revolutionary, demanding an equally revolutionary architectural mode. That

masonry construction, insofar as tall buildings were concerned, was a thing of the past to be forgotten, that the mind might be free to face and solve new problems in new functional forms.

Sullivan, in a now famous adage, said that "form follows function," but this is not entirely true of the Wainwright Building, where his sense of drama and architectural expression led him to mask parts of the edifice's structure. For instance, he set the building on a base which is thickened, seemingly to support the upper stories, although no such extra support is structurally necessary in a building with a steel frame. He greatly enlarged the masonry piers at the corners of the buildings to make them appear as if they were supporting elements, but in reality, with a steel cage, the corners of a building need little or no support. Both the highly ornamental frieze (masking the tenth floor, which contains the building's machinery) and the cornice have no real function. These and other elements of the design were clearly introduced to give the building an expression beyond pure function. Moreover, Sullivan used color and texture—instead of historical ornament—as design. The brown sandstone of the base, the red brick of the massive corner piers, and the interlaced terra-cotta of the frieze all function together, both to demarcate the various sections of the building and to produce an overall warm tonality.

Sullivan's thoughts on the tall building were further developed in 1899 when he was commissioned to plan a major edifice in downtown Chicago: the Schlesinger & Mayer department store, now known as the Carson Pirie Scott department store, on the corner of State and Madison streets [fig. 109]. In the Wainwright Building the emphasis is on the verticality of the shaft of stories and piers. Because the Chicago department store wrapped around a corner and needed large, horizontal windows, both for the display of merchandise and for lighting the partitioned interior floors, Sullivan thickened the façade spandrels and narrowed the exterior piers (though in reality they are nearly the same size within the steel cage). This gave the building a horizontal orientation (five additional bays, following Sullivan's original design, were added along the State Street façade in 1906). The structure's height is stressed only by the brilliantly designed tall corner tower, whose verti-

cally oriented windows and soaring piers effectively tie together the two more horizontal sections of the store.

There is abundant decoration on the Carson Pirie Scott department store, but it is confined mainly to the first two stories. A fantastic interlace of cast-iron scrollwork runs around the corner tower and frames the large display windows [fig. 110]. Above, however, there is very little ornament to impede the stern geometric grid of the building's piers and spandrels, all clad in smooth white terra cotta. The various unnecessary divisions and subterfuges of the Wainwright Building are no longer present. Instead Sullivan now reveals much of the under-lying structure of the building above the undulating cast-iron decora-

[109] **Sullivan, Carson Pirie Scott department store, 1899, Chicago**

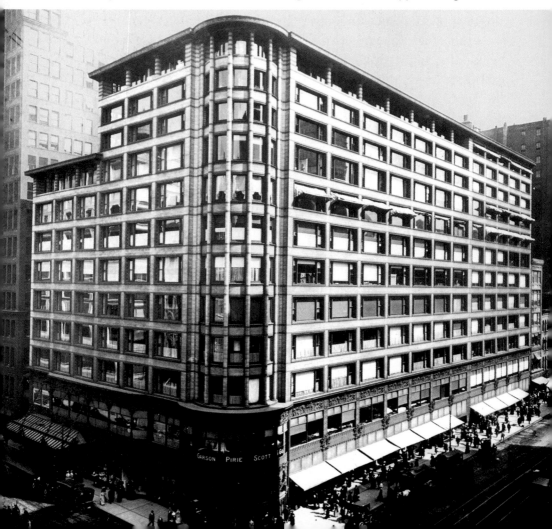

[110] **Sullivan, Carson Pirie Scott department store (detail)**

tion, and revels in the beauty and utility of its engineering and modern construction.

Both the Wainwright Building and the Carson Pirie Scott department store were seminal structures: their construction and style were immediately noted in the United States, but few contemporary architects understood Sullivan's imaginative and humane approach. His work, however, substantially influenced the International Style, an architectural idiom developed in France and Germany in the first decades of the twentieth century. This style was to dominate much of Western architecture for decades. Yet most of the structures built by its adherents, such as Walter Gropius's (1883–1969) famous Fagus Factory

of 1911 [fig. 111], failed to achieve the warmth and personality of Sulli-
van's buildings. Instead they were meticulously engineered, cold, and
shorn of ornament, bereft of the enlivening and elevating combination
of ornament and function that so characterizes the pioneering work of
Louis Sullivan.

[111] Gropius, Fagus Factory, 1911

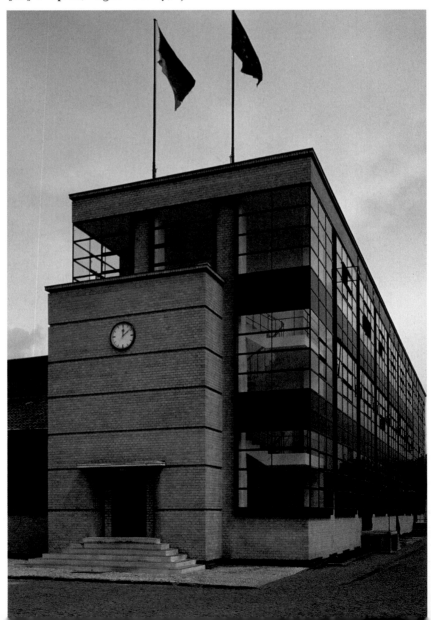

28. Picasso: Innovation Within Tradition

The Studio

Pablo Picasso was the first artist of the twentieth century whose fame extended far beyond his art. A celebrity whose activities fascinated people who knew or cared little about his art, he was eccentric, mercurial, peripatetic, often married and divorced, immensely wealthy, and very long-lived. Near the end of his life he became a sort of animate icon. Entire volumes were devoted to photographs not of his art but of Picasso at work, Picasso with one or another of his wives or mistresses, Picasso eating, Picasso playing with his offspring, and so forth. To many minds, including Picasso's, he was an embodiment of the modern artist: someone whose creativity removed him from the humdrum of ordinary life and set him on a higher, freer plane. This view of the artist, which originated in the nineteenth century, was not only novel but radically different from all earlier periods of art, in which the artist was always firmly integrated into society. Picasso, perhaps more than any other previous painter in the history of Western art, was seen as a destroyer of tradition, a controversial artistic rebel who redirected the course of painting. His Promethean creativity was reflected, so it was believed, in his own life.

That turbulent life began in 1881 when Picasso was born in Malaga, Spain. The son of a painter of rather mediocre still lifes, Picasso first studied under his father (who is said to have abandoned painting when he recognized his son's genius) and by 1896 had enrolled in art school. After studying in Barcelona and Madrid, where his accomplished

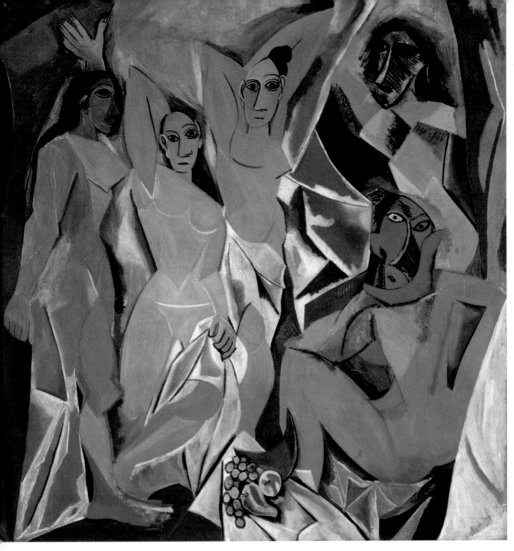

[112] Picasso, *Les Demoiselles d'Avignon (The Women of Avignon)*, begun 1907, Museum of Modern Art, New York

works painted in the traditional academic style had already received early and easy success, he made his first trip to Paris in 1900. He stayed only several months, but two years later he returned to make France his home. Here he was exposed to a range of art and artists unavailable to him in the more provincial atmosphere of Spain. His art soon caught the attention of fellow artists and dealers, and began to develop rapidly along many separate but parallel avenues. Then in May 1907 he started a work destined to reorient the course of Western painting: *Les*

Demoiselles d'Avignon (The Women of Avignon) [fig. 112]. This title, which refers to a famous brothel in the Carrer d'Avinyo (Avignon Street) in Barcelona, was not Picasso's own but was playfully given to the painting when it was first exhibited some nine years after its completion. Whatever the subject of the painting—and Picasso may have had nothing more in mind than the depiction of the five figures—it was preceded by many compositional drawings which analyzed and re-analyzed the nature of the human figure and its proportional and spatial relationships.

The result of all this visual cogitation was a painting that moved decidedly away from the traditional modes of representation that had formed the mainstay of Western art since the Renaissance. Although the work of the influential French painter Paul Cézanne (1839–1906) foreshadowed *Les Demoiselles d'Avignon*, the fragmentation of the fig-

[113] Picasso, *The Studio*, 1934, Indiana University Art Museum, Bloomington

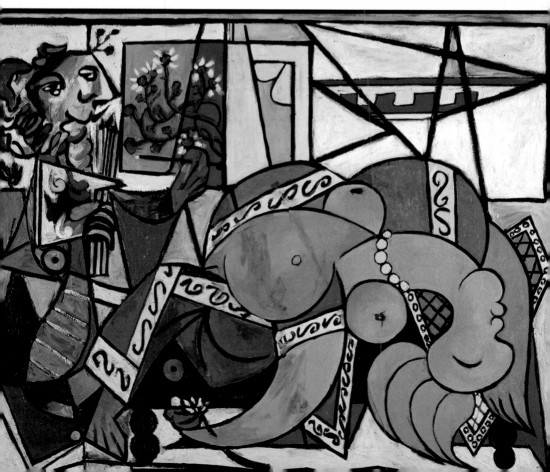

ures and ambient into discordant planes of nearly unmodulated color, as well as the willful distortion of faces (the two at the far right are strongly influenced by African masks which Picasso had been looking at in Paris), was unprecedented. It is as though he has exploded the figure, simplified and abstracted it, and then reassembled it in a new mosaic of form and space. All pretense of realism is gone, but nevertheless the figures communicate expressively with the spectator. Like the Egyptian artist of the *Triad of Mycerinus* [fig. 1], Picasso tried to depict the fundamental nature of things, their underlying structures and their verities rather than just their optical appearances. One of his many statements about art and reality could well apply here: "Any form

[114] Titian, *Venus of Urbino*, c. 1538, Uffizi Galleries, Florence

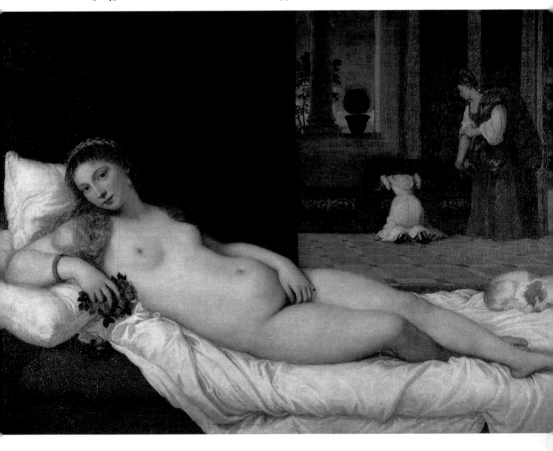

which conveys to us the sense of reality is the one which is furthest removed from the reality of the retina; the eyes of the artist are open to a superior reality; his works are evocations."

Once Picasso had created his new vision, he spent the rest of his life reshaping reality with forms "far removed from the reality of the retina." These abound in *The Studio (L'Atelier)* of 1934, a work dominated by a large and licentious female nude sprawled across a sofa [fig. 113]. Although Picasso was a highly innovative artist, he was not an iconoclast; he treasured the past and often turned to it for inspiration. In *The Studio* he chose a subject—the recumbent female nude—that had fascinated many of the great artists of the past and was a popular subject for oil painting. One of the earliest examples of this type is by Titian; it depicts a fleshy nude sometimes called Venus that is more likely a portrait of a Venetian courtesan [fig. 114]. In *The Studio* Picasso introduces another element: the painter who stands before his easel at the left side.

There is a strong autobiographical element in *The Studio*, for the woman's face is recognizable in Picasso's many portraits of his youthful mistress, Marie-Thérèse Walter. He had introduced himself to her in front of a Parisian department store in 1927 with the words, "Mademoiselle, you have an interesting face. I would like to paint your portrait. I am Picasso." Picasso was then forty-six, Marie-Thérèse seventeen. They soon became lovers, and in the 1930s he painted a series of portraits of her to which *The Studio* belongs.

In *The Studio* Picasso demonstrates his affinity for seeing the world as a series of separate but interlocking forms. As in *Les Demoiselles d'Avignon*, the figures are disposed along a number of interlocking planes, but here, especially in the body of the painter and the studio's skylight in the upper right corner, these planes are more numerous and separated more by strongly contrasting shape and color (much of it applied in unmodulated patches of strong red, yellow, and green). The shapes are also more jagged and less harmonized than in *Les Demoiselles d'Avignon*. Furthermore, there is almost no depth in the painting. The shapes hug the picture plane, creating an overall surface pattern which in itself creates the sort of exciting abstract, independent pattern of line, shape, and color seen in an oriental carpet or a stained glass

window. In this example, as well as in other works of the period, by devolving objects into fields of shape and color Picasso foreshadows the development of the nonrepresentational painting of the 1940s and 1950s as seen, for example, in the works of Jackson Pollock [fig. 119].

But unlike many of the paintings inspired by this and other works by Picasso, *The Studio* is about much more than the purely formal arrangement of shape and color. It is also filled with feeling, a witty, humane parody of the traditional type on which it depends. In traditional nudes the self-conscious pose, the breasts, and the stomach are all part of the erotic appeal of the subject, but in *The Studio* their arrangement seems almost as comic as the amusing flipperlike arms and the four large strands of blue hair. Picasso refuses to revere the venerable subject. His voluptuous, overblown nude, who takes herself very seriously indeed, is simply funny. This levity continues in the figure of the painter whose rather silly-looking face, composed of bold patches of green, red, blue, and yellow, looks very much like the paint-covered palette he holds in his hand—almost as though he has just painted himself. But the final joke appears in the canvas upon which he works. On it he paints not the posturing nude woman but a bunch of flowers, perhaps inspired by those of the little bouquet she holds at her side. These aspects of *The Studio* demonstrate Picasso's uncanny ability to base his work on hallowed artistic prototypes while substantially modifying their form and content without destroying them. Seldom in the history of art has a painter been so traditional yet so revolutionary and, at the same time, so abundantly endowed with a sense of humor.

29. Transcendental Pictures

Three Photographs by Dorothea Lange

The invention of the camera in the early 1800s was an important event in the history of art. At first, because of the rapid popularization of the photograph and its seemingly realistic nature, some people predicted that the camera might supplant painting and sculpture altogether. This was to prove untrue, except in the case of portraiture. Nonetheless photography, both in still pictures and in the movies, has become one of

[115] Lange, *Tractored Out, Childress County, Texas*, 1939

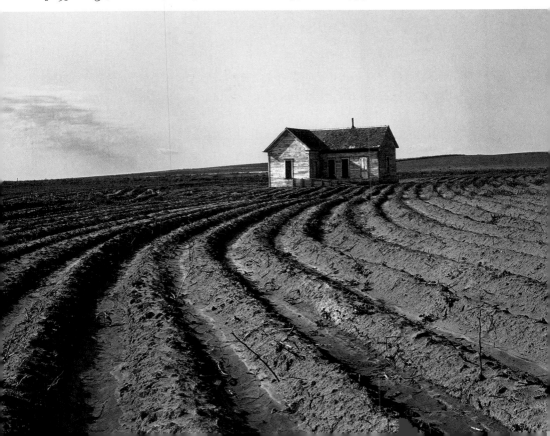

the most important arts of the twentieth century. In fact it might be argued that photography is *the* only new art form of the modern era.

Insight into the nature and purpose of this art is gained by looking at some of the remarkable photographs made during the 1930s by Dorothea Lange (1895–1965). The collapse of financial institutions and crop failures in the United States in that decade created great social unrest and dislocation. Under the administration of President Franklin Roosevelt, a number of federal agencies were created to deal with these vast societal problems.

One of these agencies was the Farm Securities Administration (FSA), established within the Department of Agriculture. In 1935 the FSA established a Historical Section under the direction of Roy Stryker, a professor of economics and a former colleague of Roosevelt's under secretary of agriculture, Rexford Tugwell. This Historical Section was responsible for, among other things, documenting through photographs the immense work of rural reconstruction and settlement undertaken by the FSA. The Historical Section was also to photograph the awful unsettled conditions of rural life which had ensued from the mismanagement of land and from the mechanization of agriculture that had made small farms uneconomical. The resulting photographs would be used to show urban America the condition of farmers and to make a case for the work being carried out by the FSA.

Roy Stryker was not a photographer, but he had already published a book on economics illustrated by what today might be called "documentary photographs." In a short time he had assembled a small team of photographers whose work for the FSA resulted in some of the most distinguished and moving photography of the twentieth century. "The photographers did not think of their work as the creation of art objects," Stryker said; "they used the intuitive, spontaneous approach, not the studied artist's approach." Stryker strenuously objected to the retouching of any FSA photograph or the inclusion of such photographs in "art" exhibitions. These photographs were to be documentation, not art. By 1942 the Historical Section had taken more than 250,000 photographs, many of which had been published in the mass media to propagandize the work of the FSA.

Before he became head of the Historical Section, Stryker already

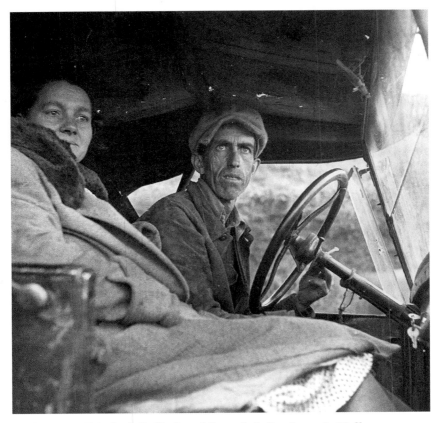

[116] Lange, *Ditched, Stalled, and Stranded, San Joaquin Valley, California,* 1935

knew the work of Dorothea Lange and her husband, the economist Paul Taylor. Born in New Jersey in 1885, Lange at first wanted to be a teacher, but she suddenly decided, even before she had bought her first camera, to become a photographer. She made this choice, she said, "as a way to maintain myself on the planet." In 1918, after working in a photographer's studio and studying for a year in New York, she moved to San Francisco where she became a successful portrait photographer of what she called "the San Francisco merchant princes." But after the crash of 1929 her photographs became increasingly devoted to the social dislocations and sufferings caused by the plunge of the American economy. She was deeply disturbed by these events. She wrote:

One morning, as I was making a proof at the south window, I watched an unemployed young workman coming up the street. He came to the corner, stopped, and stood there a little while. Behind him were the waterfront and the wholesale districts; to his left was the financial district; ahead was Chinatown and the Hall of Justice; to his right were the flophouses and the Barbary Coast. What was he to do? Which way was he to go?

At first Lange concentrated on the strife and sorrow that the Great Depression brought to San Francisco, but by 1935 she and Paul Taylor were already at work for the FSA, documenting the plight of farmers and their families who had left their land in search of jobs. Walker Evans, Ben Shahn, Arthur Rothstein, and Gordon Parks were other FSA photographers who were to become famous through their work for the agency. One of Lange's most evocative photographs, *Tractored Out, Childress County, Texas*, taken in 1939, is, like so many of her works, both a picture of considerable formal elegance and great sadness [fig. 115]. The long, gently curving furrows, stretching from the foreground to the low, limitless horizon, gradually move from shadow into light as they roll across the foreground. The same furrows also direct the viewer's eye backward to the little frame house situated in the middle of the photograph. The beauty and sweep of the furrows are, however, ironic marks of devastation, for they have been made by a tractor, a machine which worked more efficiently and cheaply than the farmer and his family who once lived in the abandoned, run-down house now engulfed by the stamp of mechanization. This is a starkly beautiful picture in which the hard, barren, and sharply lit furrows littered with dead branches and the empty, deteriorating house serve as poignant metaphors for the family now swept away by the machines.

Many of these farm families became the subject for some of Lange's most probing and famous photographs (often taken with the new, small, hand-held Leica camera which allowed the photographer a freedom and spontaneity not possible with the older and much more cumbersome view-cameras). Moving from state to state and from farm to farm looking for any type of employment, these destitute and des-

[117] Lange, *Migrant Mother, Nipomo, California*, 1936

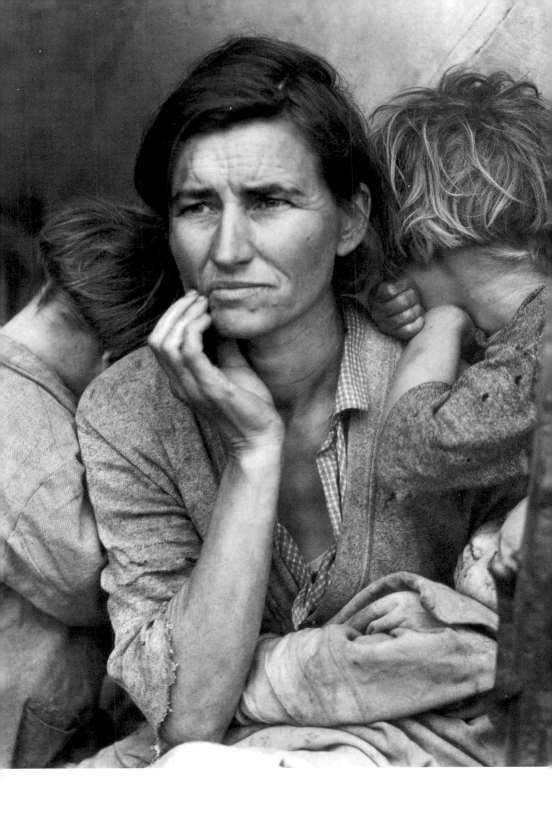

perate families have been immortalized in John Steinbeck's novel *The Grapes of Wrath* of 1939, and by the memorable film made from the book. Directed by John Ford, the film's austere cinematography was much influenced by contemporary photographs by Lange and her FSA colleagues.

In fact, the man and woman in Lange's harrowing *Ditched, Stalled, and Stranded, San Joaquin Valley, California,* of 1935 remind one vividly of the hapless people in *The Grapes of Wrath* [fig. 116]. This photograph is a finely composed work in which the bodies of the car's occupants, the steering column, and the windshield form complementary and energizing diagonal rhythms across the surface of the photograph.

The composition and lighting of the photograph are used by Lange to illuminate the plight of its subjects. The woman huddled against the cold is passive and pensive, but the man, his hands still working the stalled car's controls, looks out at the photographer with eyes that are both fearful and imploring. Like its owners, the car is worn and battered. Lange's skill as a manipulator of form, as an acute observer of detail, *and* as a piercing and sympathetic social commentator are very much in evidence in this remarkable photograph which seems to reach beyond the microcosm of the depression to stand for the essence of despair everywhere. It is not hard to see why photographs like this still stir the feelings of contemporary viewers.

Lange's most famous photograph, *Migrant Mother, Nipomo, California,* taken in 1936, has become one of the icons of the Great Depression and Dust Bowl of the thirties [fig. 117]. While returning home after photographing migrant farm laborers in central California, Lange passed a sign reading "Pea Pickers Camp." About twenty miles down the road she turned her car around on instinct and drove back to the camp. There she found the subject of *Migrant Mother,* a woman of thirty-two who told the photographer that she and her children were surviving on frozen vegetables from the fields and on birds they caught. There was no work in the camp, and the woman was stranded because she had sold the tires of her car to buy food. Lange, who remained in the camp for only ten minutes, made a series of photographs of the woman and her children. Some of these were taken from a distance

and showed the woman and her four shivering children in their flimsy tent surrounded by their meager possessions; others were close-ups of the woman with her three youngest children. Of all these, the most moving was an extreme close-up of the mother holding her baby and bracketed by two children. The framing of the mother by the children, the series of diagonal, interlocking forms throughout the composition, and the unity and isolation of the whole achieved by the intertwining of the shapes and the absence of surrounding space, all create a vivid sense of closeness and interdependency.

The severe lighting of the photograph and the unflinching detail reveal the anguish of the prematurely aged woman and the despondency of her children, whose bodies rather than their faces express their emotions. The woman's old, worn dress, the unkempt hair of the children, and the baby's soiled clothes and dirty face confront the spectator. Like all major works of art, the message of *Migrant Mother* is conveyed brilliantly through its forms. As in Titian's *Flaying of Marsyas* [fig. 50] or Goya's *The Third of May 1808* [fig. 95], these forms elucidate a tragic story told with the utmost economy—but now the subject is not drawn from mythology or history. Rather, *Migrant Mother* is about the particular dilemma of a single ordinary human who has been elevated by Lange's unforgettable photograph into a boundless icon of suffering and desperation. Like the Madonna she recalls [fig. 44], the migrant woman is a powerful and universally understood portrait of motherhood.

Lange's photographs are carefully calculated works of art which shape and modify the reality they document; they contradict Stryker's notion of the photograph as "only" a document. The pictures are highly selective in subject, form, lighting, and detail, and, like any superior work of art, they express the artist's most deeply felt beliefs and passions. These photographs, however, always transcend their particular moment and subject to express, more than mere words can, the hardship and suffering of ordinary people caught up in events not of their making and beyond their control.

30. The Twentieth-century Artist

Jackson Pollock's Lavender Mist

Pablo Picasso was a major innovator, but in all his art, even the most revolutionary, he revered the past. He borrowed frequently from Greek and Roman art while always returning to his famous Spanish artistic ancestors, Velázquez and Goya. Several of his late works are homages to famous paintings by these old masters whom he so venerated.

In the late 1940s and early 1950s, when Picasso was around seventy, several artists and their accompanying theorists began to espouse a novel view of art and artists which was diametrically opposed to that held by him. One of its essential elements was that any borrowing or inspiration from the past was a sign of inferiority. Dependence on tradition was to be jettisoned and replaced with something novel. A "new" art of pure artistic inspiration, realized in unconventional ways, became a much touted ideal. Both critics (many of whom were influenced by Marx and Trotsky) and artists also began to believe that any art that was representational, that is, depicting a recognizable subject— a landscape, a person, and so forth—was a decadent recapitulation of the dead past, tainted by the sentimental, nonartistic associations of the subject itself. To be good, art needed to be revolutionary.

Jackson Pollock (1912–1956) both embraced and helped create these views. Everything about Pollock—his mythical Western origins, his rugged good looks, his hard drinking, his rages, and his violent death—became the stuff of legend. Born in Cody, Wyoming, Pollock studied with Thomas Hart Benton (1889–1975) at the Art Students

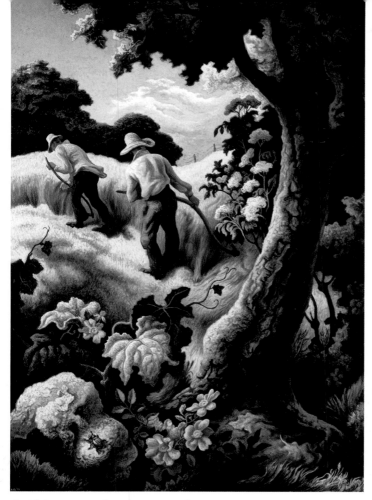

[118] Benton, *July Hay*, 1942, The Metropolitan Museum of Art, New York

League in New York from 1930 to 1933. By that time Benton had, after a youthful flirtation with contemporary European art, developed a vigorous style of figure and landscape painting strongly influenced by the past, especially by the painting of Renaissance Italy. A colorful, profane, and talented painter from Missouri, he increasingly felt that the New York art world was too dominated by European taste and fashion. He eventually left the East Coast for his native Midwest, where he continued to paint representational works, often of popular American subjects [fig. 118].

Pollock's study with Benton cannot be judged a success. His attempts to work in Benton's style are marred by rather inept drawing,

difficulty in depicting the figure, and a general lack of technical accomplishment. The strongly expressive forms of Benton's paintings were, however, to exert a major, if not negative, influence on him. Pollock confessed, "My work with Benton was important as something against which to react very strongly, later on...." But Pollock's highly eclectic interests ranged far beyond Benton to North American Indian painting, to the contemporary Mexican muralists (he assisted one of them, David Alfaro Siqueiros), and to many of the so-called progressive European painters, including Picasso, whom Benton especially reviled.

After leaving Benton's studio, Pollock worked on a WPA Federal Arts Project from 1935 until 1943, when he had his first solo show in New York. Here he exhibited paintings which, while derivative and still vaguely figurative, embodied the sort of newness a number of critics were looking for. His career was launched with a vengeance. With the assistance of critics and art dealers, his style soon began to develop rapidly toward the type of paintings that in the late 1940s and early 1950s were to earn him a momentous place in the history of modern painting.

These paintings, of which *Lavender Mist* is one of the most famous examples, are completely nonrepresentational [fig. 119]. Moreover they were not painted with a brush, the traditional tool of painters; instead Pollock laid a canvas on the floor of his studio, stood above it, and dripped, splattered, and drizzled paint on its surface. Because he walked around the canvas while painting, the established reference points of top, bottom, and sides of traditional paintings were not very important [fig. 120]. And Pollock did not always paint in the conventional, time-honored medium of oil paint; instead he used a wide variety of commercially available paints, including house paint. Sometimes he even embedded objects — sand, broken glass, cigarette butts — into the wet paint.

Lavender Mist (originally Pollock had called it *Number 1, 1950*, but the more associative title was given to the painting by one of Pollock's critic friends) is immense (87 x 118 inches), more like a mural than an easel painting. Lavender, mauve, blue, white, and black pigments have been dripped, splattered, scrubbed, and drizzled onto the sprawling

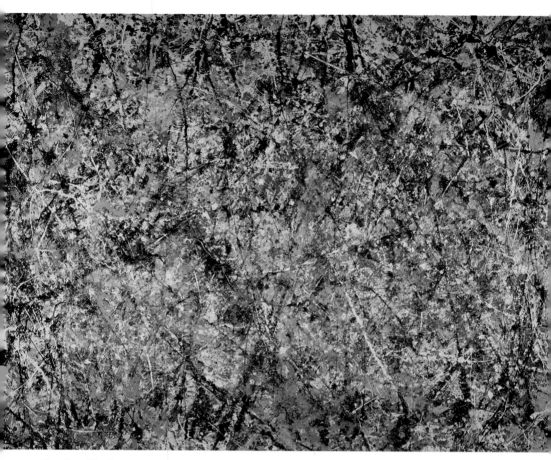

[119] Pollock, *Lavender Mist*, 1950, National Gallery of Art, Washington D.C.

canvas to form a crusty, undulating surface. The sheer size of the canvas, its myriad of broken, textured colors, and the omnipresent, energetic marks made by Pollock flinging and dripping paint from a stick dipped in a can of paint make it impressive indeed. This type of work by Pollock has been called Action Painting (the term Abstract Expressionism, often used for Pollock's work, is actually much more ambiguous), an apt description because the surface of *Lavender Mist* reveals clearly the process and the motions (sometimes called gestures) by which it was painted; it is a picture very much about the physical act of painting.

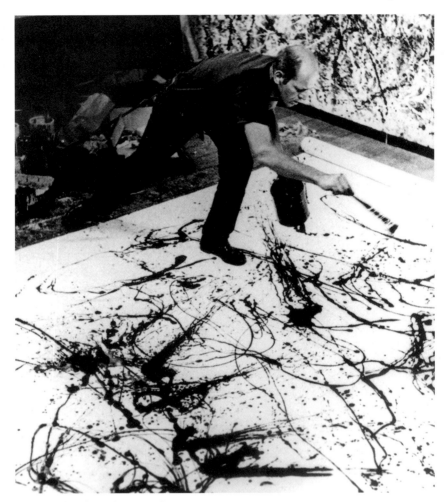

[120] **Pollock in the act of painting**

Because of the rather random and often accidental results of the painting process used for *Lavender Mist* and the other drip paintings, it was impossible to control exactly where the paint was to go. Pollock likened his painting to drawing with a stick in the air above the painting, but in truth his method called for little of the disciplined, rigorous control and the skill traditionally associated with the construction of images through drawing. For Pollock and many of his critic-allies, however, the time-honored methods of carefully planning, constructing,

and articulating a painting were of secondary importance. What really counted most was not education or talent but the unique and rapid visual expression of the momentary state of one's psyche. The manifestation of this state was realized most perfectly by the physical act of painting: the artist's hand guided by inspiration and feelings only. Reason and calculation were supposedly very minor elements in this process.

In a now famous statement about his work, Pollock summed up his feelings about painting:

> When I am in my painting, I'm not aware of what I'm doing. It is only after a sort of "get acquainted" period that I see what I have been about. I have no fears about making changes, destroying the image, etc., because the painting has a life of its own. I try to let it come through. It is only when I lose contact with the painting that the result is a mess. Otherwise there is pure harmony, an easy give and take, and the painting comes out well.

It is not easy to grasp exactly what Pollock means in this passage. It seems as if some subconscious force allowed him to realize his forms on canvas. (This idea may have been partially acquired in the Jungian psychoanalysis that Pollock underwent between 1939 and 1941.) This subconscious force, he implies, rather than a willful, premeditated act by the artist himself, was responsible for the painting's inception. Pollock seems to have realized approximately what he was doing only after he was deeply involved in the painting process. In any case, there seems to have been no plan or design for the work which, once begun, continued on its own steam, or, as Pollock suggested, the work had "a life of its own." This statement consequently rejects the cognitive, disciplined, and rational basis of traditional painting, including even such revolutionary works of the twentieth century as Picasso's *Les Demoiselles d'Avignon* [fig. 112], which were the results of rigorous observation and planning. In Pollock's view, what mattered was a sort of unconscious inspiration, not training or talent: this notion, more than his paintings, was the really revolutionary aspect of his art. The recognition and elevation of such unconscious inspiration has become commonplace among many artists and their critics in the post-Freud, post-Jung era. Such wholly personal expression arising solely from the uncon-

scious has in fact become closely identified with the idea of modernity itself.

Pollock's paintings, while they were acclaimed by many critics, some of whom made their reputations defining him, were not universally praised. History is written by the victors, and seldom has an artist been so rapidly canonized as Pollock; but at the time his paintings were sweeping the New York art world, several dissenting voices, now nearly forgotten, were raised. Some of these called Pollock an outright fraud while others questioned the very principles upon which his art was based. One of the primary criticisms was that because Pollock's works were nonrepresentational, they conveyed no meanings that could be understood communally. Instead the paintings, especially the drip paintings, contained encoded messages recognizable only by the artist himself. The shared information and emotions of universally understood images, such as Rembrandt's *Self-Portrait* [fig. 84] or Goya's *Third of May 1808* [fig. 95], were jettisoned and replaced by a cryptic set of marks supposedly derived from an individual's private inspirations or from the painting's "life of its own." Other critics worried about the abandonment of traditional ideas of discipline, skill, and rational planning. These guiding principles of all great Western art were, they felt, the prerequisites needed to shape and refine artistic vision into images accessible to all who saw them.

There can be little doubt that Pollock's enormously influential paintings, and, of equal importance, the ideas that shaped them, redirected much of modern art. Today, nearly a half-century after his death, the repercussion of his work is still felt in the desperate search for self-expression and uniqueness that characterizes much contemporary art, in which novelty and energy are often equated with talent but discipline and rigor often count for little. In truth, Pollock's art is inimical to many traditional ideas of art as a communication between artist and onlooker. His paintings dwell not on the larger, more universal issues usually dealt with by the art of the past but with the highly personal, often opaque, movements of his own troubled ego.

31. The Elevation of the Ordinary

Hopper's Hotel Lobby

Edward Hopper (1882–1967) was the antithesis of Jackson Pollock in almost every way. In his art, in his view of his own creativity, in his general outlook toward life, and in what we would now call "life-style," Hopper, who was Pollock's contemporary—they both worked in New York at the same time—bore little resemblance to his stormy fellow artist. Often art historians center their theories on certain figures, such as Pollock, whom they view as overwhelming forces—men or women whose work creates a style that dominates and defines a period. But they often forget, or more frequently ignore, artists whose work falls far outside their tightly constructed views of history. Edward Hopper was one such artist.

By character and by choice, Hopper led a remarkably uneventful life, something that certainly cannot be said of Pollock, whose art *was* his life. Quiet, modest, private, self-disciplined, and industrious, Hopper painted rather small canvases in an unpretentious New York apartment. During the summer months he traveled to a tiny house in New England where he and his wife, Joe Nivison, worked peacefully.

At the time of his death in 1967, Hopper had achieved much success in spite of the fact that his art was never considered fashionable and never promoted by the avant-garde New York critics who often dictated what did or did not get exhibited and consequently what got sold. Hopper's success did not, however, come easily. He was born in 1882 in Nyack, New York, where his father was a storekeeper. After graduating

211

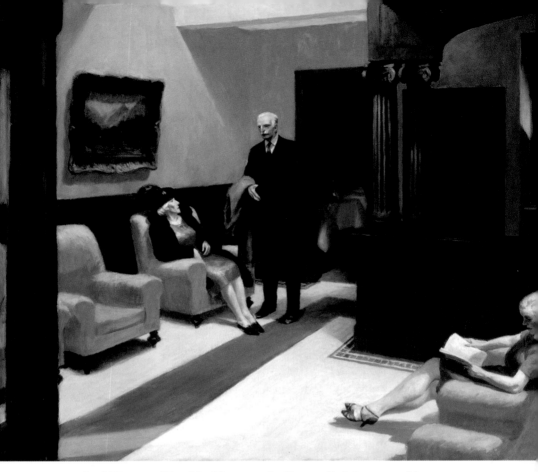

[121] Hopper, *Hotel Lobby*, 1943, Indianapolis Museum of Art, Indianapolis

from high school in Nyack, he studied in New York at the New York School of Art with a rather talented group of painters, including William Merritt Chase and Robert Henri. In New York he also studied illustration, and it was as a commercial illustrator for the print medium, rather than as a painter, that he found his first success. He made three early trips to France, the first in 1907, the last three years later. The country made a lasting impression on the young artist and, though he never returned, his love of French culture and art remained an important and constant element in his life.

Not until 1924, the year of Hopper's marriage at the age of forty-one, did he have his first exhibition, which resulted in critical and monetary success. He then immediately gave up his work in illustra-

tion, which he had done solely to support his art, and devoted himself full-time to painting. A series of exhibitions of ever-increasing importance followed, and he was given a retrospective at the Whitney Museum of American Art in 1950. Fourteen years later he was again celebrated at the Whitney with an even larger retrospective which traveled to both Detroit and St. Louis. At the end of his life Hopper could look back on a successful, if not meteoric, career with a sustained production of distinguished paintings over a long period of time — again, the opposite of an artist like Pollock, whose star burned more brightly but for a much shorter time.

Early in his career, by about 1925, Hopper had developed a style and interpretation of subject which he was to retain with little variation for the rest of his life. This fact seems to contradict one of our basic received ideas about how a twentieth-century artist works. On the basis of Picasso, Pollock, and many other painters and sculptors who reinvented their style rapidly, radically, and continually, we tend to think that all modern artists race through many idioms and "isms." This is indeed often the case. But Hopper, like many of the artists of the past, developed a style which he thought adequately expressed his underlying aspirations. He then spent years perfecting and refining it.

Hopper's style was employed for the depiction of a purposefully limited group of subjects which had substantial meaning for him. Among these were landscape, especially the rocky New England coast; cities, both New York and smaller places which he visited on his frequent trips around the United States; restaurants; offices; single figures; trains; and train tracks bordered by houses. In the painting of many of these subjects, Hopper explored and analyzed the different times of day and their effect on color and light, both natural and artificial. If there were figures he dwelt on the interaction, or lack of interaction, between them and their relation with their surroundings.

Many of these aspects are essayed in one of Hopper's finest paintings, the haunting *Hotel Lobby* of 1943 [fig. 121]. Like many of his paintings, at first glance this looks deceptively simple. Four figures — an elderly couple, an indistinct man behind the desk, and a younger woman — are the sole occupants of an otherwise deserted corner of the lobby of a small and modest hotel. Hopper has carefully circumscribed

[122], [123]
Hopper,
Preparatory
drawings for
*Hotel
Lobby*,
1943,
Whitney
Museum of
American
Art, New
York

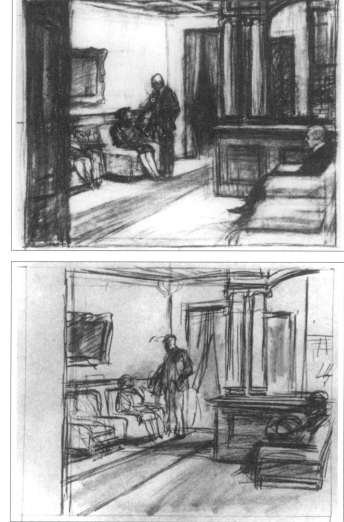

and demarcated this space by the introduction of the entrance door at the far left, by the arch and columns which run diagonally across the room in the near background, and by the closed, darkened dining room behind. The lobby is rather eerily and unevenly lit by the cold glow of the electric lights in the ceiling. Each figure and object in the room seems to be a discrete entity; communication between them is either nonexistent or held to an absolute minimum.

[124], [125] Hopper, Preparatory drawings for *Hotel Lobby*, 1943, Whitney Museum of American Art, New York

The final deposition and meaning of *Hotel Lobby* was not a spontaneous invention of the artist but rather the result of a process of elimination and refinement which we are able to follow through a series of four preparatory drawings made with Conté crayon. In the earliest of these Hopper has fixed the boundaries of the lobby and its furniture, but four people instead of three occupy the space in front of the desk [fig. 122]. A woman—we see only her legs—sits next to the elderly couple drawn together by exchanged glances and by the man's right hand and arm which seem either to touch the woman's shoulder or rest on the arm of her chair. Across from her is a man looking in the couple's direction.

In the next drawing, which is less worked out, probably because Hopper already had arrived at the major elements of his composition, the couple has been moved slightly apart and the seated woman has disappeared; the man across from her remains, though now in less distinct form [fig. 123].

In the painting, however, this man has been replaced with the reading woman who, by her outstretched, crossed legs and arms placed on the armrests, occupies the space in a more decisive manner. For her, Hopper made a separate drawing (probably using his wife as the model) seated in a slightly different chair [fig. 124]. In a fourth drawing he further studied her arms and the body and hands of the elderly seated woman [fig. 125]. When he actually painted the elderly couple, he made another major modification: he separated them slightly and made the man look away from the woman, who still looks at him. In the painting he also added the desk clerk who is absent from all the drawings.

Through all these carefully calculated changes, from the earliest thoughts on paper to the final painting on canvas, Hopper has reduced the number of figures in the lobby and enhanced the viewer's sense of their isolation from one another. In so doing he has charged the simple space and its motionless occupants with a sense of uneasy anticipation and loneliness which we discern but find impossible to define with more precision. The muted greens, browns, blues, and whites, and the coolness of the light, heighten these feelings. So, far from being a rather straightforward depiction of a simple scene, as it seems at first glance, in Hopper's subtle and emotionally probing idiom *Hotel Lobby* becomes a meditation on deeply seated, if not fully explicable, human emotions and a substantial work of art in a minor key.

32. Rethinking Sculpture

David Smith's Cubis

There are certain constants in all art. Painters manipulate pigment on flat surfaces to create shape, line, space, and light with color. Architects use a range of forms—the arch, the column, the cantilever—in various

[126] Smith, *Star Cage*, 1950, Frederick R. Weisman Art Museum, Minneapolis

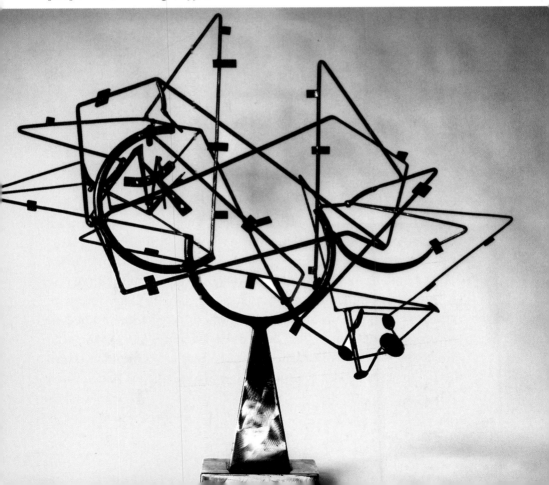

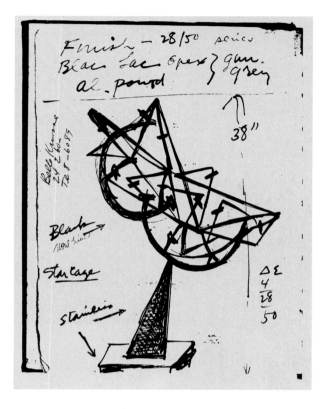

[127] Smith,
Drawing for *Star Cage*, 1950

materials to span, enclose, and form inhabitable volume. And sculptors carve or construct shapes which either move into space or are penetrated by it. Occasionally an artist will substantially modify the way these constants are used. Such was the case with David Smith (1906–1965), one of the icons of modern sculpture and a figure often compared to Jackson Pollock for his revolutionary ideas about modern art. Smith's most famous and daring works are a series of constructed metal sculptures, called *Cubis*, done at the end of his life. While strikingly innovative, these are in many ways a summation of much of his earlier thinking about the making of metallic sculptural form.

Smith was born in Decatur, Indiana, in 1906, but at age fifteen he moved with his parents to Paulding, Ohio. In 1923 he first studied art by correspondence from the Cleveland Art School. The next year he enrolled at Ohio University in Athens, in southern Ohio, but stayed there only one year. He then moved back to Indiana, working during

the summer as a welder in the Studebaker automobile factory at South Bend followed by a short stint at the University of Notre Dame. Much, perhaps over much, has been made of Smith's time at the Studebaker factory, but it was an important experience. As he wrote:

> After four months in department 346 at the Studebaker plant alternating on a lathe, spot welder and milling machine, I was transferred to 348 on Frame Assembly. This was worked on a group plan, payment made to 80 men in proportion to the completed frames which were riveted and assembled on an ova conveyor track. It was necessary for each man to be able to handle at least six operations. Riveting, drilling, stamping, etc., all fell into my duties but my interest was the $45 to $50 per week which would enable me to study in New York.

Smith did earn the money to study in New York at the Art Students League in 1926, but what he had learned in the Studebaker factory — technique, materials, the use of a wide variety of metalworking tools and metal assemblage — would prove extremely influential in the development of his art.

Although strongly influenced by the sculpture of Picasso and Julio Gonzalez, Smith's metal constructions from the early 1930s onward are remarkably innovative. One major milestone in his development is *Star Cage*, a steel construction from 1950 [fig. 126]. Like many of his sculptures, *Star Cage* was first ideated in a drawing [fig. 127]. In a 1955 lecture, Smith discussed how he felt about drawing and line:

> Simply stated, the line is a personal choice. The first stroke demands another in complement, the second may demand the third in opposition, and the approach continues, each stroke more free because confidence is built by effort. If the interest in this line gesture making is sustained, and the freedom of the act developed, realization to almost any answer can be attained. Soon confidence is developed and one of the secrets of drawing felt, and arcs come so easily and move so fast that no time is left to think. Even the drawing made before the performance is often greater, more truthful, more sincere than the formal production later made from it. Such a statement will find more agreement with artists than from connoisseurs. Drawings usually are not pompous enough to be called works of art. They are often too truthful. Their appreciation neglected, drawings remain the life force of the artist.

Smith's early ideas about *Star Cage* (his wife seems to have first thought of the idea) are preserved in a drawing. They include a triangular stainless steel support placed on a steel base, both features which are retained in the sculpture, though the support is now upright instead of angled. In the finished piece, the two large semi-circles from the drawing are joined by another of only slightly smaller size. The series of lines is expanded and substantially modified in the metal version. One can see just how important the drawing—Smith's "life force"— was in this process. The finished *Star Cage* does indeed look like a bold ink drawing given three-dimensional form in steel. The small rectangular blocks or intersections which resemble the rectangular marks in the notebook drawing and the metal circles which suggest ink blobs— such blobs are not, however, found on the drawing—are especially interesting when translated to metal. Color, often an element of drawing, is frequently an integral part of Smith's work, and the entire network of "lines" that form the upper part of *Star Cage* are painted blue. Although probably indebted to Pollock's action painting [fig. 120] and its concept of linear gesture, the idea of sculpture as drawn line moving through space with such complexity and force is Smith's own.

Toward the end of his life in 1965—before he, like Pollock, was tragically killed in a traffic accident—Smith began the series of *Cubis*, the works for which he is best known. These are sculptures of widely varying shape and construction characterized by box- or cubelike shapes, cylinders, and disks, all of varying size, made of polished stainless steel and spot welded together. These forms are arranged in daring and unexpected ways to explore—with new materials and without the use of the human figure—many of the fundamental problems that have confronted sculptors throughout history as they have attempted to arrange solid form in space. To stress the highly abstract nature of the *Cubis* and to avoid any of the traditional emotional or romantic associations evoked by a title like *Star Cage*, Smith simply numbered the forms.

A brilliant example of one of these is *Cubi XVII*, signed and dated December 4, 1963 [fig. 128]. The piece is set on a square base from

[128] Smith, *Cubi XVII*, 1963, Dallas Museum of Art, Dallas

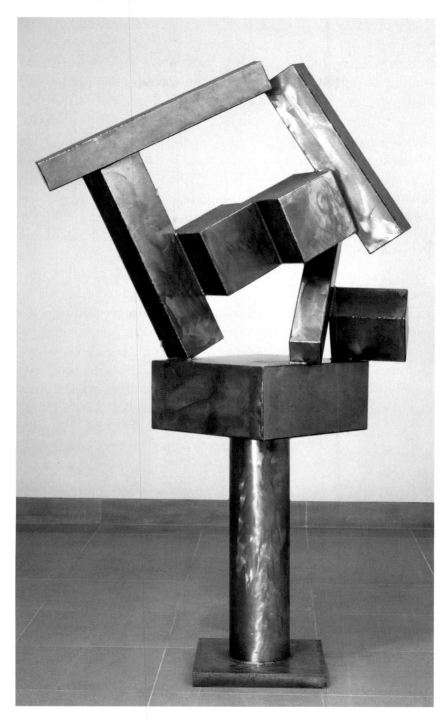

which rises a thick cylinder capped by another square, which is some four or five times larger than the base and rotated about 45 degrees from it. Smith has deliberately misaligned the two squares, thereby preventing the work from having any clearly definable front, back, or side views; a similar compositional strategy was used almost exactly five hundred years earlier by Donatello in his *Judith and Holofernes* [fig. 33] in Florence.

Positioned on top of the upper base of *Cubi XVII* are a series of diagonally set cubes, the lowest three of which rest only on one corner, the absolutely smallest possible support surface. This makes all the cubes seem precariously balanced. Higher cubes are placed on the lower ones, but by the most masterful and wonderfully calculated composing, Smith has created what appears to be an almost momentary equipoise between base, cylinder, upper base, and the cubes above—a sort of dazzling sculptural juggling act. The polished surface of the stainless steel, which carries the marks of Smith's buffers while refracting and reflecting the ambient light, heightens this sense of formal excitement. Ultimately the play of traditional sculptural form—shape and mass interacting with the surrounding space—is the core and strength of Smith's remarkable work. Stripped of all human and anecdotal associations, *Cubi XVII* is the essence, and heart, of sculptural form.

Epilogue

All the masterpieces explored in this book, with the exception of the *Triad of Mycerinus* which, while related to them, belongs to another tradition, are products of Western civilization. Looking back, we can see that they are an extremely diverse group. The idea that the West and its art and thought are a monolithic, homogenous whole is, as these objects prove, very mistaken indeed. Instead the cultures and artists that produced the *Kritios Boy* and David Smith's *Cubis* are vastly different. But there are commonalities in Western art which are as notable as the differences.

One of the most prominent of these commonly held qualities is the process of change and reform shared by all periods and many artists. Unlike the art of Egypt and of many other cultures, Western art is always metamorphosing, transforming itself from one form into another. Moreover the idea of conscious reform, of rebellion against the past, is a hallmark of Western art, especially in the post-Renaissance period. Often with such reform has come the revival of older forms and types which are reused and infused with new meaning. Throughout its development, Western art has moved forward, backward, and then forward again. The West has continually and consciously striven to move beyond its past into new avenues of expression. This spirit of artistic restlessness is part of the West's exploratory culture. It is also manifested in its remarkable history of geographical and astronomical discovery and in its lengthy, brilliant, and unparalleled record of scientific inquiry.

The artistic production of the West is also distinguished by the wide spectrum of types it has produced over its long history. Paintings,

sculptures, and buildings created for religious and secular purposes exist in great variety in all times and places, but few art-producing civilizations rival the diversity of type and image found in the West.

During its long history, Western art has been almost exclusively object-based; it has, in other words, portrayed the world in a more or less recognizable fashion. The only notable exception to this is the nonobjective abstract art of our century. Whether this decided departure from tradition will mark a turning point in the history of Western art remains to be seen.

Much of the history of Western art has been concerned with the representation of the human form and its place in the earthly and heavenly realms. From the first art in Greece to the early twentieth century, the human body, often seen nude, has remained the linchpin of art. Moreover the portrayal of human form has been realistic with several notable exceptions, such as the early Middle Ages or the twentieth century, when religious or personal expression was paramount and conventional ideas of realism and beauty yielded to a much more expressive treatment of the body. The interest in the realistic portrayal of the individual has also created one of the West's most popular artistic types, the portrait, a prime example of its human-centered art.

The interest in the individual is also ultimately responsible for producing the cult of the artist in the West. Although for the most part artists remained anonymous until the Renaissance, the subsequent history of Western art is largely a story of artistic personality. From Giotto to Jackson Pollock, the idea of the artist as a particular man or woman conditions the way his or her art is perceived. Sometimes, as in the case of Picasso, for instance, the personality can become as important as the art.

All these characteristics of Western art give it an ongoing vitality and energy that make it an important part of the society to which it belongs. From prehistoric cave paintings to the present day, art has played an important part in the religious, political, and secular life of the West. It has helped shape our collective imagination and has provided a set of ineradicable shared images of gods, heavens, hells, rulers, and people of all ranks and walks of life. The objects examined in this

book represent just a few of the thousands of profound and complex works produced by artists who were nourished by, and in turn nourished, this great Western tradition.

Suggested Reading

Chapter 1. Cyril Aldred, *Egyptian Art* (New York, 1985).

Chapter 2. John Boardman, *Athenian Red Figure Vases: The Archaic Period* (London, 1983).

Chapter 3. John Boardman, *Greek Art* (London, 1985).

Chapter 4. Paul Zanker, *The Power of Images in the Age of Augustus* (Ann Arbor, 1990).

Chapter 5. William MacDonald, *The Pantheon: Design, Meaning, and Progeny* (Cambridge, Mass., 1976).

Chapter 6. Elizabeth Malbon, *The Iconography of the Sarcophagus of Junius Bassus* (Princeton, 1990).

Chapter 7. Otto von Simson, *Sacred Fortress: Byzantine Art and Statecraft in Ravenna* (Chicago, 1948).

Chapter 8. Bruce Cole, *Giotto: The Scrovegni Chapel, Padua* (New York, 1993).

Chapter 9. John White, *Duccio: Tuscan Art and the Medieval Workshop* (London, 1979).

Chapter 10. John Pope-Hennessy, *Donatello Sculptor* (New York, 1993).

Chapter 11. Jane Hutchison, *Albrecht Durer: A Biography* (Princeton, 1990).

Chapter 12. Kenneth Clark, *Leonardo da Vinci* (Harmondsworth, England, 1988).

Chapter 13. Howard Hibbard, *Michelangelo* (New York, 1985).

Chapter 14. Bruce Cole, *Titian and Venetian Painting* (Boulder, Colo., 1999).

Chapter 15. Leo Bronstein, *El Greco* (New York, 1990).

Chapter 16. John Pope-Hennessy, *Cellini* (New York, 1985).

Chapter 17. Howard Hibbard, *Caravaggio* (New York, 1983).

Chapter 18. Jonathan Brown, *Velazquez: Painter and Courtier* (London, 1986).

Chapter 19. Howard Hibbard, *Bernini* (London, 1965).

Chapter 20. Christopher Brown, *Van Dyck* (London, 1982).

Chapter 21. Kenneth Clark, *An Introduction to Rembrandt* (New York, 1978).

Chapter 22. Gabriel Naughton, *Chardin* (London, 1996).

Chapter 23. Luc de Nanteuil, *Jacques-Louis David* (New York, 1990).

Chapter 24. Sarah Symmons, *Goya* (London, 1998).

Chapter 25. Jan Hulsker, *The New Complete Van Gogh: Paintings, Drawings, Sketches* (Philadelphia, 1996).

Chapter 26. Ruth Butler, *Rodin: The Shape of Genius* (New Haven, 1993).

Chapter 27. Robert Twombly, *Louis Sullivan: His Life and Work* (Chicago, 1986).

Chapter 28. Hans Jafee, *Pablo Picasso* (New York, 1966).

Chapter 29. Christopher Cox, *Dorothea Lange* (New York, 1987).

Chapter 30. Ellen Landau, *Jackson Pollock* (New York, 1989).

Chapter 31. Gail Levin, *Edward Hopper: An Intimate Biography* (New York, 1995).

Chapter 32. Rosalind Krauss, *The Sculpture of David Smith* (New York, 1977).

Illustration Credits
and Permissions

Fig. 1. Triad of King Mycerinus and Two Goddesses. Museum Expedition. Courtesy Museum of Fine Arts, Boston. Copyright © 1998, Museum of Fine Arts, Boston. All rights reserved.

Fig. 3. Triad of King Mycerinus and Two Goddesses (detail). Museum Expedition. Courtesy Museum of Fine Arts, Boston. Copyright © 1998, Museum of Fine Arts, Boston. All rights reserved.

Fig. 4. Gizeh pyramids. Art Resource, New York. Photograph copyright © by Erich Lessing.

Fig. 5. Calyx krater. The Metropolitan Museum of Art, Purchase, Bequest of Joseph H. Durkee, Gift of Darius Ogden Mills and Gift of C. Ruxton Love, by exchange, 1972 (1972.11.10). Photograph copyright © 1986 by The Metropolitan Museum of Art.

Fig. 6. Calyx krater (detail). The Metropolitan Museum of Art, Purchase, Bequest of Joseph H. Durkee, Gift of Darius Ogden Mills and Gift of C. Ruxton Love, by exchange, 1972 (1972.11.10). Photograph copyright © 1986 by The Metropolitan Museum of Art.

Fig. 7. Statue of a Kouros. The Metropolitan Museum of Art, Fletcher Fund, 1932 (32.11.1).

Fig. 8. Kouros. National Archaeological Museum, Athens.

Fig. 10. Augustus of Prima Porta. Alinari/Art Resource, New York.

Fig. 11. Augustus of Prima Porta (detail). Alinari/Art Resource, New York.

Fig. 12. Polyclitus. Museo Nazionale, Provincia di Napoli e Caserta-Napoli.

Fig. 13. Augustus of Prima Porta (detail). Art Resource, New York.

Fig. 14. Gemma Augustea. Kunsthistorisches Museum.

Fig. 15. Pantheon. Art Resource. Copyright © Archivi Alinari, 1989. All rights reserved.

Fig. 17. *Interior of the Pantheon*. National Gallery of Art, Washington, D.C. Samuel H. Kress Collection.

Fig. 18. Maison Carrée. Giraudon/Art Resource, New York.

Fig. 20. Labors of Hercules Sarcophagus. Palazzo Ducale di Mantova.

Fig. 23. The Battle of Issus. Museo Nazionale, Provincia di Napoli e Caserta-Napoli.

Fig. 24. The Emperor Justinian and his court. Scala/Art Resource, New York.

Fig. 25. The Court of Empress Theodora. Scala/Art Resource, New York.

Fig. 26. Court of Theodora (detail). Scala/Art Resource, New York.

Fig. 27. Resurrection of Christ and Noli me tangere. Alinari/Art Resource, New York.

Fig. 28. Interior view of the Scrovegni Chapel. Alinari/Art Resource, New York.

Fig. 29. Resurrection of Christ and Noli me tangere (detail). Alinari/Art Resource, New York.

Fig. 30. Maesta. Nimatallah/Art Resource, New York.

Fig. 31. Maesta (back). Scala/Art Resource, New York.

Fig. 32. Maesta (detail). Scala/Art Resource, New York.

Fig. 33. Judith and Holofernes. Art Resource, New York.

Fig. 34. Judith and Holofernes. Art Resource, New York. Copyright © Archivi Alinari, 1991. All rights reserved.

Fig. 37. Knight, Death and the Devil. Indiana University Art Museum. Photograph by Michael Cavanagh and Kevin Montague. Copyright © 1998 Indiana University Art Museum.

Fig. 38. Knight, Death and the Devil (detail). Indiana University Art Museum. Photograph by Michael Cavanagh and Kevin Montague. Copyright © 1998 Indiana University Art Museum.

Fig. 39. Last Supper. Art Resource, New York.

Fig. 40. Last Supper. Art Resource, New York.

Fig. 41. Rough study of the "Last Supper." Royal Collection Enterprises. Copyright © Her Majesty Queen Elizabeth II.

Fig. 43. St. Phillip c. 1495–1497. Royal Collection Enterprises. Copyright © Her Majesty Queen Elizabeth II.

Fig. 48. Pieta. Cameraphoto/Art Resource, New York.

Fig. 49. Rondanini Pieta. Art Resource, New York. Copyright © Archivi Alinari 1991. All rights reserved.

Fig. 50. The Torture of Marsyas. Art Resource, New York. Photograph copyright © by Erich Lessing.

Fig. 51. The Torture of Marsyas (detail). Art Resource, New York. Photograph copyright © by Erich Lessing.

Fig. 53. Prophet Jeremiah. Musei Vaticani.

Fig. 54. Christ Cleansing the Temple. National Gallery of Art, Washington, D.C. Samuel H. Kress Collection.

Fig. 55. Christ Driving the Money Changers from the Temple. The Minneapolis Institute of Arts.

Fig. 56. Burial of Count Orgaz. Giraudon/Art Resource, New York.

Fig. 57. The Entombment. Art Resource, New York. Photograph copyright © by Erich Lessing.

Fig. 61. Perseus. Alinari/Art Resource, New York. Copyright © Archivi Alinari, 1991. All rights reserved.

Fig. 63. Perseus (detail). Art Resource, New York. Copyright © Archivi Alinari, 1991. All rights reserved.

Fig. 65. The Calling of St. Matthew. Scala/Art Resource, New York.

Fig. 66. Martyrdom of St. Matthew. Alinari/Art Resource, New York.

Fig. 69. Creation of Adam (detail). Musei Vaticani.

Fig. 70. Philip IV of Spain in Brown and Silver. National Gallery, London.

Fig. 71. Portrait of Charles V. Art Resource, New York.

Fig. 76. Cornaro Chapel. Art Resource, New York.

Fig. 78. Members of the Cornaro Family. Art Resource, New York.

Fig. 79. Ecstasy of St. Theresa (detail). Scala/Art Resource, New York.

Fig. 80. Ecstasy of St. Theresa (detail). Scala/Art Resource, New York.

Fig. 81. Charles V at Mühlberg. Art Resource, New York.

Fig. 82. Charles I in Three Positions. Royal Collection Enterprises Ltd. Photographed by Rodney Todd-White, October 1990.

Fig. 83. Equestrian Portrait of Charles I. National Gallery, London.

Fig. 85. Self-Portrait (Rubens). Royal Collection Enterprises Ltd.

Fig. 88. The Toilet of Venus The Metropolitan Museum of Art, Bequest of William K. Vanderbilt, 1920. (20.155.9). Photograph copyright © 1993 The Metropolitan Museum of Art.

Fig. 89. Carafe, Goblet and Fruit. The Saint Louis Art Museum.

Fig. 90. The House of Cards. National Gallery, London.

Fig. 91. Death of Marat. Musées Royaux des Beaux-Arts de Belgique.

Fig. 92. Oath of the Horatii. Musée du Louvre.

Fig. 93. Brutus (David). Musée du Louvre. Photograph copyright © by R.M.N.

Fig. 94. Distribution of the Eagle Standards (David). Musée du Louvre. Photograph copyright © by R.M.N.

Fig. 97. The Disasters of War—Plage 30—Ravages of War. Indiana University Art Museum. Photography by Michael Cavanagh and Kevin Montague. Copyright © 1999 Indiana University Art Museum.

Fig. 98. In a Café. Musée d'Orsay. Photograph copyright © by R.M.N.– H. Lewandowski.

Fig. 99. A Bar at the Folies-Bergère. Courtauld Gallery.

Fig. 100. The Night Café. Yale University Art Gallery. Bequest of Stephen Carlton Clark, B.A. 1903.

Fig. 101. The Night Café (detail). Yale University Art Gallery. Bequest of Stephen Carlton Clark, B.A. 1903.

Fig. 102. Departure of the Volunteers of 1792. Arc de Triomphe. Pascal LeMaitre. Copyright © C.N.M.H.S.

Fig. 103. Burghers of Calais, First Maquette. Copyright © Musée Rodin. Photograph copyright © by Bruno Jarret/ADAGP.

Fig. 104. Burghers of Calais, Second Maquette. Copyright © Musée Rodin. Photograph copyright © by Bruno Jarret/ADAGP.

Fig. 105. Monument of the Burghers of Calais. Copyright © Musée Rodin. Photograph copyright © by Bruno Jarret/ADAGP.

Fig. 106. Court of Honor looking west, World's Columbian Exposition, Chicago. Chicago Historical Society. Photograph by C. D. Arnold.

Fig. 109. Carson Pirie Scott & Company, Chicago. Chicago Historical Society.

Fig. 110. Ornamental detail over main entrance of Carson Pirie Scott building at 1 South State Street, Chicago. Photograph by Arthur Siegel.

Fig. 111. Fagus Factory. Art Resource, New York.

Fig. 112. Les Demoiselles d'Avignon. The Museum of Modern Art, New York. Acquired through the Lillie P. Bliss Bequest. Photograph copyright © 1999 The Museum of Modern Art, New York.

Fig. 113. L'Atelier (The Studio). Indiana University Art Museum, Gift of Dr. and Mrs. Henry R. Hope. Photograph by Michael Cavanagh and Kevin Montague. Copyright © 1999 Indiana University Art Museum.

Fig. 114. The Venus of Urbino. Art Resource, New York. Photograph copyright © by Erich Lessing.

Fig. 115. Tractored Out, Childress County, Texas. Library of Congress.

Fig. 116. Ditched, Stalled, and Stranded, San Joaquin Valley, California. Library of Congress.

Fig. 117. Migrant Mother, Nipomo, California. Library of Congress.

Fig. 118. July Hay. The Metropolitan Museum of Art, George A. Hearn Fund, 1943. (43.159.1). Photograph copyright © 1982 The Metropolitan Museum of Art.

Fig. 119. Lavender Mist. National Gallery of Art, Washington, D.C. Photograph by Richard Carafelli.

Fig. 121. Hotel Lobby. Indianapolis Museum of Art, William Ray Adams Memorial Collection.

Fig. 126. Star Cage. Collection Frederick R. Weisman Art Museum, University of Minnesota, Minneapolis.

Fig. 128. Cubi XVII. Dallas Museum of Art, The Eugene and Margaret McDermott Art Fund, Inc.

Index

A NOTE ON THE AUTHOR

Bruce Cole is Distinguished Professor of Fine Arts, Professor of Comparative Literature, and chairman of the Department of the History of Art at Indiana University. Born in Cleveland, Ohio, he studied at the Western Reserve University, Oberlin College, and Bryn Mawr College, where he received a Ph.D. He has written widely on Italian Renaissance art, and his many books include *The Renaissance Artist at Work, Italian Art, 1250–1550,* and, most recently, *Titian and Venetian Painting, 1450–1590.*